FINDING GRACE
The Face of America's Homeless

DEDICATION

This book is dedicated to my children

Emily, Lacey, Laurie, Lyndsey, Robert, Eric, Jeff and Gracee

who are the grace of my life

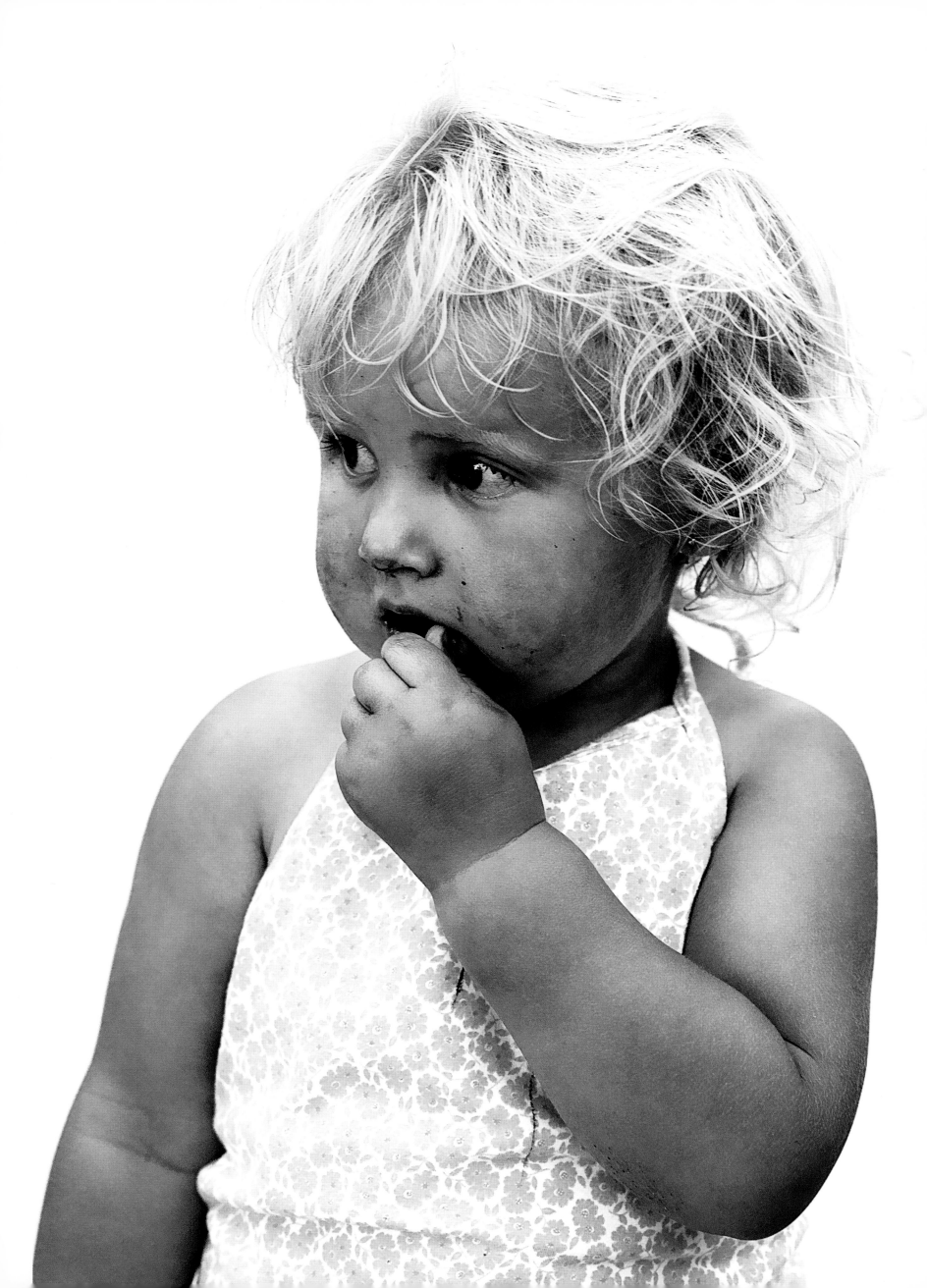

EARTH AWARE

Earth Aware Editions

17 Paul Drive

San Rafael, CA 94903

www.earthawareeditions.com

415.526.1370

www.findinggracehomeless.org

Library of Congress Cataloging-in-Publication Data available.

ISBN-13: 978-1-60109-105-5

ROOTS of PEACE ◯ REPLANTED PAPER

Palace Press International, in association with Roots of Peace, will plant two trees for each tree used in the manufacturing of this book. Roots of Peace is an internationally renowned humanitarian organization dedicated to eradicating landmines worldwide and converting war-torn lands into productive farms and wildlife habitats. Together, we will plant 2 million fruit and nut trees in Afghanistan and provide farmers there with the skills and support necessary for sustainable land use.

10 9 8 7 6 5 4 3 2 1

Printed in China by Palace Press International

FINDING GRACE
The Face of America's Homeless
Photography by Lynn Blodgett

Preface by Marian Wright Edelman
Foreword by Danny Glover
Introduction by Andrew Eccles
Photo Edited by Laurie Kratochvil

EARTH AWARE
San Rafael, California

TABLE OF CONTENTS

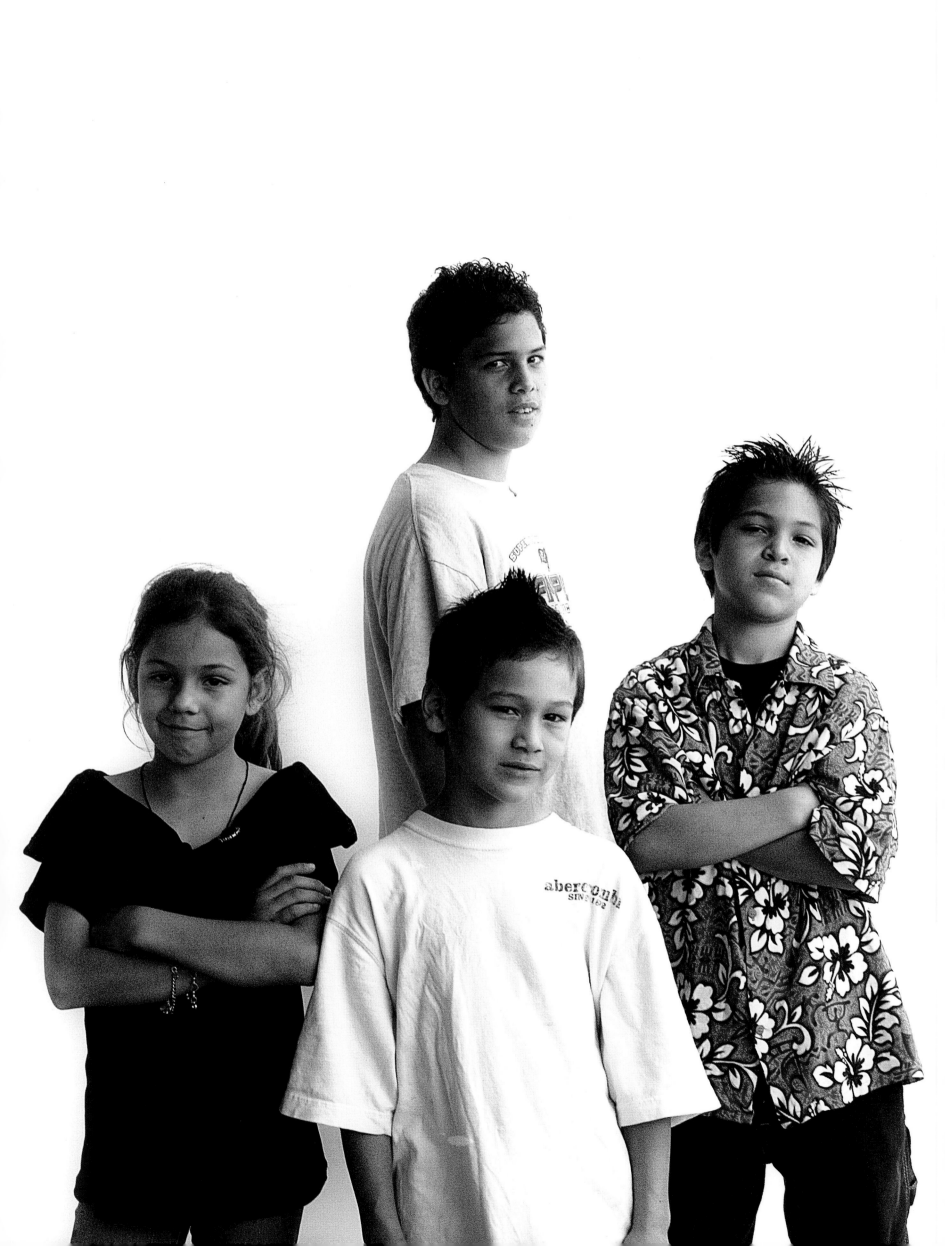

America's homeless are among the great unseen. They are tucked away in temporary shelters, living tenuous existences with few belongings. Even when they are in our presence, we instinctively look away. What's most disturbing is that 40 percent of the homeless comprise families with children. There are 1.35 million homeless children in the United States today; half of them are younger than six years old. They are sons and daughters, nieces and nephews and cousins. *Finding Grace*, like the missing pages of a photo album, invites us to see the children, women and men of all ages, races and places who are part of our extended family once or twice removed.

As a civil rights attorney in the 1960s, I was confronted by the abject poverty of the Mississippi Delta where Black families had no income and children were going hungry. Like the homeless today, they were out of our sight—invisible. If you can't see a child's distended belly, you can avoid having to do anything about it. But as poor as they were they were part of our community. Sadly, few homeless children have a sense of being connected to a neighborhood or having lasting friendships. And too few benefit from the services available in the communities where they live.

Some homeless children may have report cards from two or three different schools in a single academic year. Routine visits to a pediatrician are rare. Because 12-year-old Deamonte Driver and his family had been in and out of homelessness in Prince Georges County, Maryland, he hadn't seen a dentist for years. He died from complications after bacteria from an abscessed tooth spread to his brain and after his mother tried unsuccessfully for months to find a dentist. And his health coverage lapsed because his renewal papers were sent to a homeless shelter where his mother no longer lived.

Lynn Blodgett's photographs capture much of the pain and dignity, innocence and sadness of a diverse array of our homeless neighbors and fellow Americans. He frames the spark of hope in a mother's eye, the promise of a child's laugh. Statistics speak from a distance while Blodgett's photographs frame the shame of homelessness in the richest nation on earth with startling intimacy. They are windows into the humanity of people living without a stable place to call home. They remind us to notice what we have trained ourselves not to see and they inspire us to recommit ourselves to the vision of a society fit for every child and human being.

Ending homelessness is a goal America has given lip service to episodically—during the New Deal and the Great Society. Rev. Martin Luther King's 1968 Poor People's Campaign attempted to move our nation to address poverty more profoundly. Looking back over the arc of what has been achieved since the interrupted War on Poverty began in the mid-1960s, I see tremendous progress. Looking forward, I see so much left to do. But we can and must end child poverty in the United States over the next decade—beginning with children.

It is a shame that we are still fighting to ensure basic survival rights for American families—health care, nutrition, affordable housing, good jobs with good wages, and safe, thriving communities with quality schools. If we are to succeed, we must include everyone in our family photo album—all of our children and their mothers and fathers, aunts and uncles. Every single child needs and deserves a chance to live and dream and thrive.

—Marian Wright Edelman

Marian Wright Edelman is president of the Children's Defense Fund.

Our country is in crisis: it is suffering an epidemic of homelessness. More than three and a half million people are homeless in America each year, and one million of them are children. Homelessness surrounds us every day. And yet, though the poor and unsheltered are right before our eyes, we have ceased to notice them. The indifferent gaze of the general public has rendered them faceless and anonymous. Homeless people have somehow – conveniently – been deemed unworthy of our grief. It is all too easy for mainstream society to be lulled into believing that extreme poverty is the result of indolence, a myth from which those in more secure circumstances can draw a measure of comfort, creating distance between themselves and the people they see – or don't see – on the streets.

There is something self-perpetuating in this process of marginalization, and also something deeply inhumane. Millions of people are being casually robbed of their ability to imagine their futures, to define their own identities. Their utter lack of societal status is reinforced to them every time someone brushes them aside or fails to meet their eyes.

We call ourselves a democratic nation. We say that our politics are rooted in responsibility, equality and compassion. Our behavior toward homeless individuals is a conflict of national values and culturally ingrained habits that have allowed us to systematically dismiss those less fortunate for too long.

But perhaps such habits can begin to be changed by the merest shift in perspective. Can we acknowledge our own ethical accountability? Can we find untapped resolve in our conscience as a country? Homelessness can be seen as more than just a persistent problem; it's a tragic circumstance that we can take concrete steps toward addressing.

We can provide disadvantaged individuals with affordable housing, perhaps offering tax breaks to those who invest money in that housing. A bill called the National Housing Trust Fund Act, for example, is currently before Congress. It aims to provide money to states that can be matched and used by developers of housing for lowest income Americans – those making less than 30 percent of the mean income of their area. Sponsored in the Senate by both a Democrat and a Republican, this proposal would not only create housing but would also support electricians, plumbers, and other businesses.

We can institute a plan for universal health care. We can develop programs to train people in methods for revitalizing local communities. These are goals to talk about, think about, and accomplish. They are not beyond our means. They are not too much to ask.

We cherish our democracy in theory, but to honor it in practice we must all participate and collaborate in the improvement of our society. No individual can end homelessness, but we can each find our own way to embody the struggle against it. To do so, will have to draw on our profoundly human gift of imagination. We will have to acknowledge that the same resources that we use for destruction can be redirected any way we collectively choose. Nothing can stand against our political will once we decide to bridge the vast divides in our economic system, or once we resolve to honestly examine and address our educational system, our health care system and our social systems. We must decide to act.

But first: we must decide to look.

–Danny Glover

Actor, producer and humanitarian Danny Glover has been a commanding presence on screen, stage and television for more than 25 years.

INTRODUCTION

For the past ten years I have taught a class at the Santa Fe Workshops in New Mexico. I teach in the hope of inspiring my students. But I also teach to be inspired by them, and to be reminded why I fell in love with photography in the first place.

Every workshop has about fourteen participants, and it's uncanny how similar the cast of characters is each year. Most attendees are professional photographers who are already competent and capable. There'll be one photographer who specializes in sports and another dedicated to corporate portraiture. There's the good-looking, charismatic guy who gets hired primarily because – you guessed it – he's good-looking and charismatic. There's usually also at least one recent graduate of photo school who worries that his or her inexperience will hold back the entire class. The group is rounded out with the mandatory class clown, and finally, there's the successful businessman with the time and money to pursue photography as a pastime.

The first day of class, I decided Lynn Blodgett was a perfect fit for the businessman category, and I wasn't sure what he hoped to learn in my workshop. His portfolio consisted of model tests that often bordered on sentimental. I didn't see a clear focus in Lynn's work nor did I see anything outstandingly unique.

Then I sent the class outside on a photo shoot. Instead of working with models in the studio, I encouraged them to seek out local subjects and photograph them as though they were completing work for a magazine. The assignment was to take two photos that would run as a double-page spread. The pictures needed to tell a story, and they could be of similar subjects or opposing ones. To illustrate the concept, I showed them a previous student's powerful pairing of portraits: The town sheriff gazed back from one page, local gang members from the other. When Lynn turned in his photos, I was forced to reconsider my first impression. In the course of that single day, Lynn had photographed a boy and his disfigured father – and he had captured some of the most compelling portraits I had ever seen taken by a workshop participant.

Lynn returned to my workshop in Santa Fe for a second time, and when that class came to an end, he asked me for private consultations. We began meeting regularly at my New York office to discuss his pictures. When Lynn brought in shots taken outside a homeless shelter in Salt Lake City, they were very honest, very moving, and quite simply the best pictures I had seen him take so far. Yet I knew the photos weren't yet equal to his amazing and captivating subjects.

I decided to introduce Lynn to Richard Avedon's American West series. He drew inspiration from Avedon's work, returning to the shelter to take more pictures. We discussed ways to control the quality of light and create stronger compositions. We contemplated going "beneath the surface" by asking

certain subjects to remove articles of clothing. Many people carry scars, tattoos and other signs of the life lived, and we wondered what might be revealed. Lynn continued to photograph the homeless in city after city: Dallas, New Orleans, Santa Monica, San Francisco. I continued to give him advice, and he continued to listen. The pictures grew better and better.

Months passed, and then one day, we rented an empty studio and pinned more than two hundred of Lynn's photographs up on the walls. The first thing that struck me was how many there were – not photographs, but people without homes. And this was only a tiny cross section of the estimated thousands living on the streets and in shelters all over the country. The next thing that struck me was the beauty of many of these people. Some were so good looking that I could imagine them living in the Hollywood Hills, had their fate taken a different turn. But it was the photographs themselves – rich in contrast against the stark white background, alarmingly sharp and detailed – that forced me to acknowledge each weathered face and tattered piece of clothing. It became clear to me that Lynn was creating a remarkably powerful, intensely intimate series of portraits. I felt that his photographs were deeply moving and that they had the potential to create real change. Throughout the following year, Lynn continued to photograph the homeless.

Some subjects are stoic, almost proud, while others cry or flirt. Wrinkles are etched into faces, wind blows through untamed hair and dandruff falls from long, gray beards. Mothers, brothers, husbands and children, all with lives and stories. All without homes. *Finding Grace* brings us face to face with homeless people, which is perhaps closer than most of us would dare to venture on our own. These photos are stirring and hauntingly beautiful images that allow us to become conscious of people, emotions and fears we were once only aware of subconsciously. Lynn Blodgett does not make those of us with homes feel guilty nor those of us without feel exploited. He has handled a most uncomfortable subject with grace and dignity, and treated us all with absolute respect.

The photos in *Finding Grace* confirm my original love for photography as they remind me of its power. Lynn is a remarkable man, and he has become a remarkable photographer. I am proud to have played a part in bringing his insightful and sensitive vision to you.

Lynn Blodgett is the reason that I teach.

–Andrew Eccles

Andrew Eccles is a professional photographer in New York, where he has been shooting celebrities, models, athletes, musicians and dancers since 1987.

FACES

"We think sometimes that poverty is only being hungry, naked and homeless. The poverty of being unwanted, unloved and uncared for is the greatest poverty."

—Mother Teresa

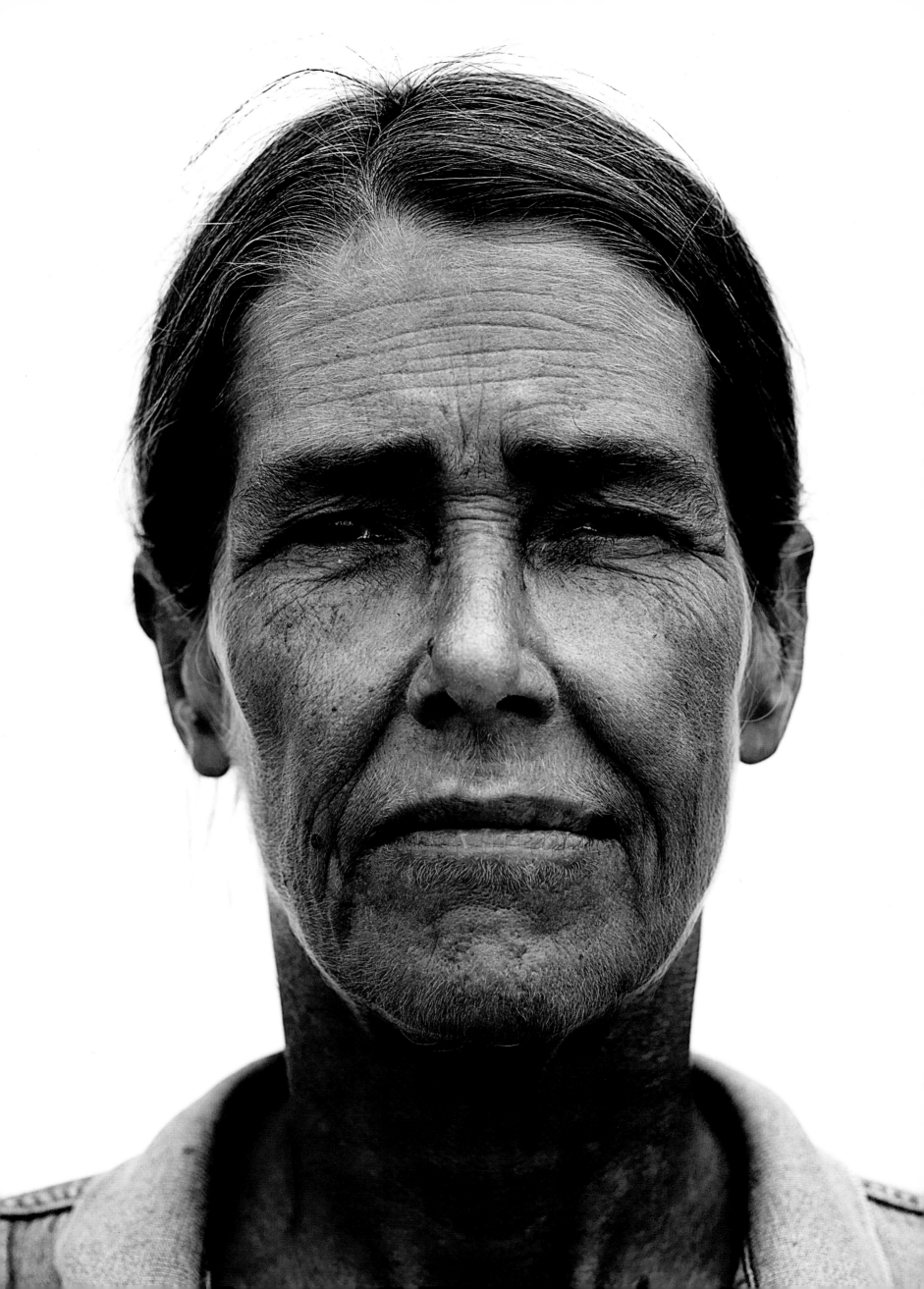

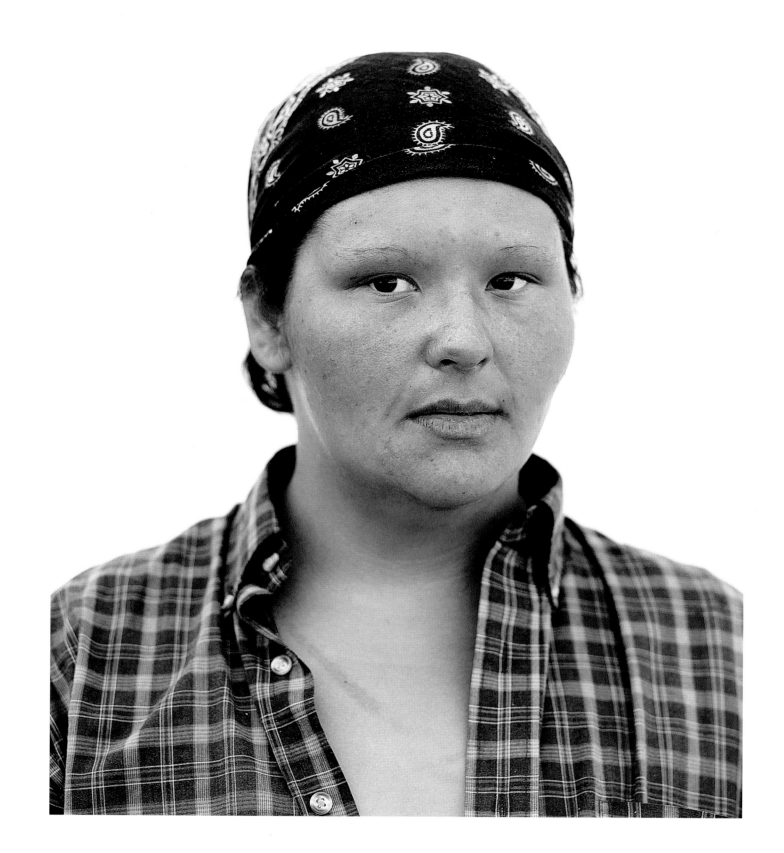

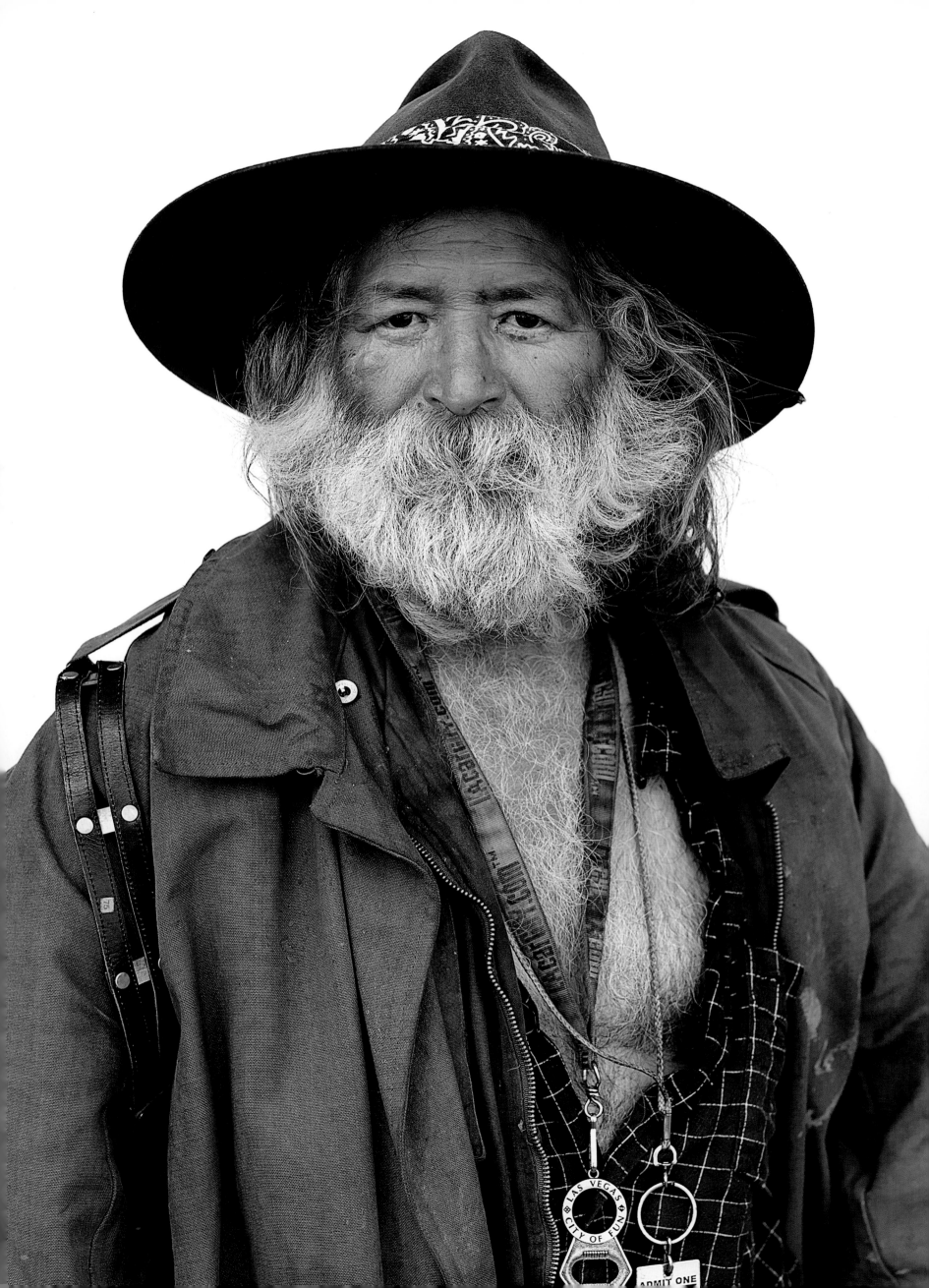

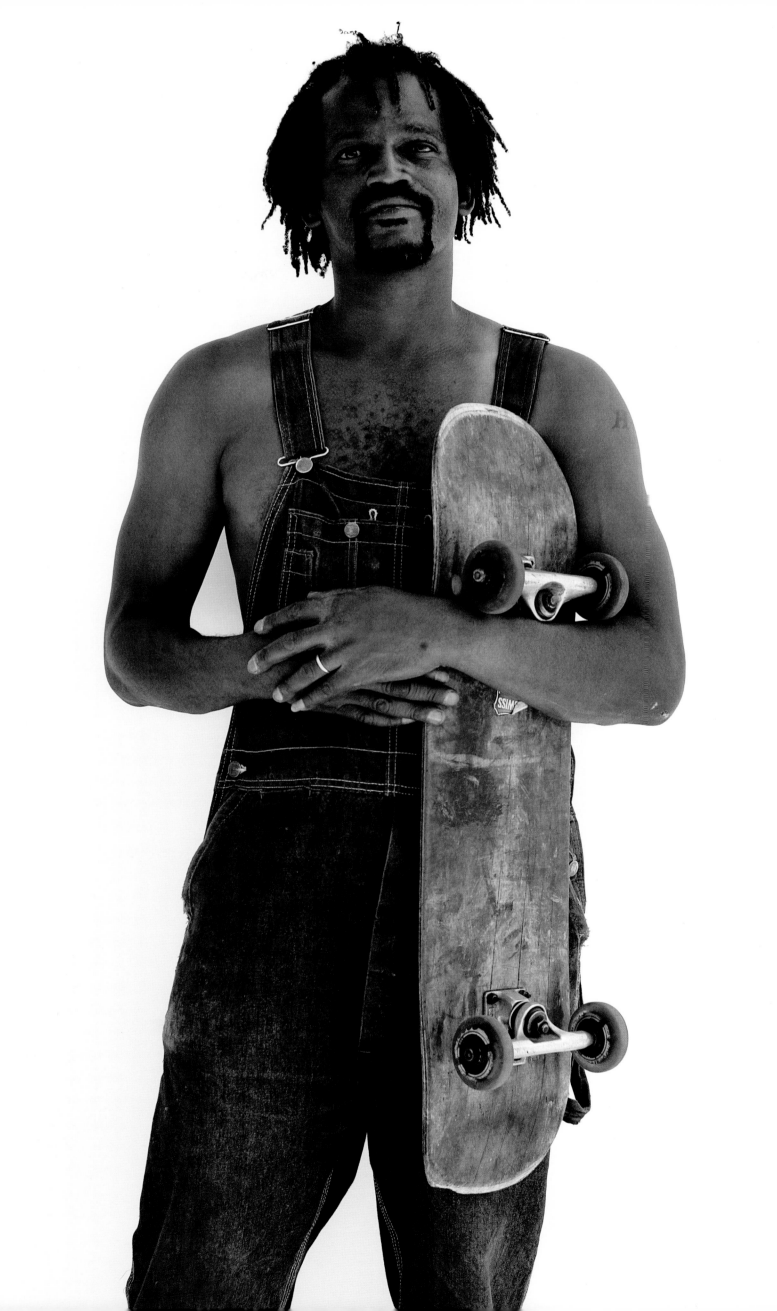

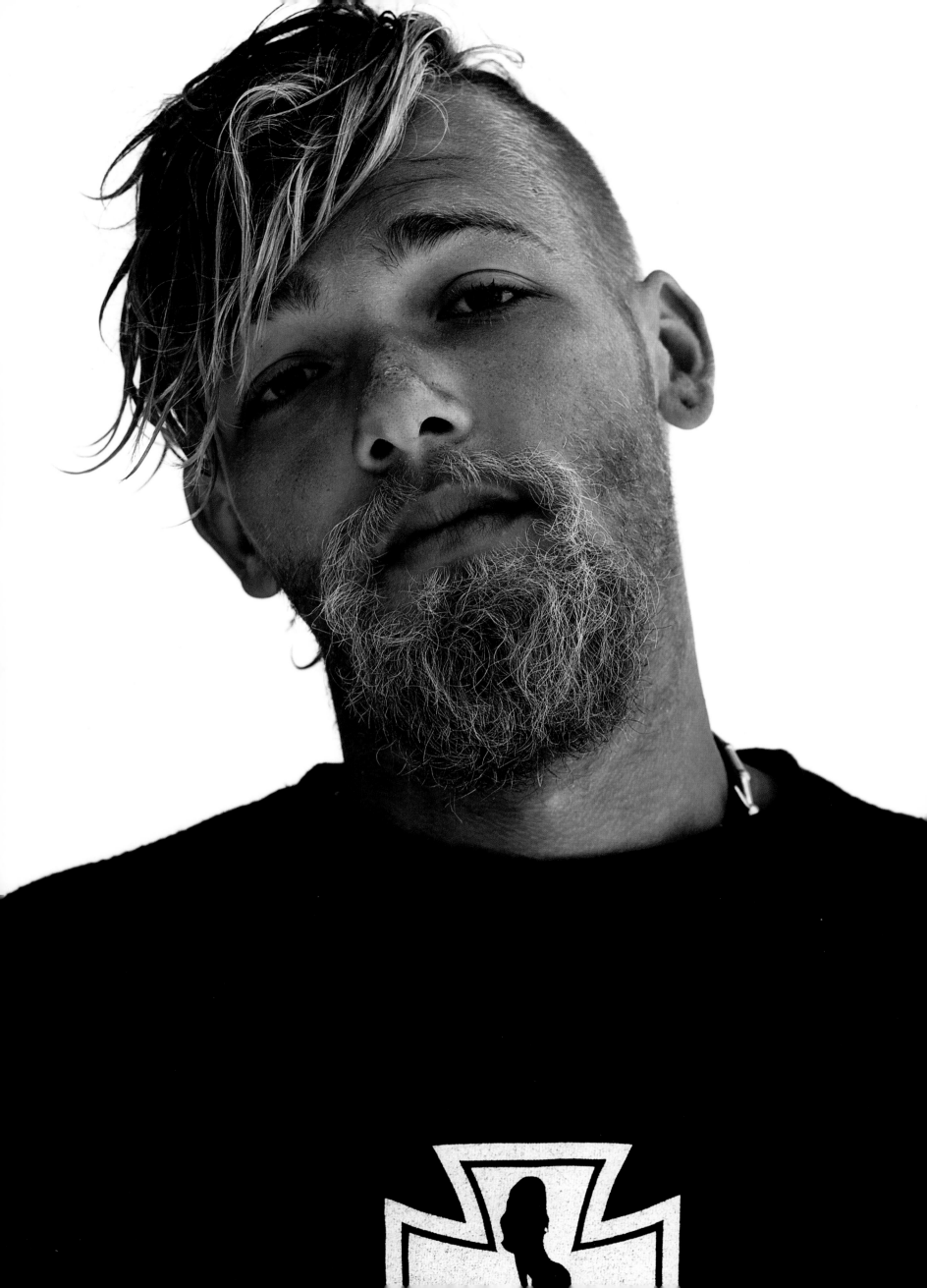

John & Donna

Salt Lake City, UT

I met John on a Monday. He was on his own, wearing a shirt that masked some of his thinness and symptoms. The next day as his wife, Donna, joined him, John changed noticeably. For the first time, he was willing to look directly into the lens. He told me that he had AIDS and that they'd been married for nineteen years. Other people said that Donna also suffered from AIDS, but I did not ask her about that. I could see that they held each other up, that they gave each other strength.

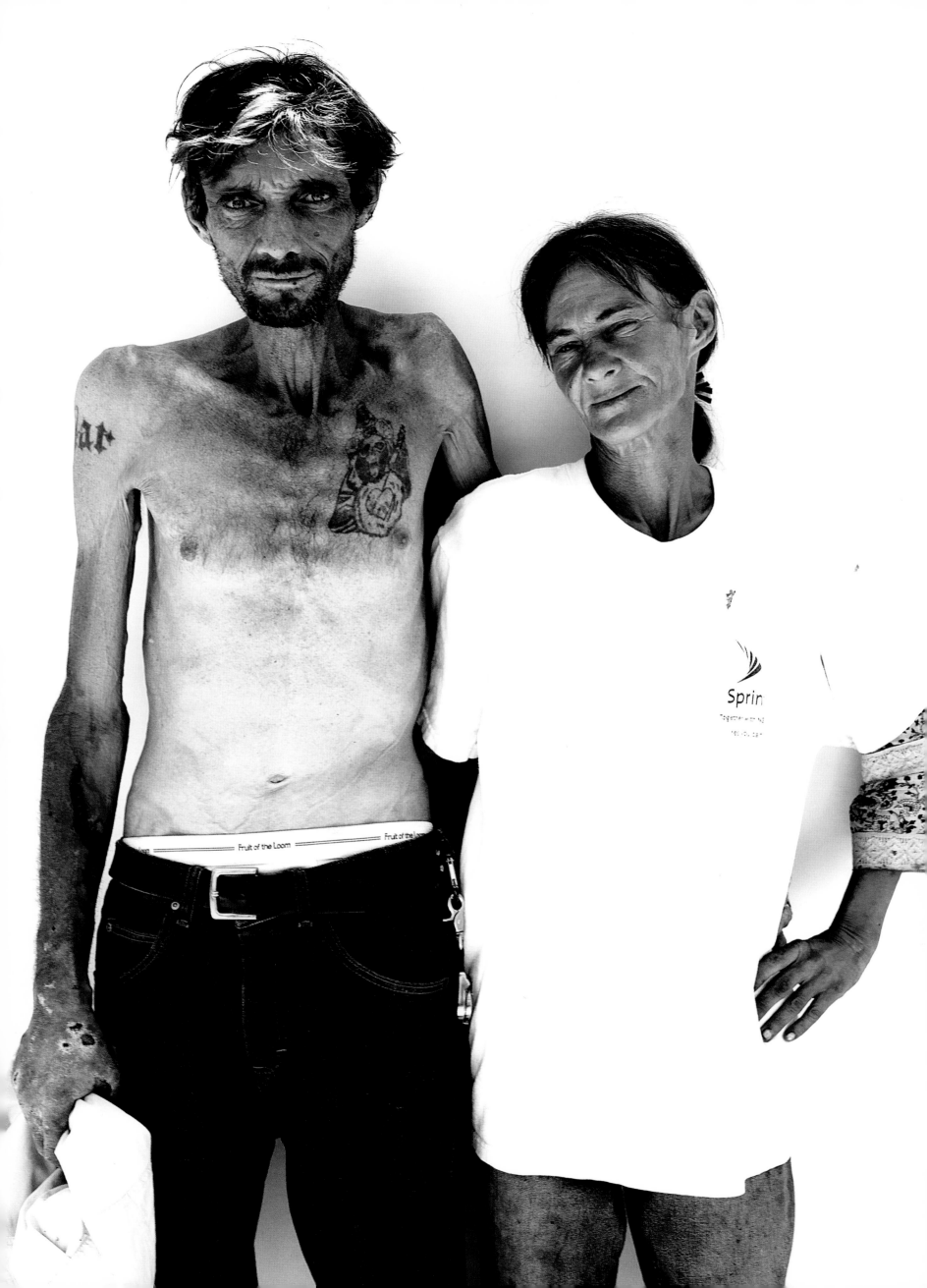

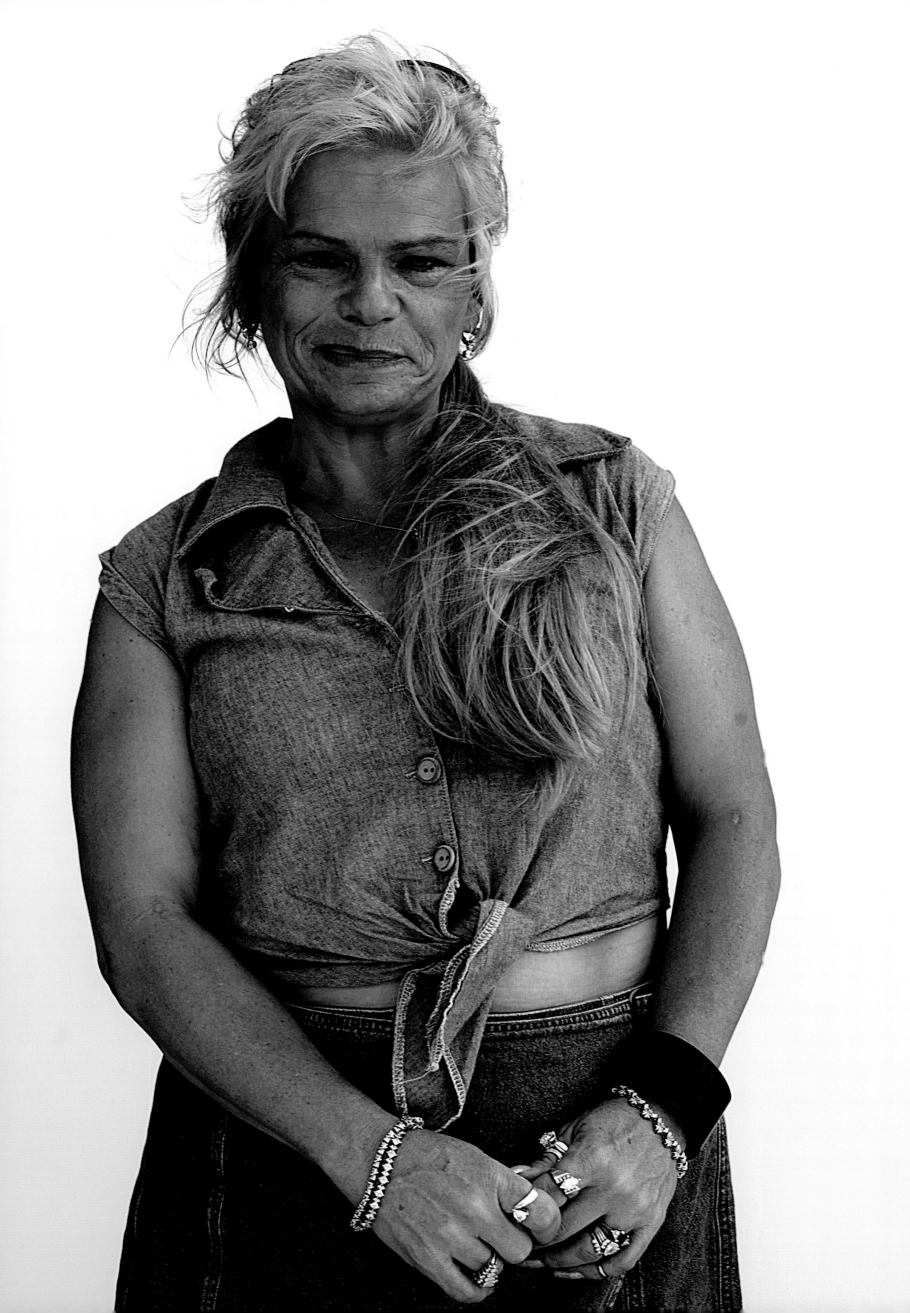

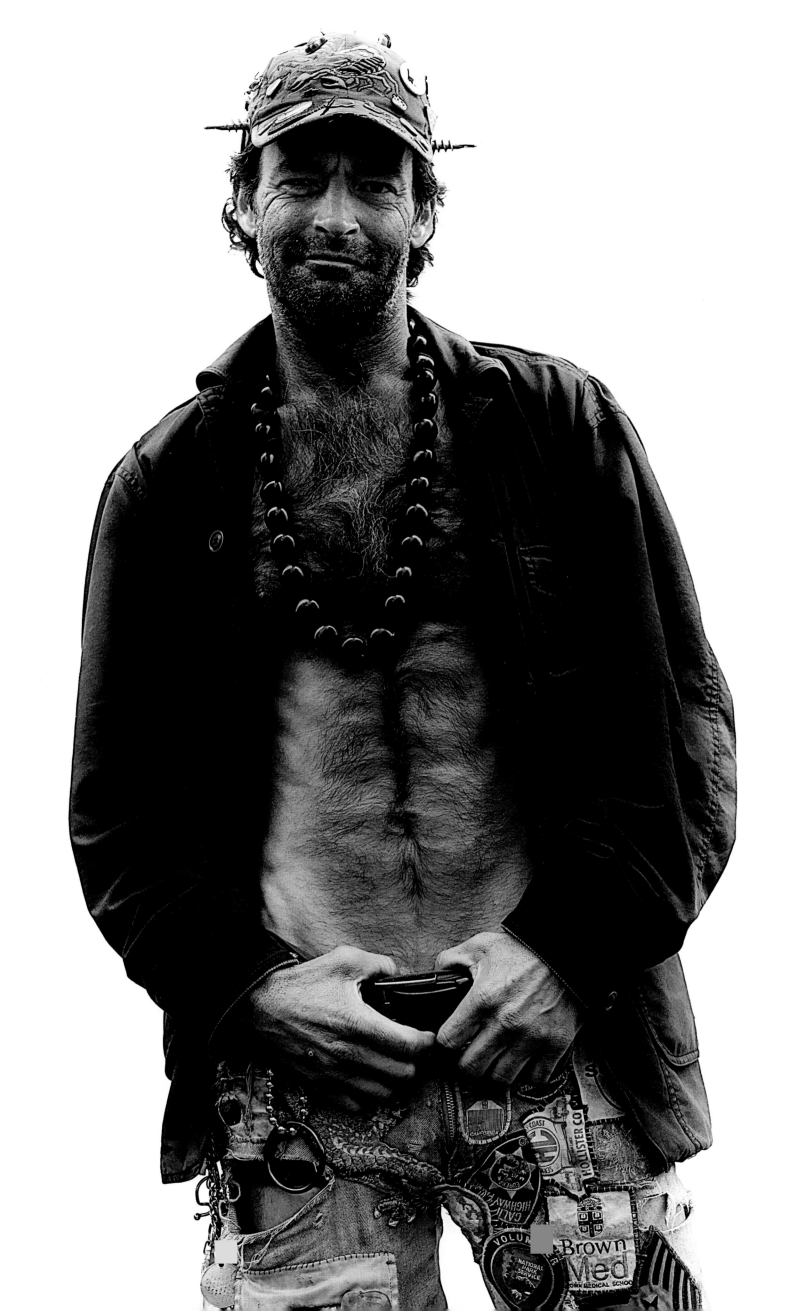

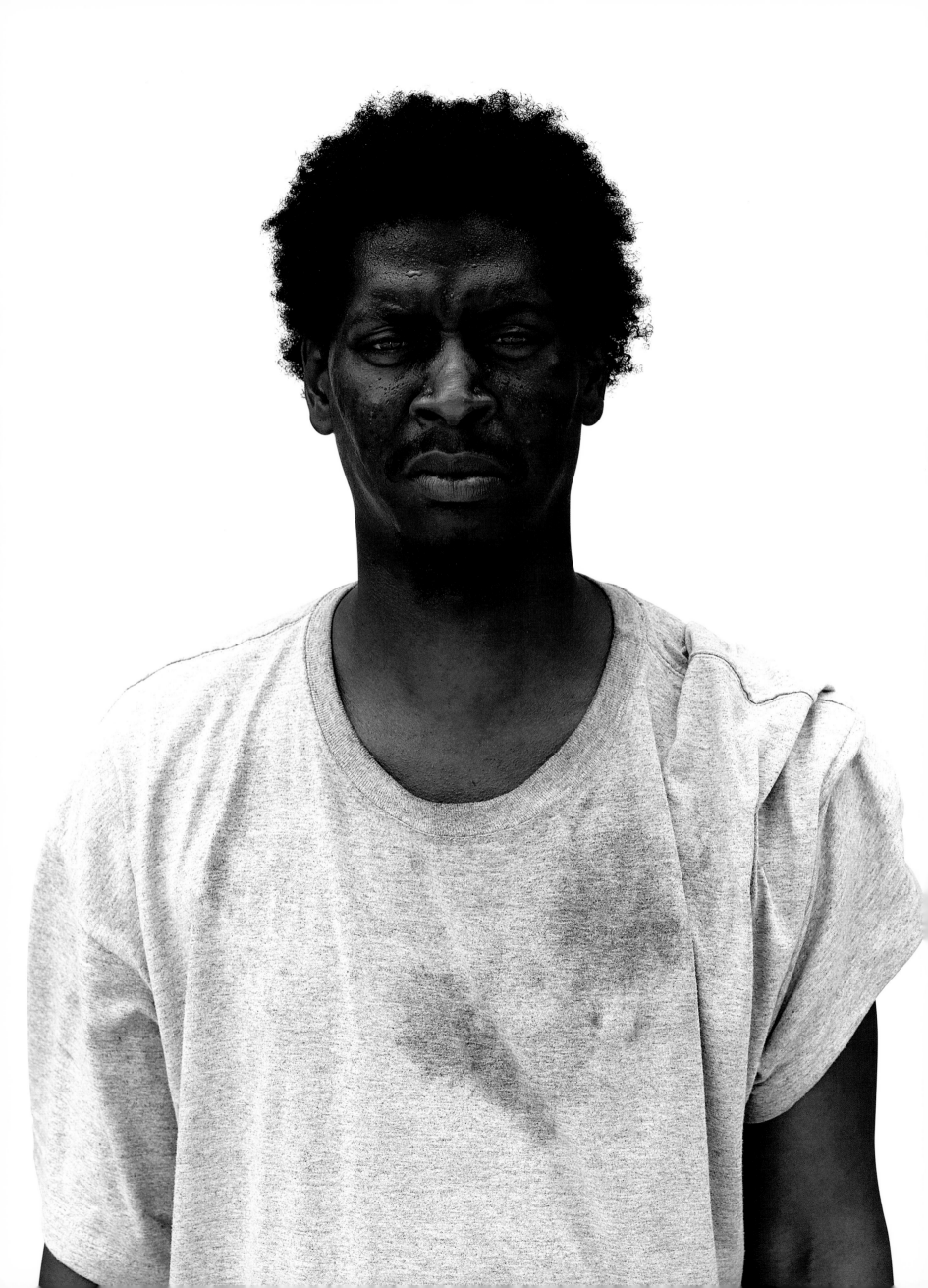

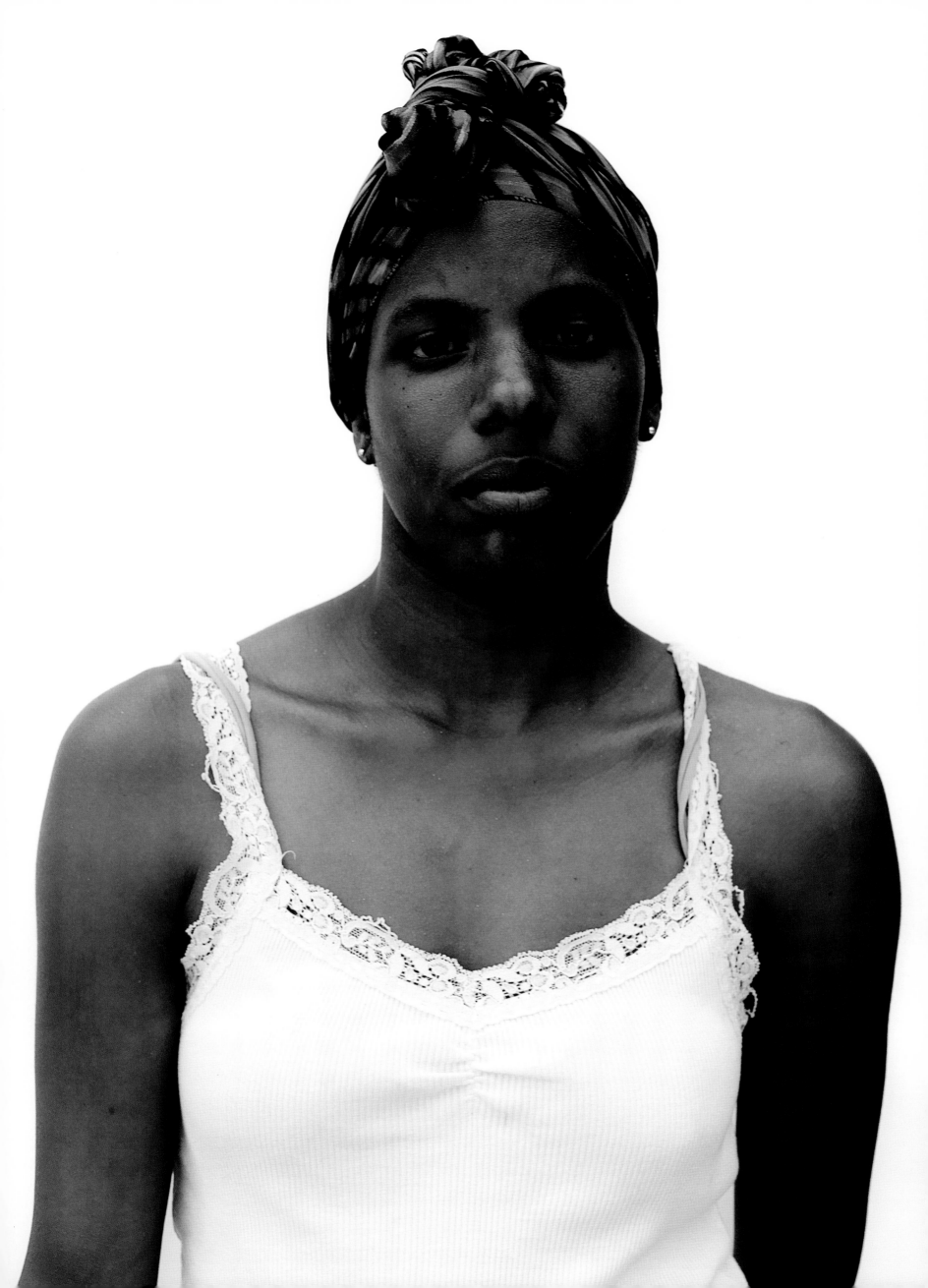

The Brothers Favor

Dallas, TX

I met these homeless brothers outside a locked shelter in Dallas. They faced 105-degree heat the same way they faced other challenges – together. A shirt was the only protection from the sun he could offer, but I watched this man gently drape it over the head of his contorted brother. As I clicked the shutter, I wondered how hard it would be to protect and keep one person intact without regular shelter or food, and how much more was required to care for a disabled loved one.

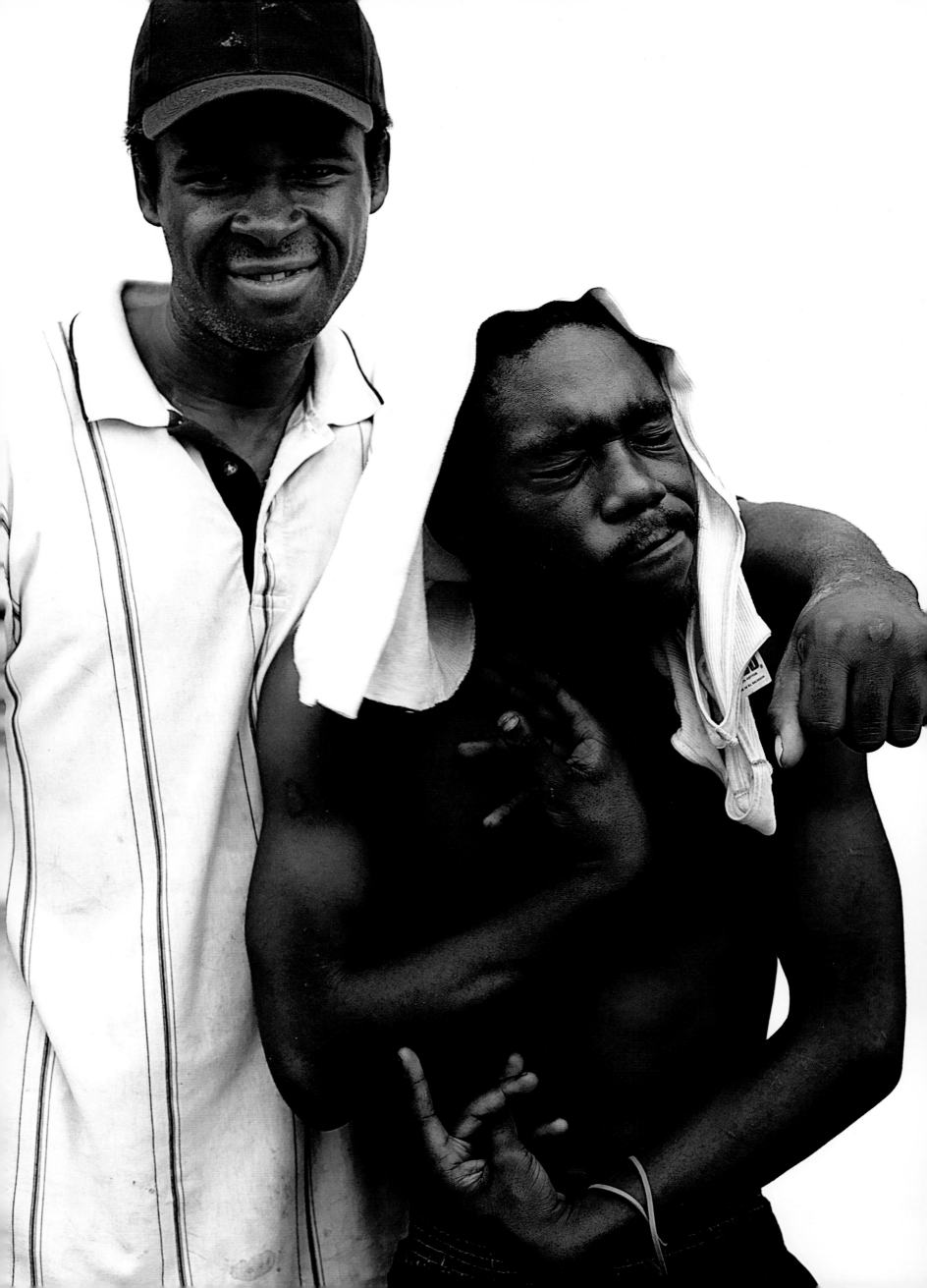

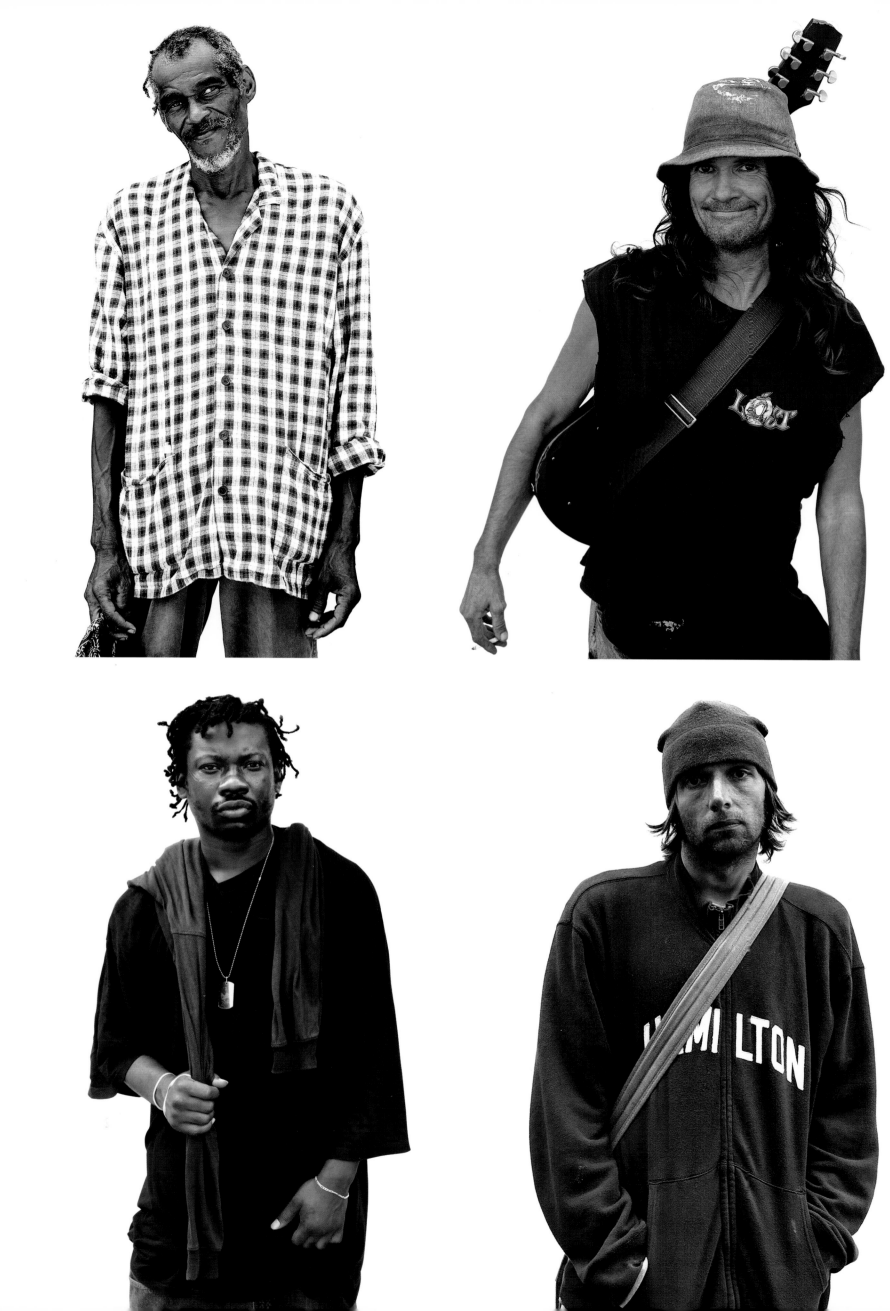

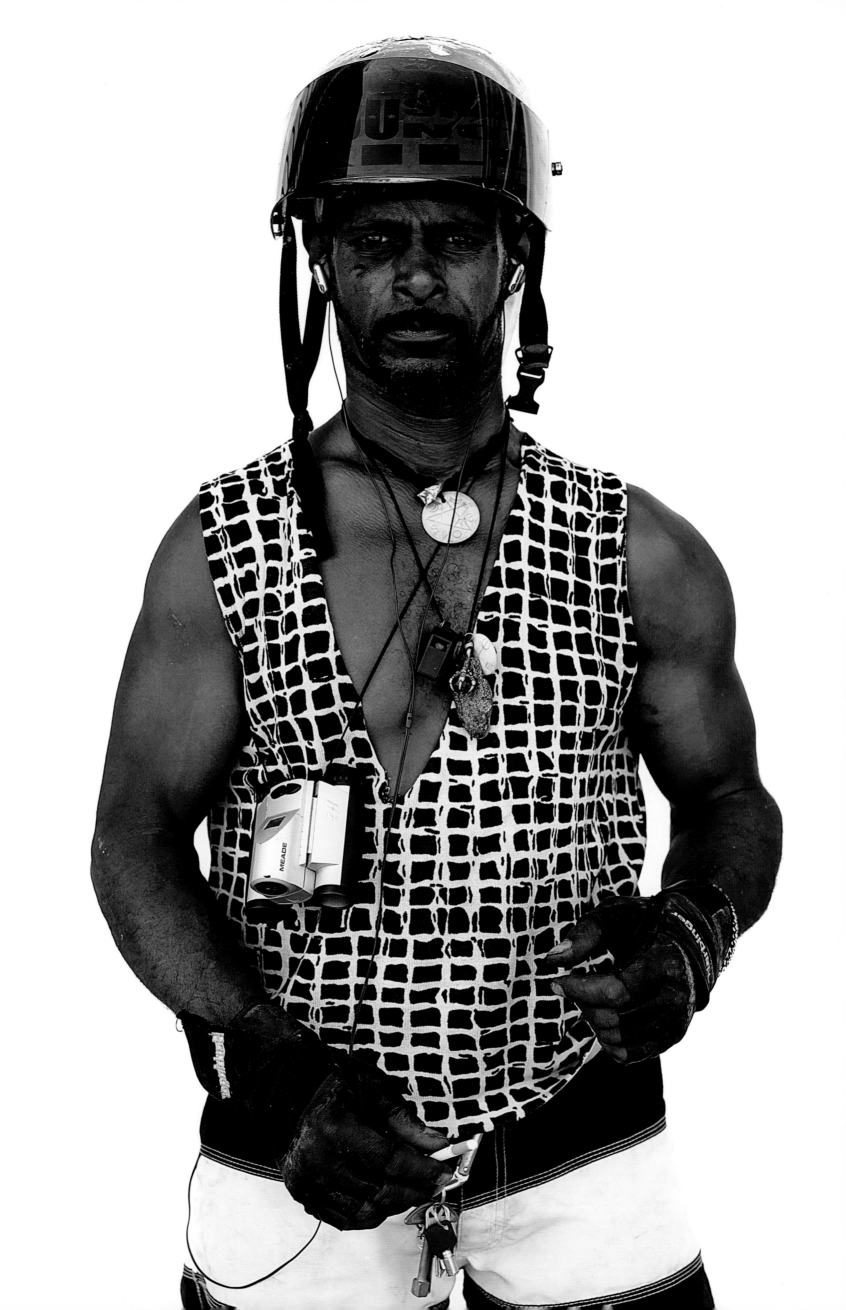

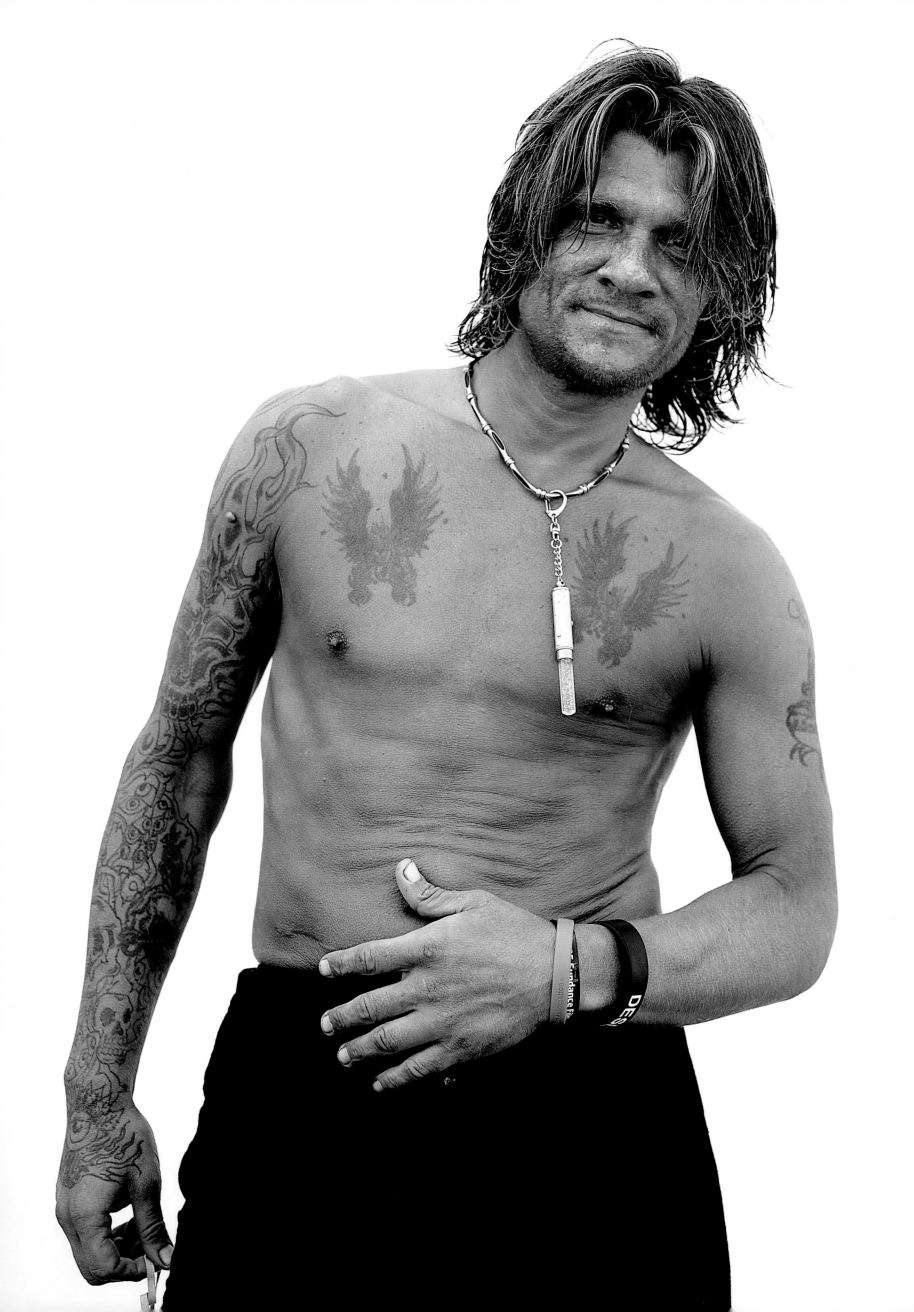

Coby

Coby is a likable, energetic guy who calls himself a "dumpster diver." He lives in California, under a carport near the beach. A few days before we met, a man left a restaurant, then tossed a chicken dinner in a nearby dumpster. Coby eagerly dove in after the meal and retrieved it. Within moments, the man was back, knocking the food from Coby's hands. "Stay out of my garbage," he snarled.

Mother & Daughter
Raleigh, NC

A kind and compassionate man ran the Salvation Army shelter in Raleigh, North Carolina. He was one of the few managers who allowed me to take photographs on shelter property. While I was setting up, I could hear and see an argument going on. As she argued loudly with a man in the nearby park, this young woman seemed both fearful and fierce. But later, when she arrived at the shelter holding her little daughter's hand, I saw only a loving mother, scooping her child into her arms in a shower of endearments and kisses.

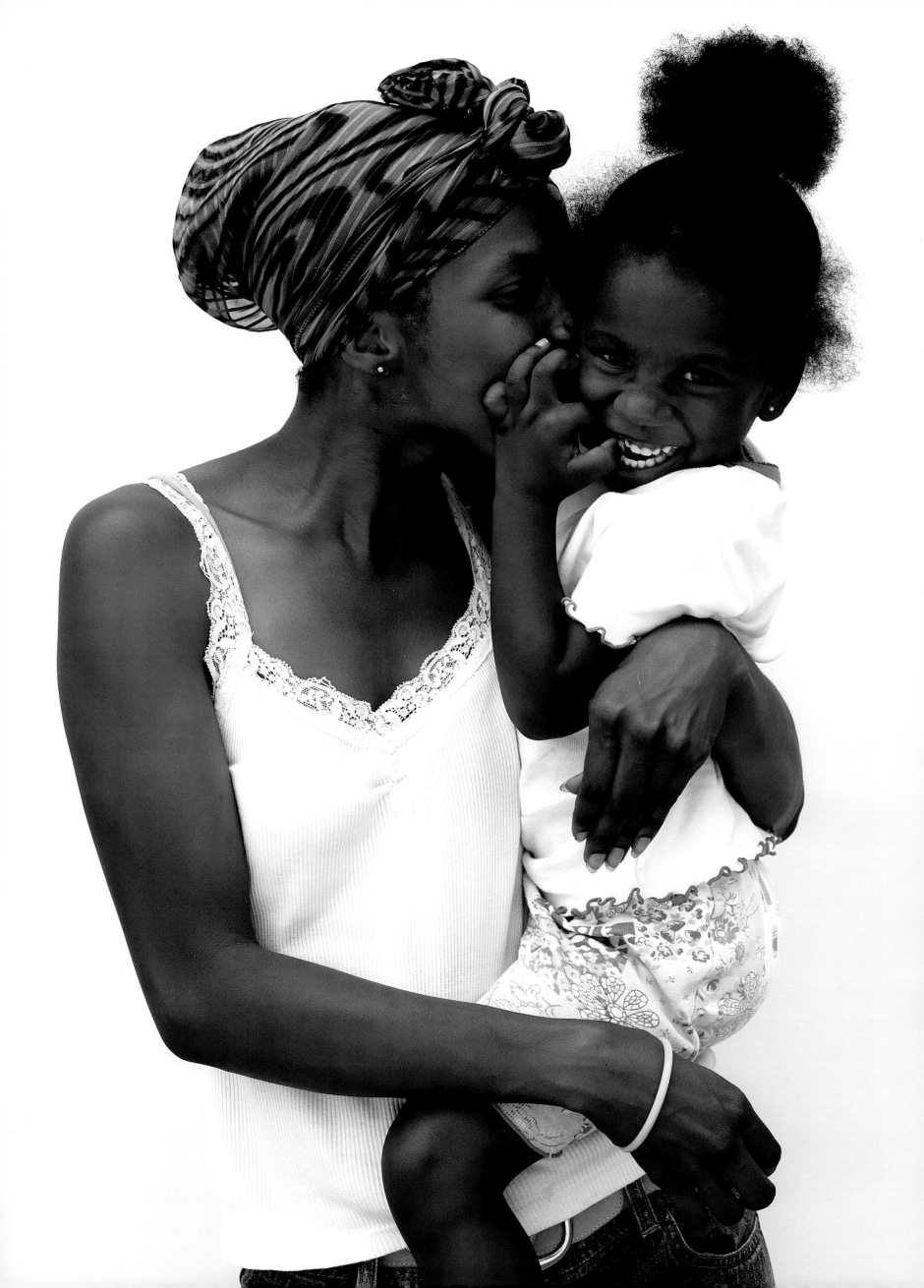

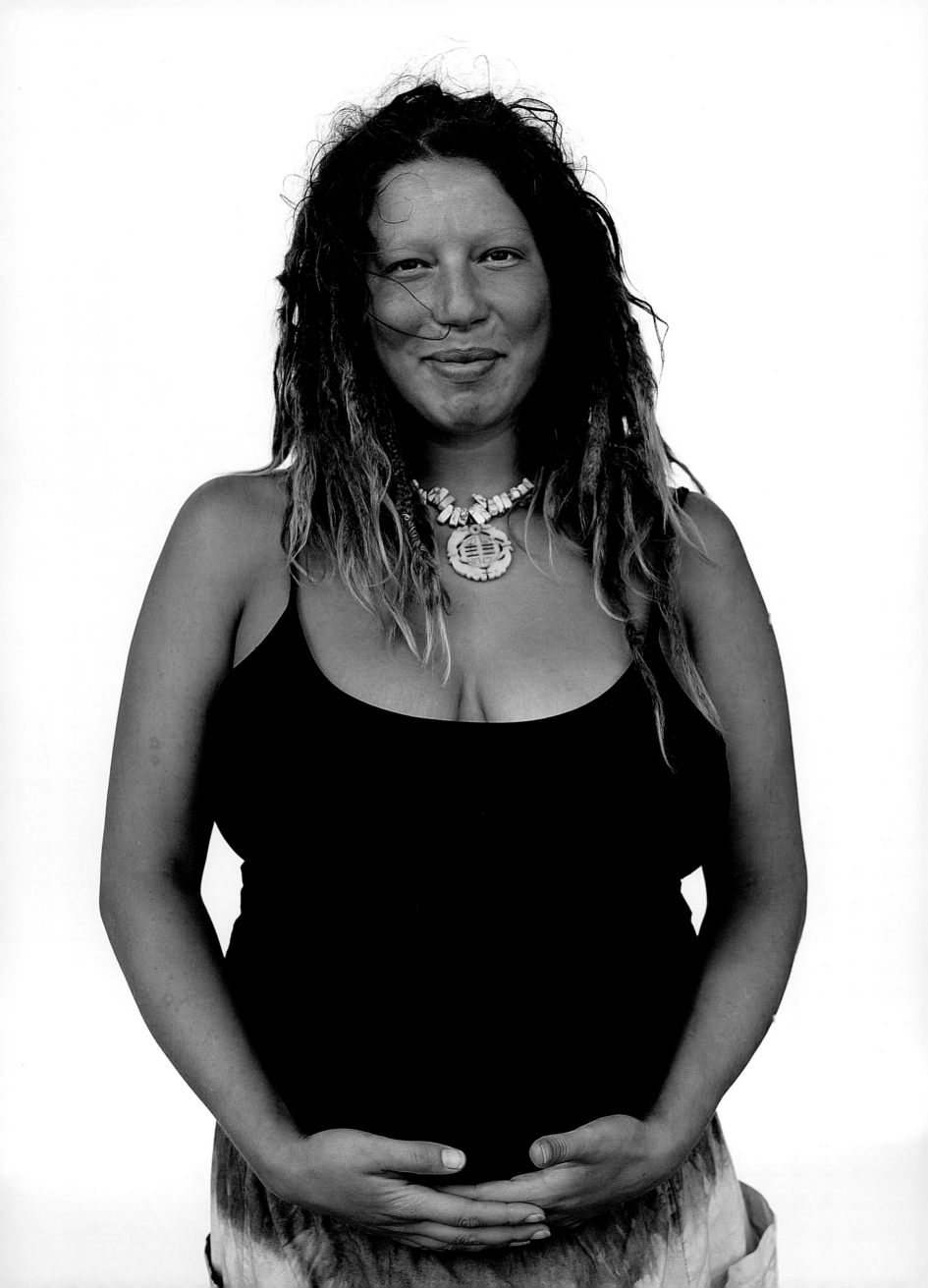

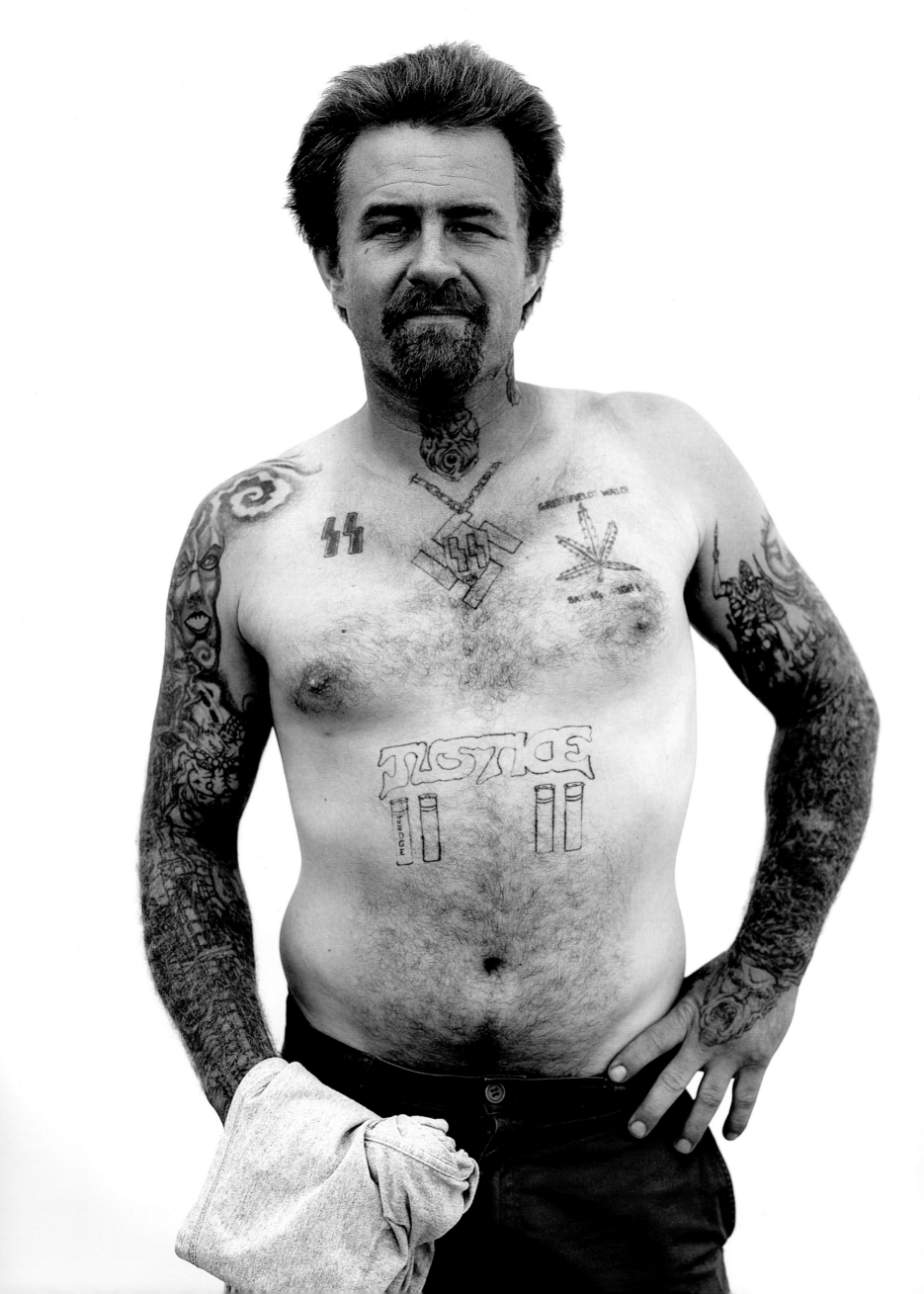

Lamont

Washington, DC

Despite Lamont's obvious physical strength, he stood against the backdrop looking drained and downcast. Seeing the tattoo across his chest, I said, "Tell me about Katasha." Lamont's face lit up instantly, a smile rising to his lips. "Katasha is my little girl," he said, "and she's my pride and joy."

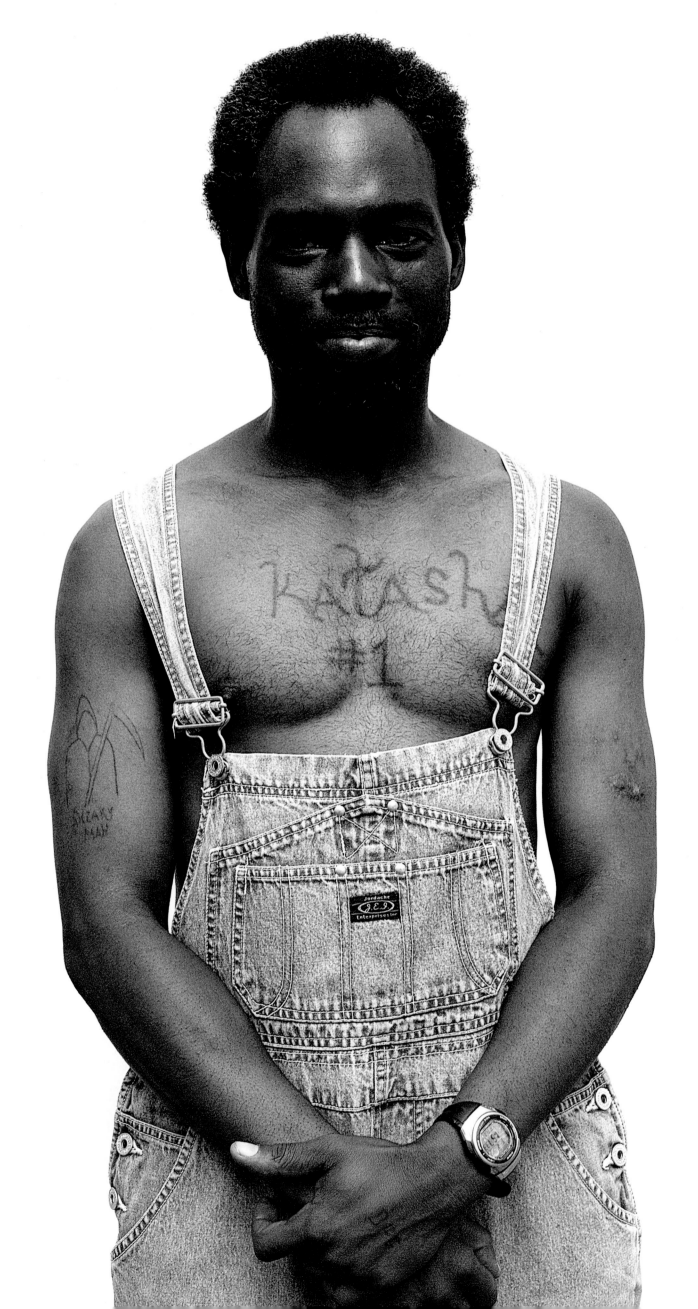

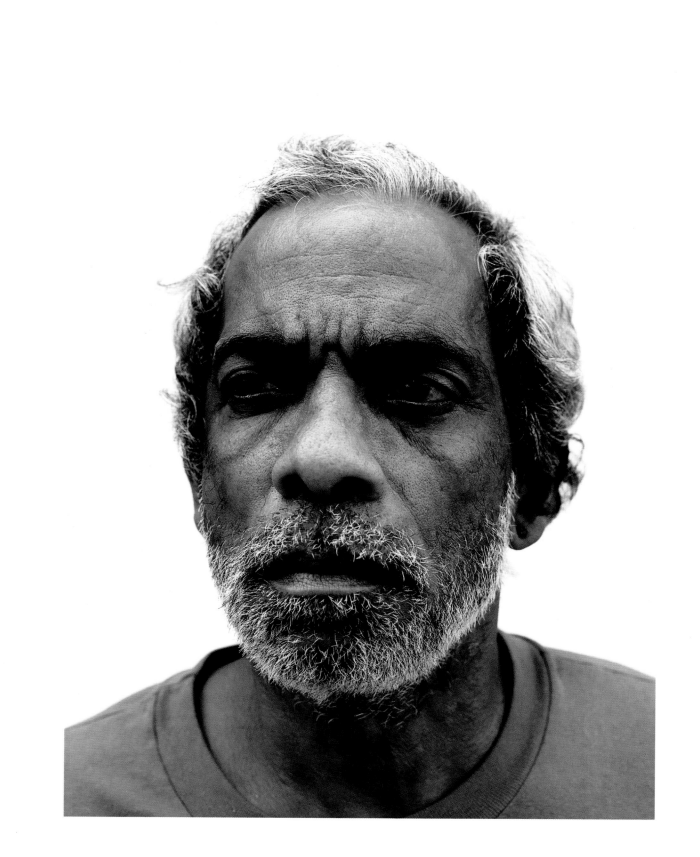

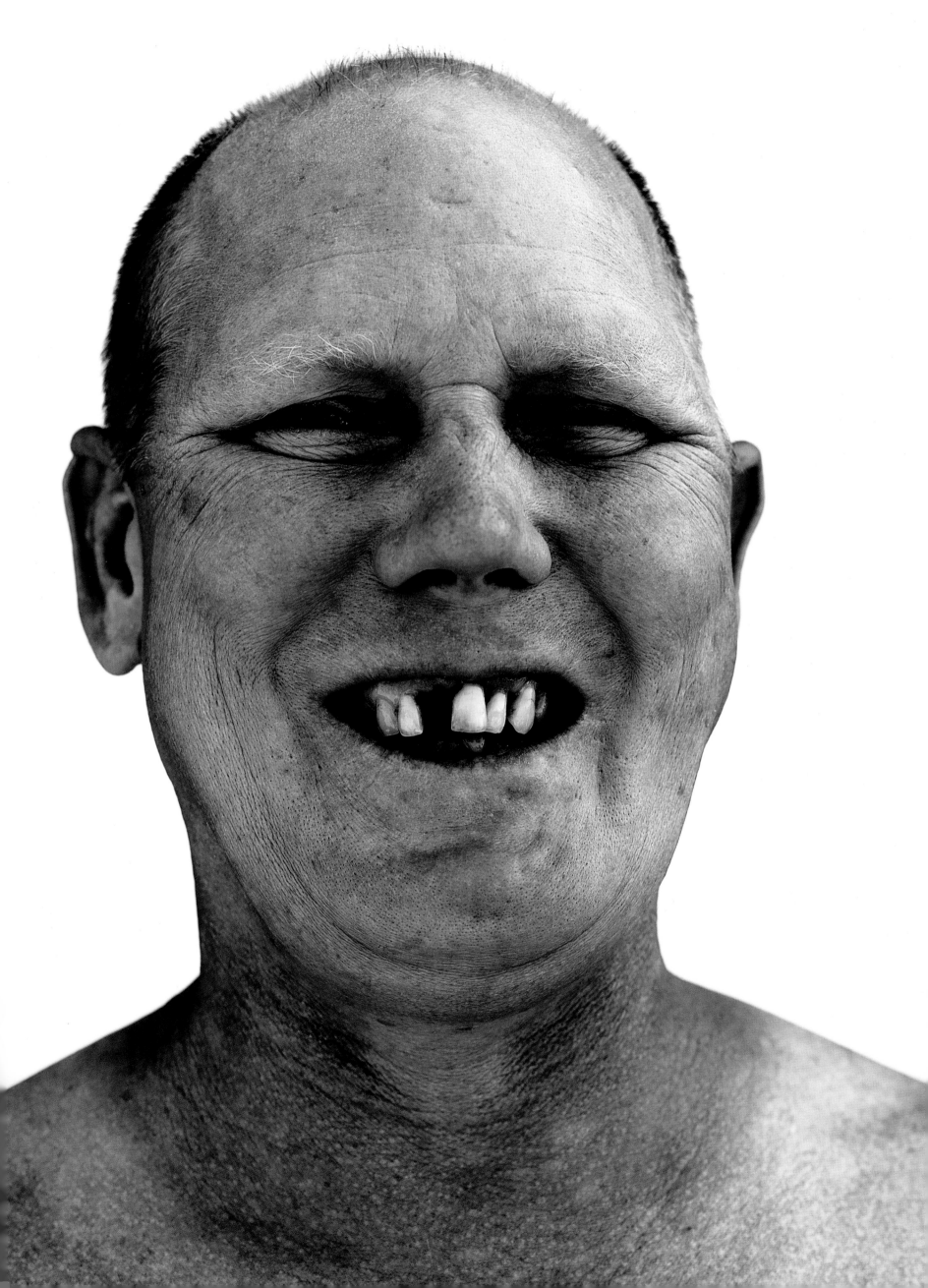

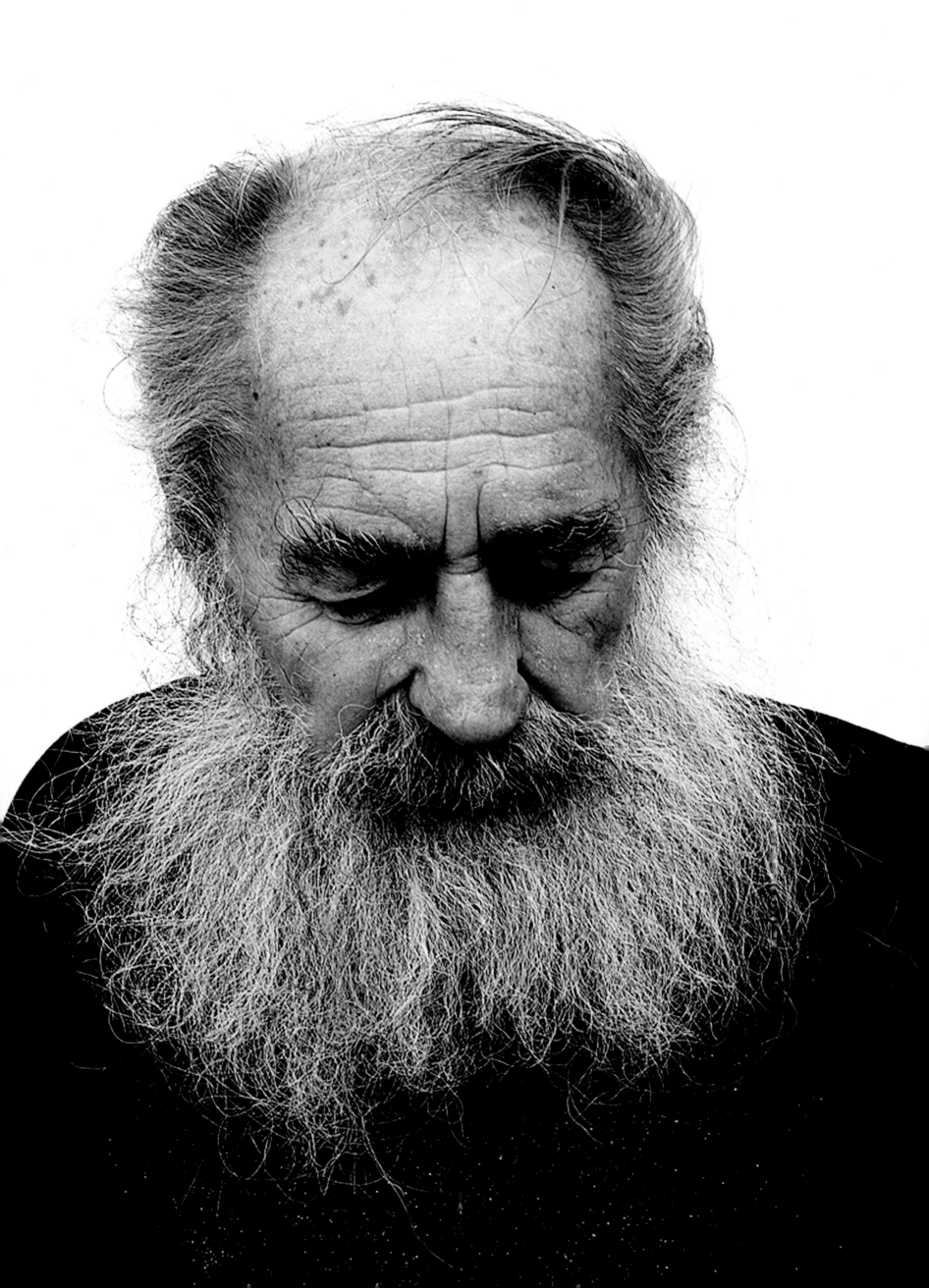

Jan

Jan and I first met in a homeless shelter in Newark, New Jersey. I took his photograph then, but eighteen months later his signed release form was missing. Returning to New Jersey, I was told Jan hadn't been at the shelter in awhile, but he'd been seen "over near the university." Rutgers is an urban, non-localized campus, and my heart sank at the odds against finding him. Eventually, I did. Familiar cane in hand, Jan described fleeing his home in Czechoslovakia. When he reached Poland, he entered the army and fought until the end of World War II.

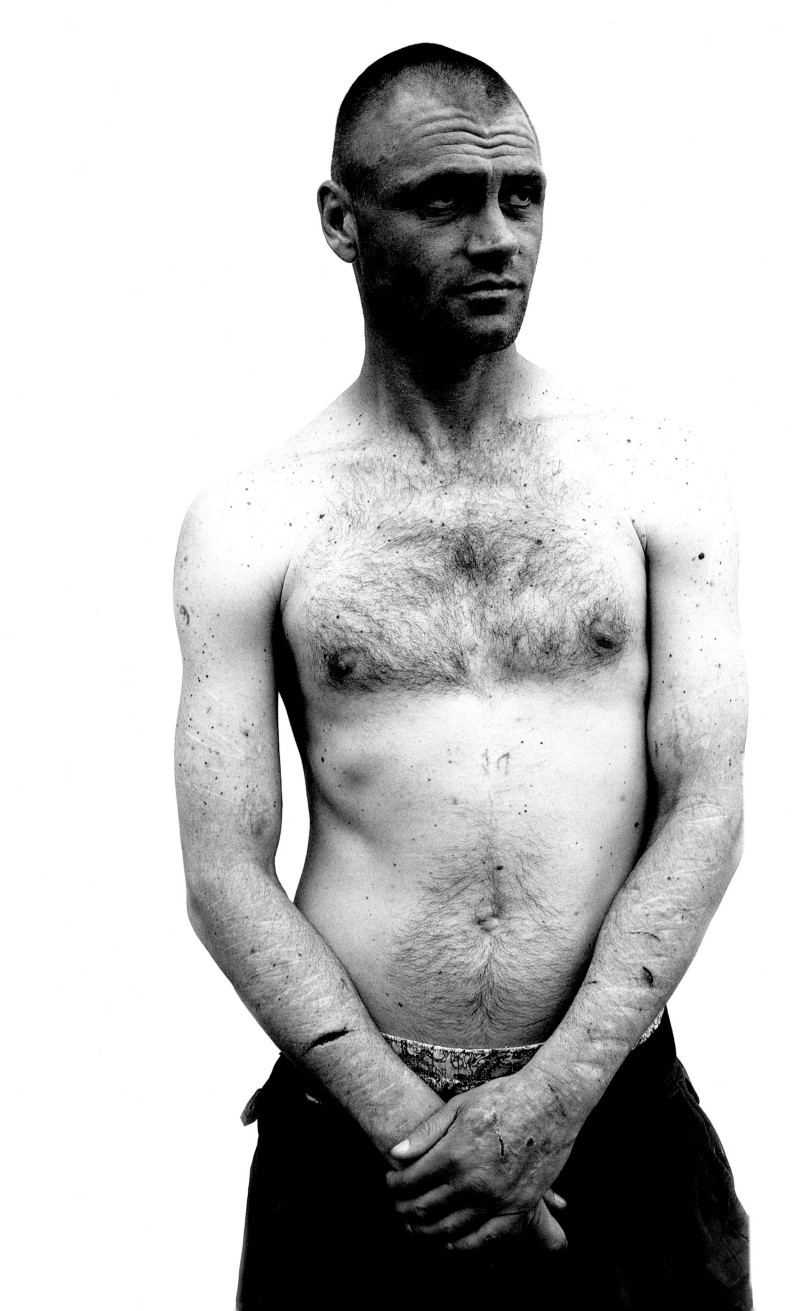

Matt

Matt was wearing a jacket and shirt when I began to photograph him in 2006. Hoping to see him more clearly, I asked if he would remove both articles of clothing. I never imagined the wounds he would expose. Matt is what is known as a cutter. His arms and legs are covered with scars and self-inflicted wounds. In March 2007, I saw Matt again, sitting on a street curb in downtown Salt Lake City, looking more downtrodden and more despondent. I stopped the car and crossed to him. "My dad owns this place," he said pointing to the business directly behind him. When I asked if I could help, he answered, "No, nothing you can do. But thank you, Lynn."

Vinny

With a "Yankees" ring on his finger and an unmistakably Brooklyn accent, Vinny seemed displaced on a sandy street in California. He was bareheaded and coatless the first time we met, and he could easily have been any regular guy back in New York, drinking beer and watching a ball game with friends. The second time I ran into Vinny he looked like this, his openness, strong build and good looks camouflaged beneath multiple protective layers.

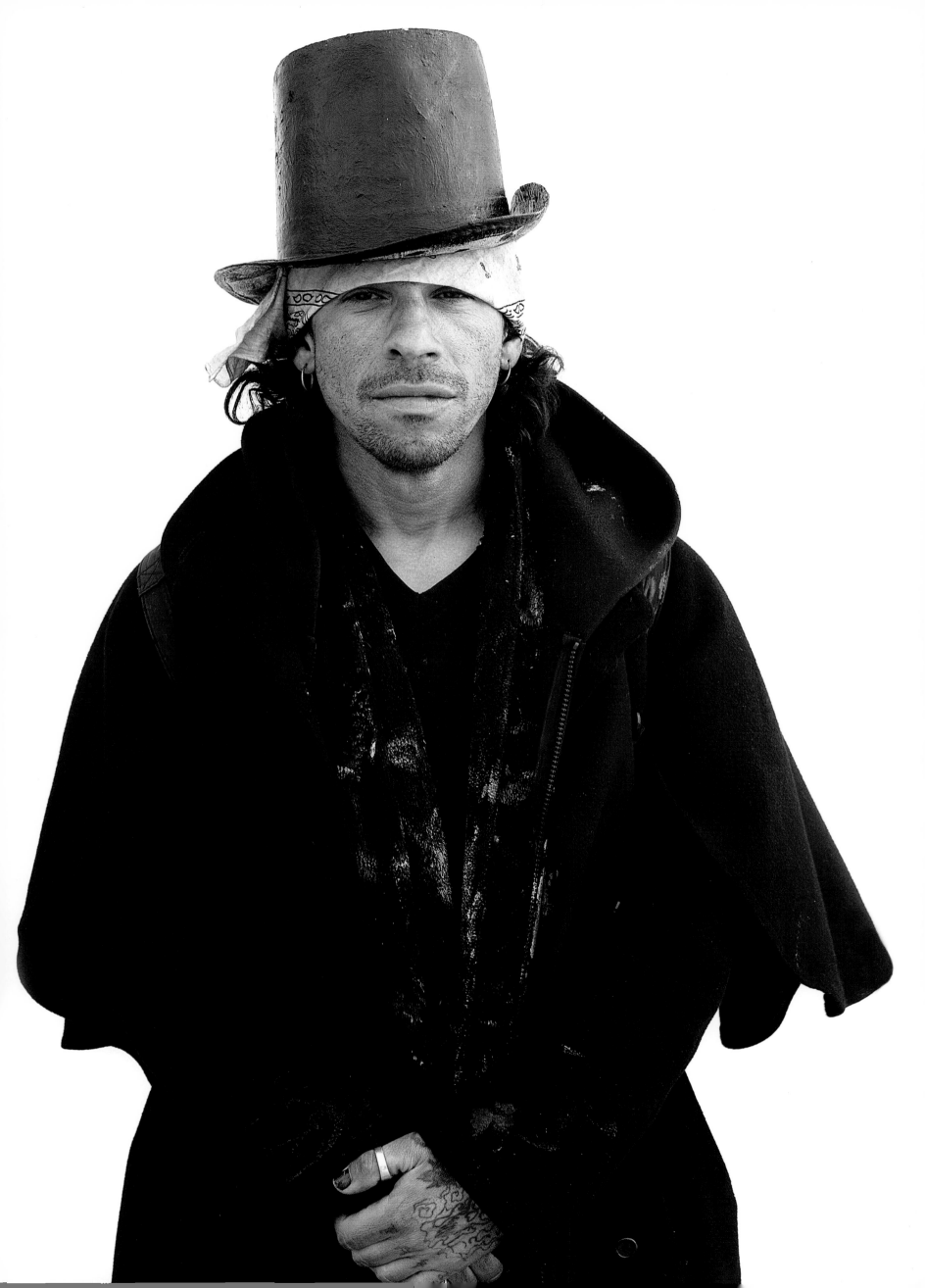

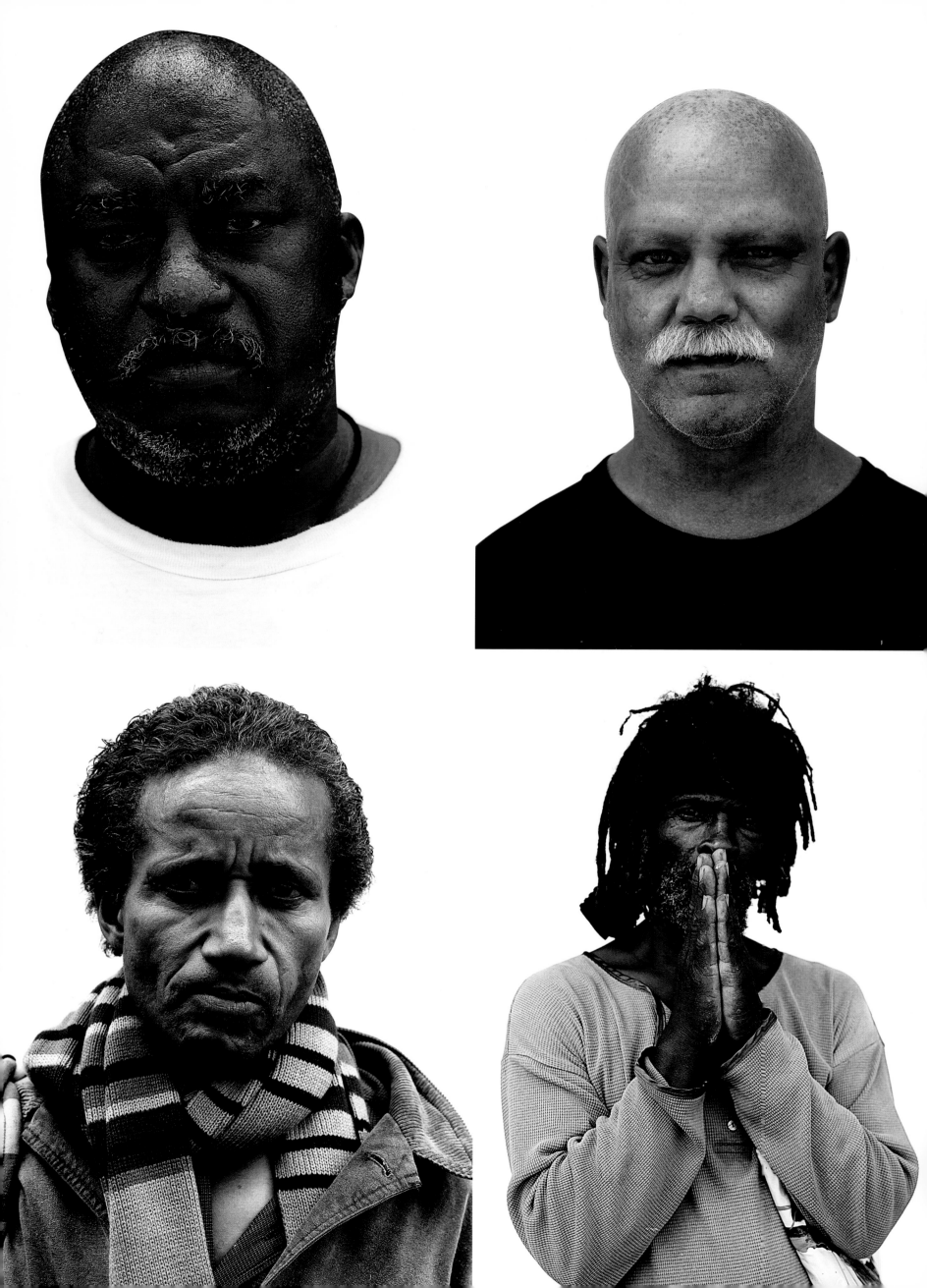

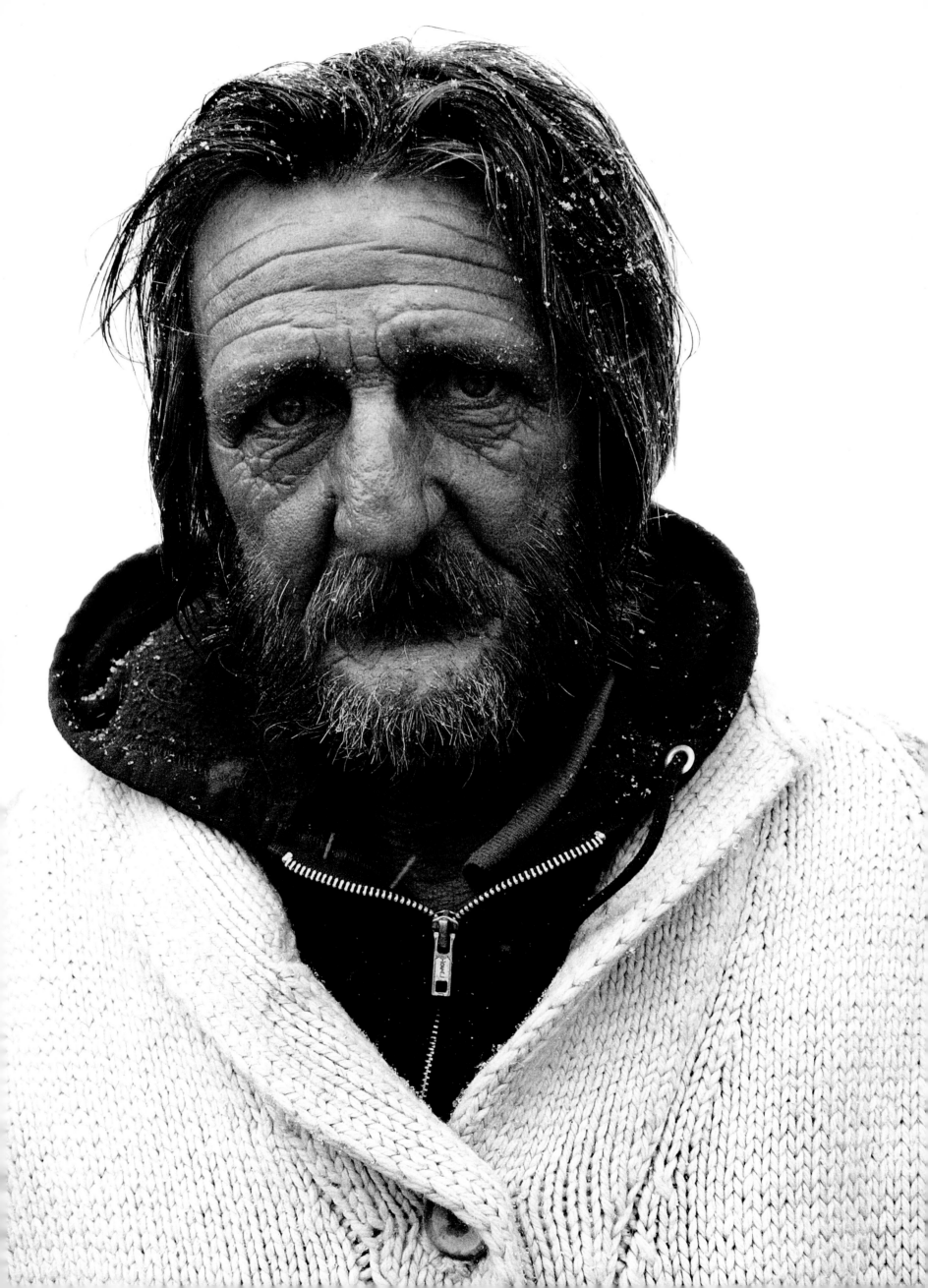

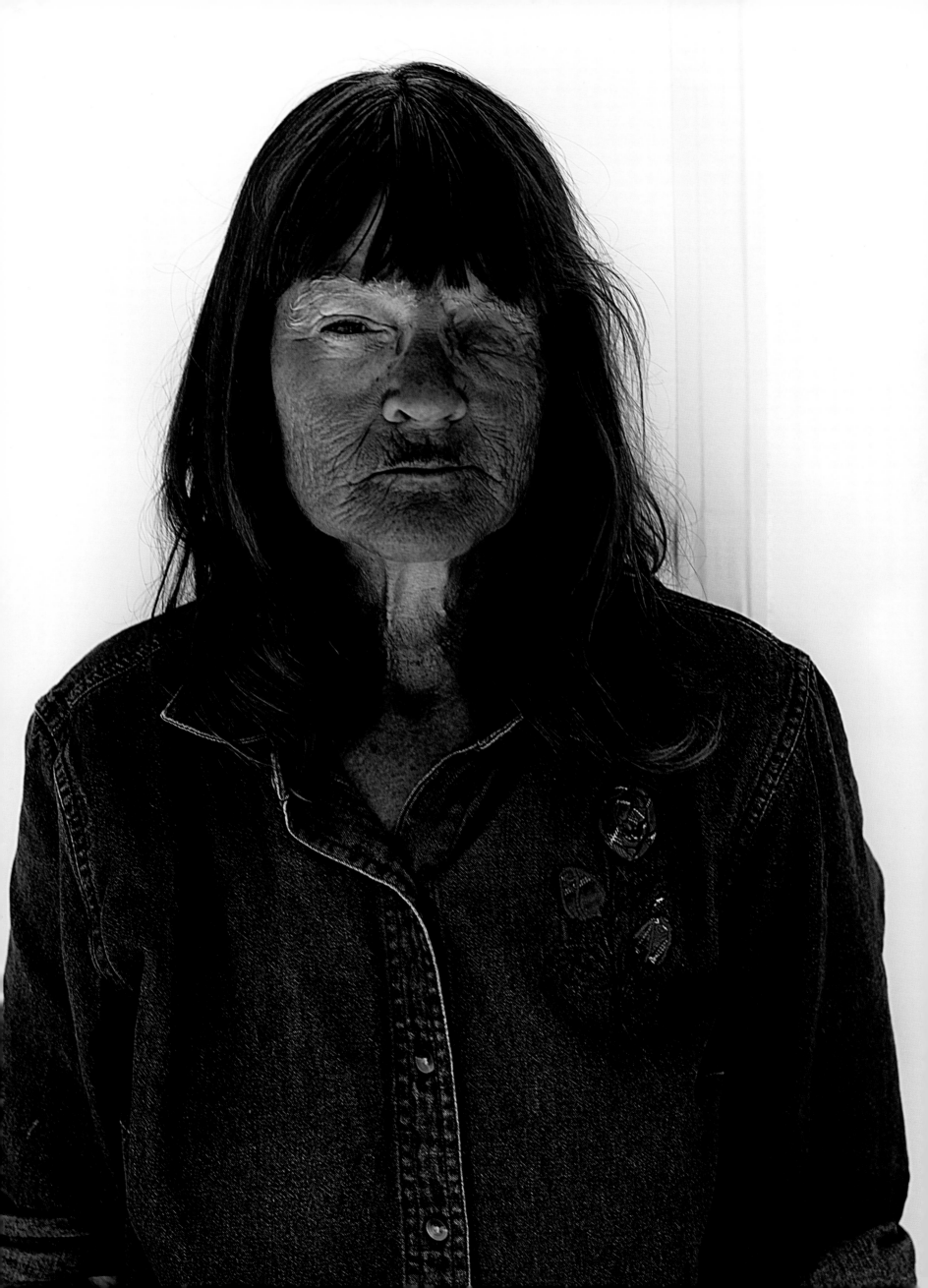

Dawn

Salt Lake City, UT

During our second meeting in 2006, I asked Dawn what had happened to her eye. "I got some beauty salon chemicals in it and they ate it away," she replied. "When it happened, it hurt like crazy, and I was so far out of it with pain that my brain just shut down." By the time Dawn got help, it was too late.

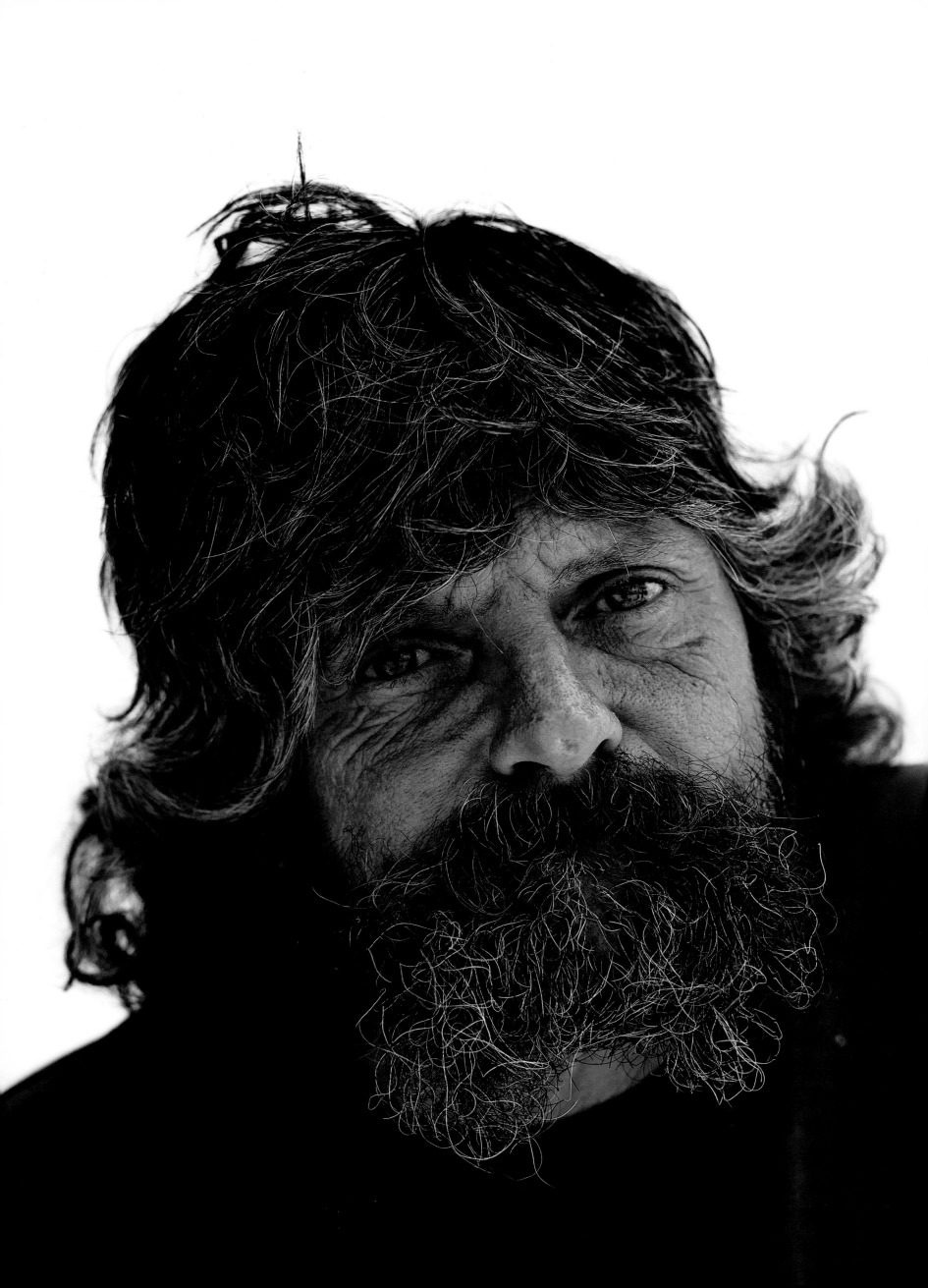

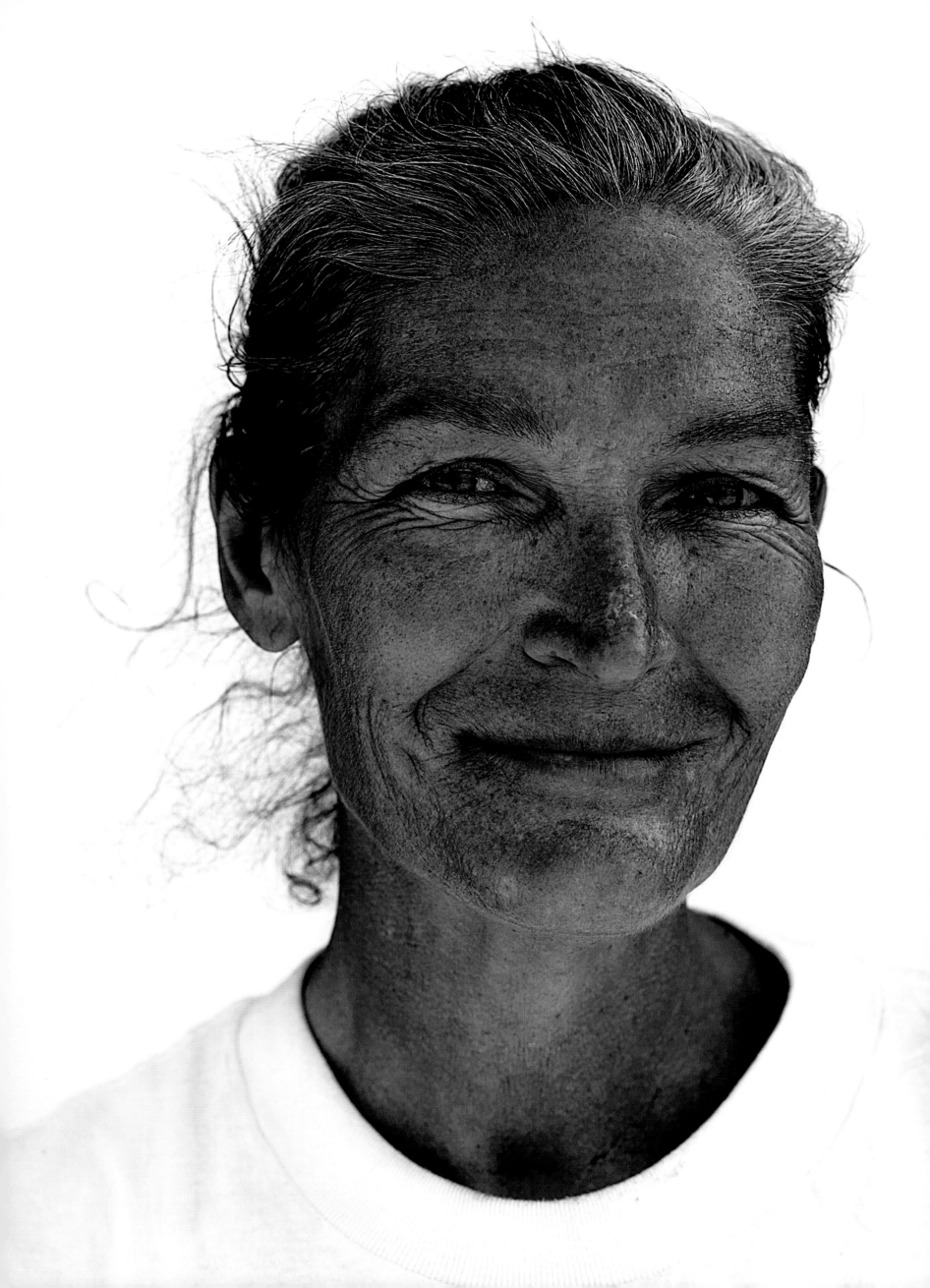

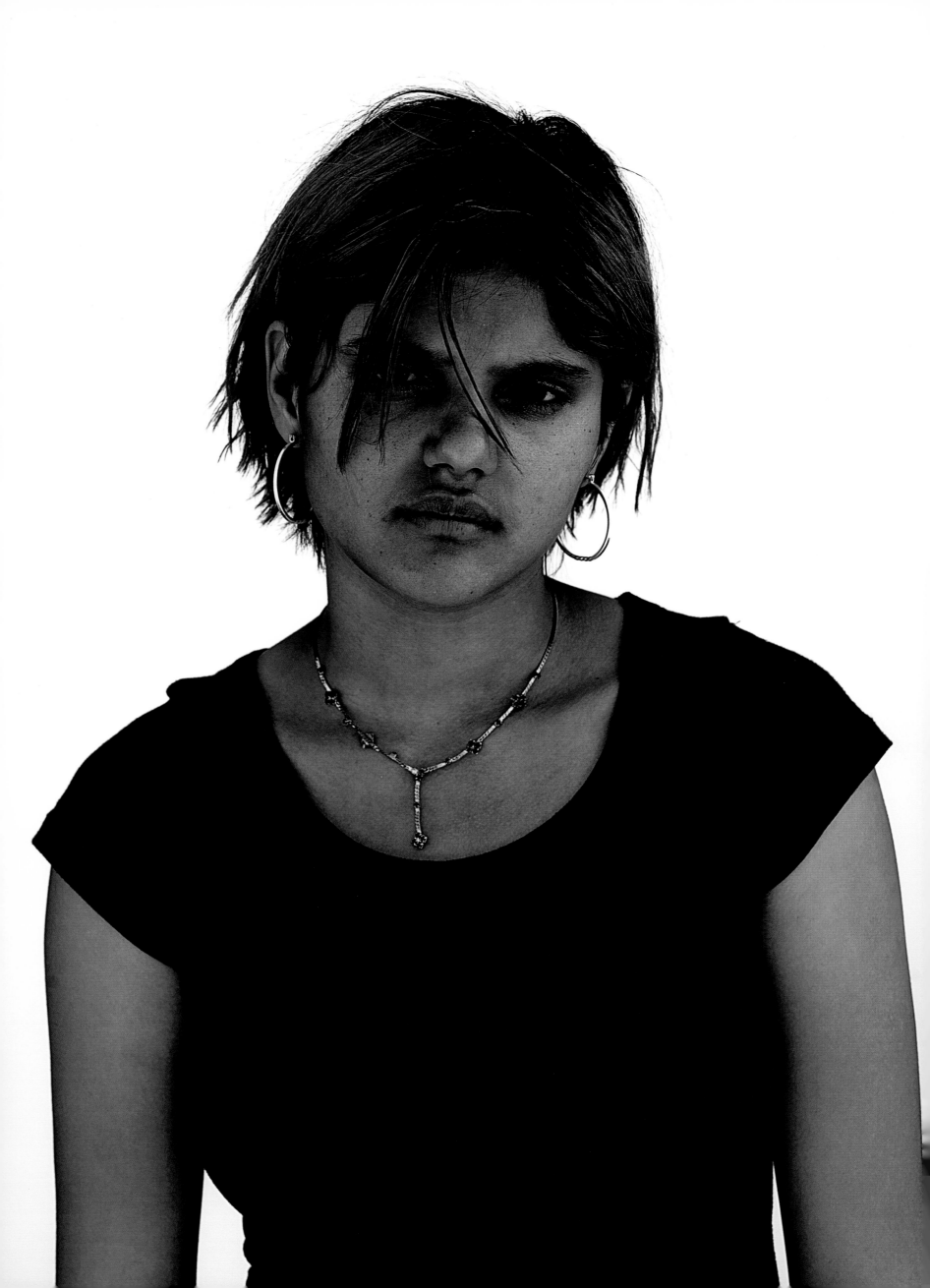

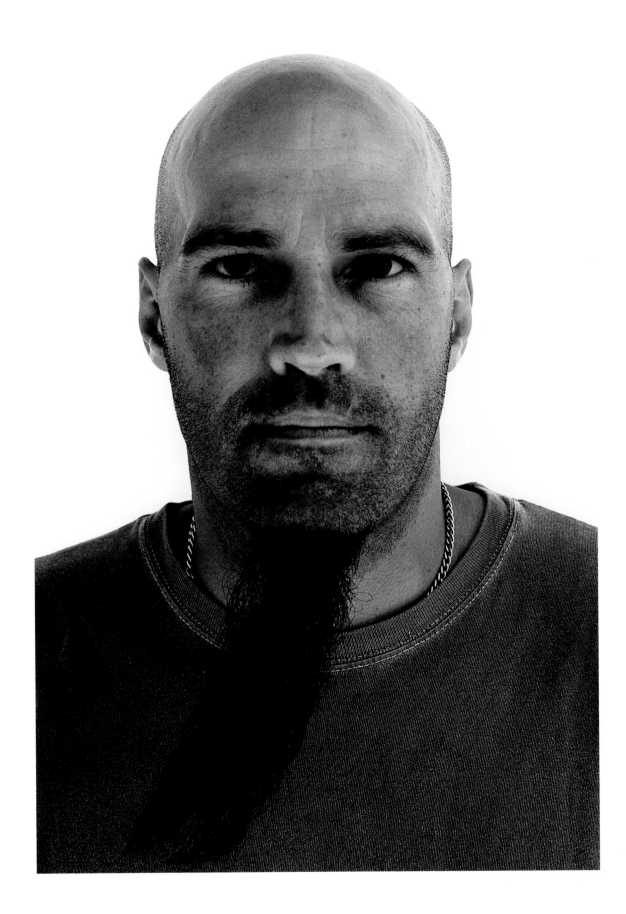

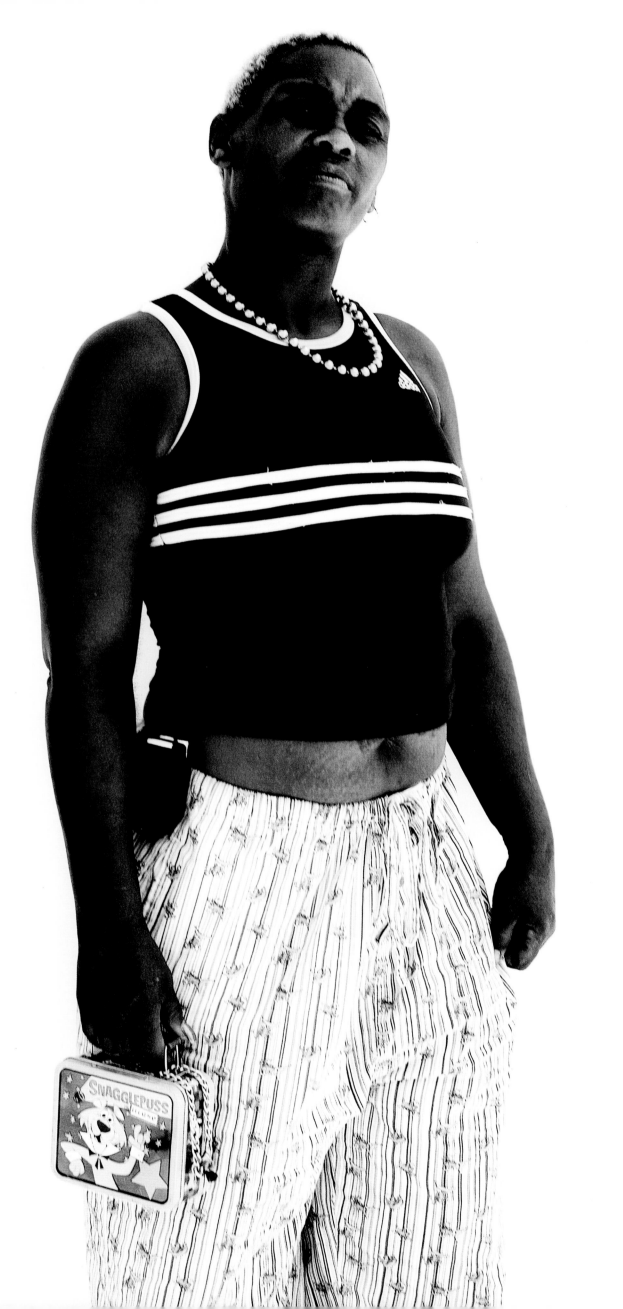

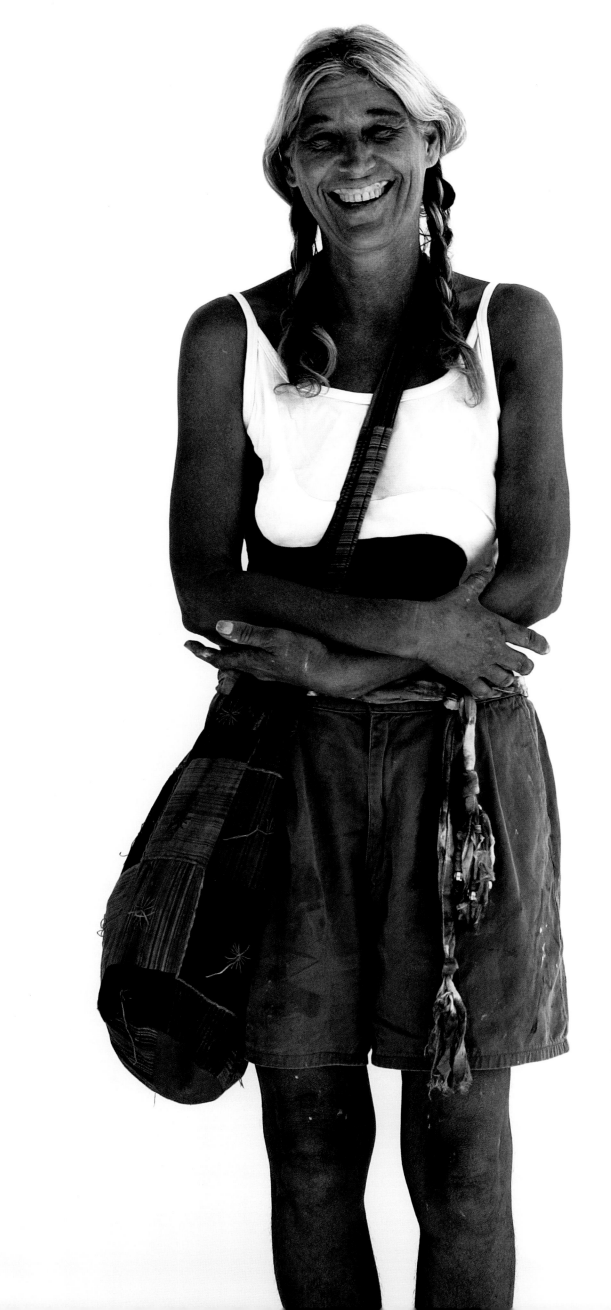

Mike

Salt Lake City, UT

When I met Mike, I said to him, "Do people say you look like Christ?"

"Yeah," he answered, "I get that all the time."

He smiled. And then I saw that all his teeth were broken off.

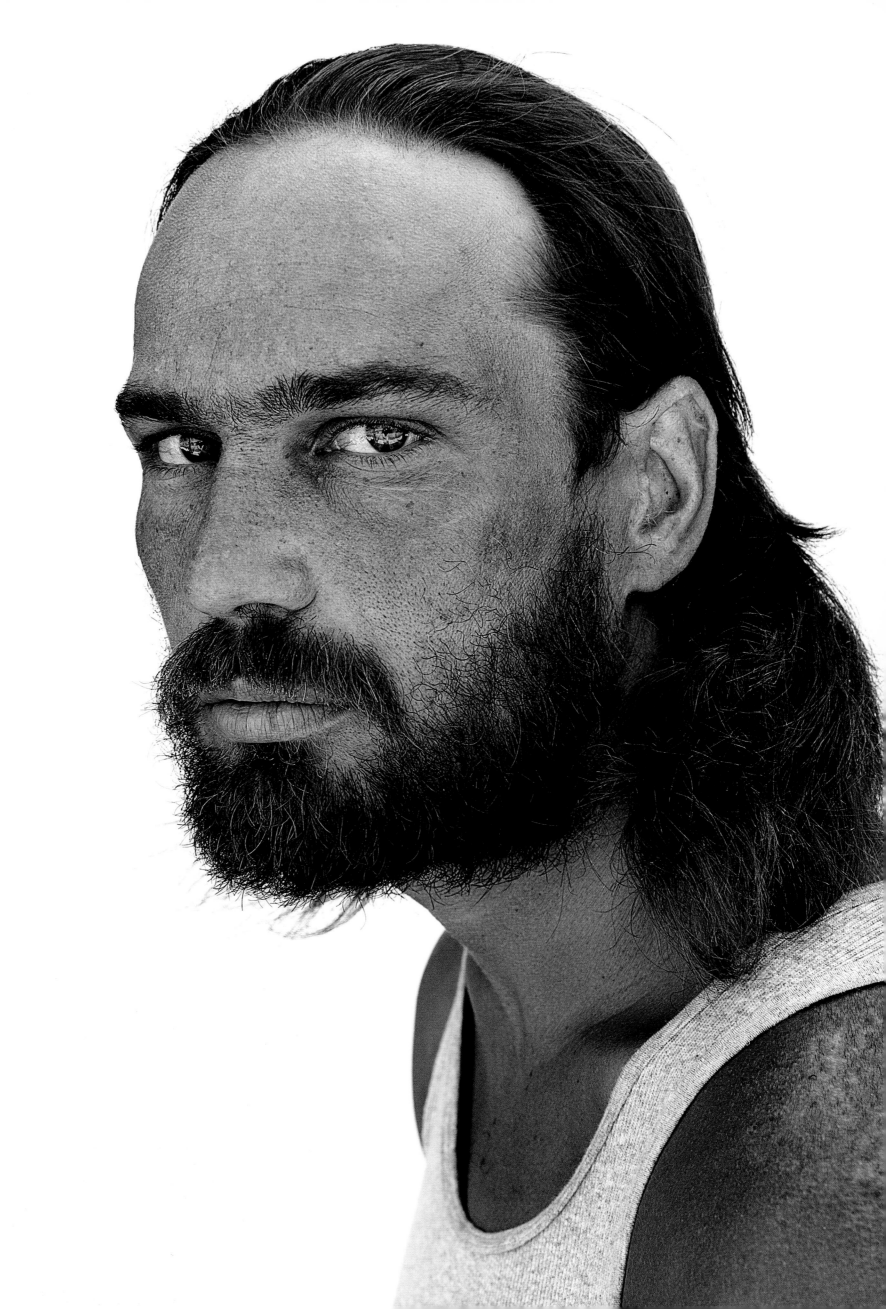

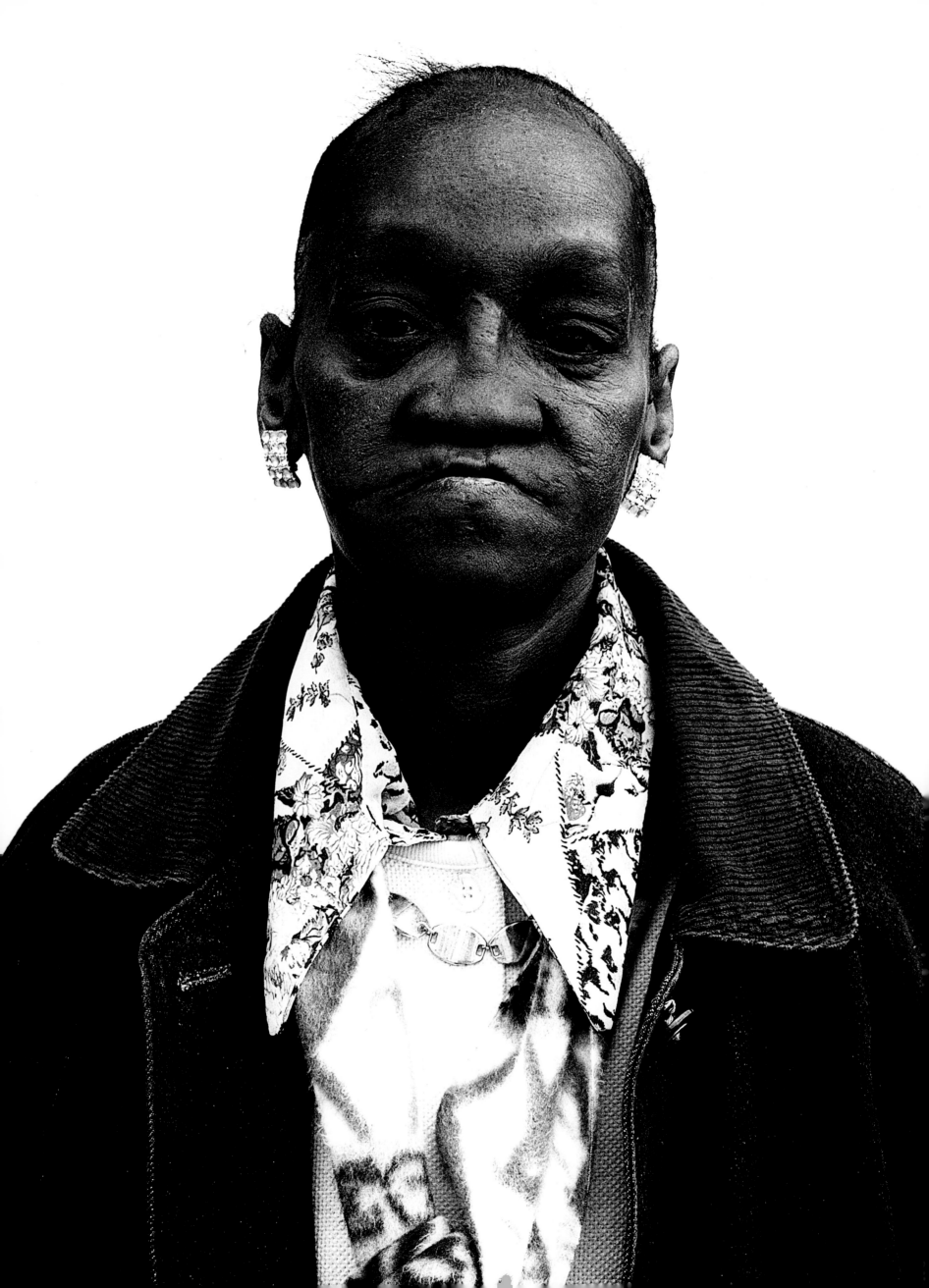

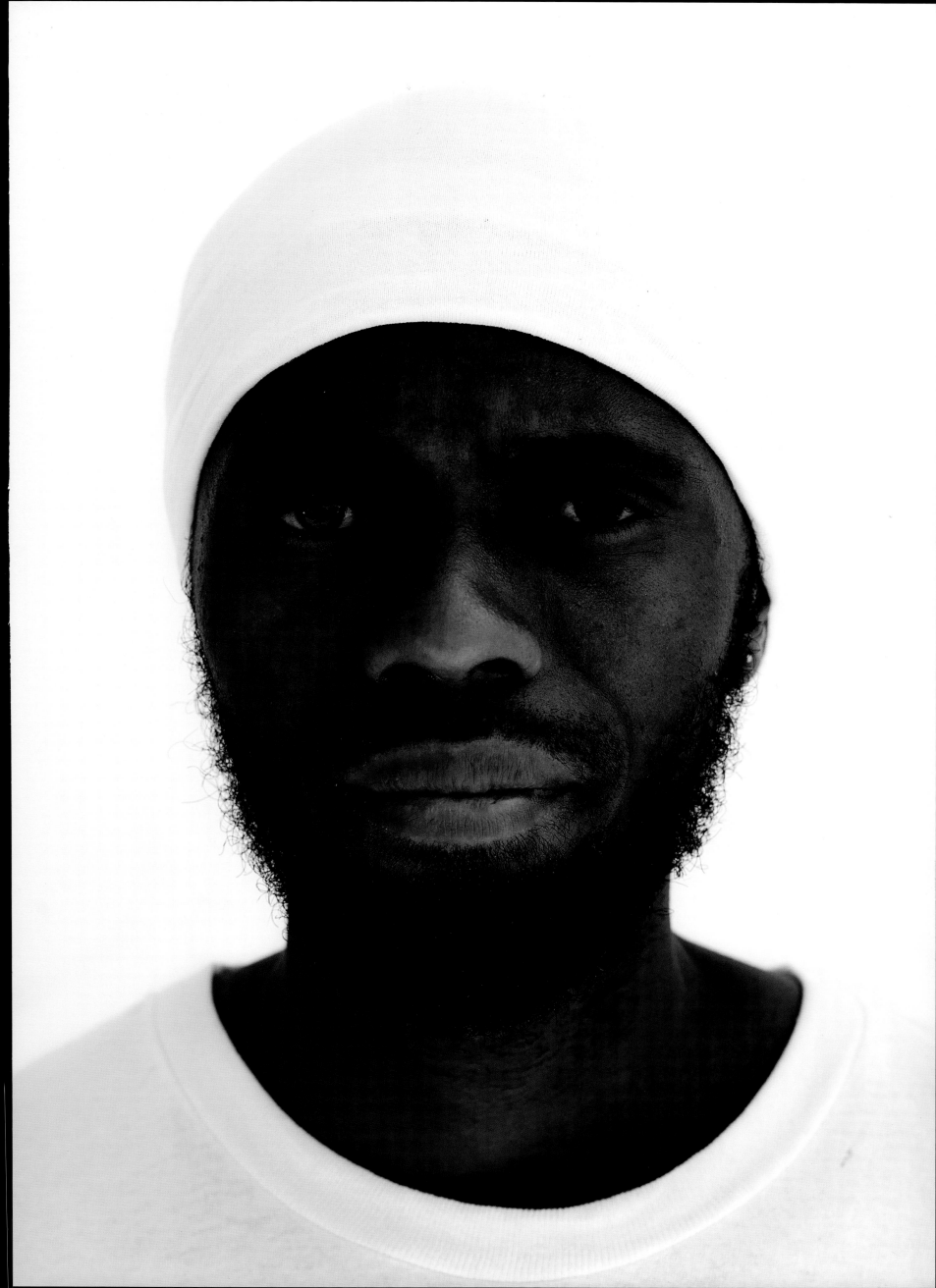

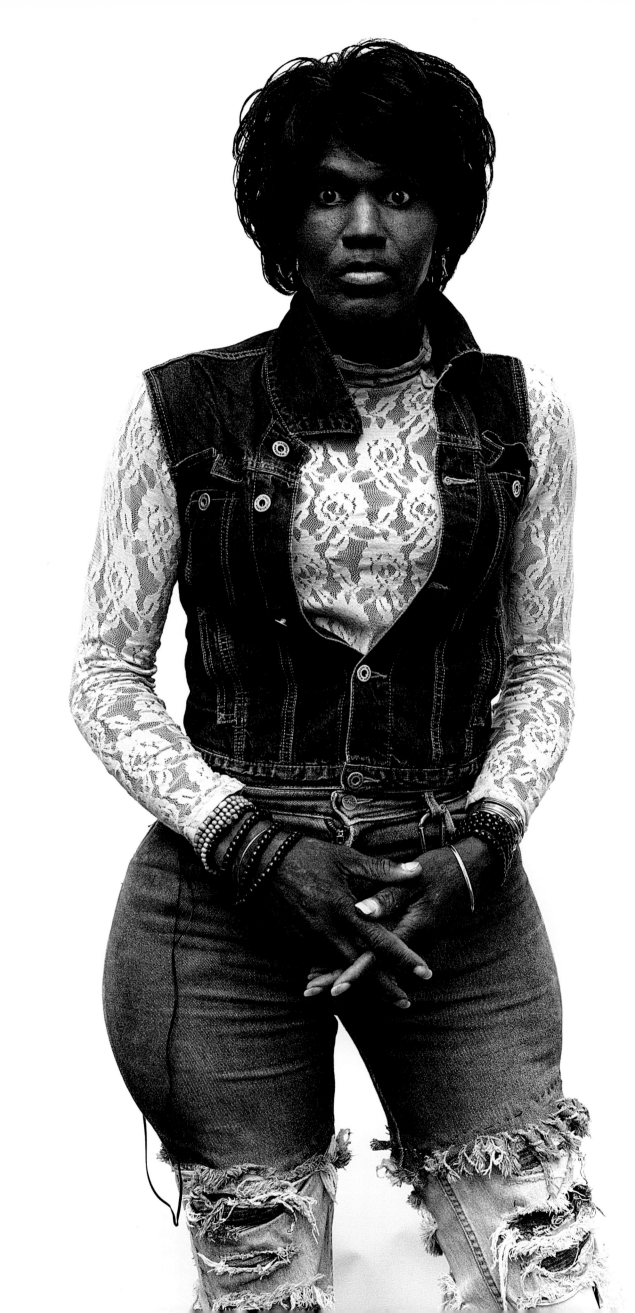

Tee

I didn't have very much time left in Washington D.C., and the light was, as always, disappearing. My assistant Corinne and I decided to stop by a park across from an old school that had been converted into a large shelter. As I prepared to take my last photographs, an attractive blonde-haired African-American woman named Pamela stepped before my lens. Close behind Pamela was her friend, a tall African-American woman wearing a lacy blouse and jeans who told me her name was Tee. Her intense gaze caught the lens. Later, as we were packing up, Corinne commented that Pamela and Tee had told her they were members of an organization composed of transvestites. "You don't say," was my response.

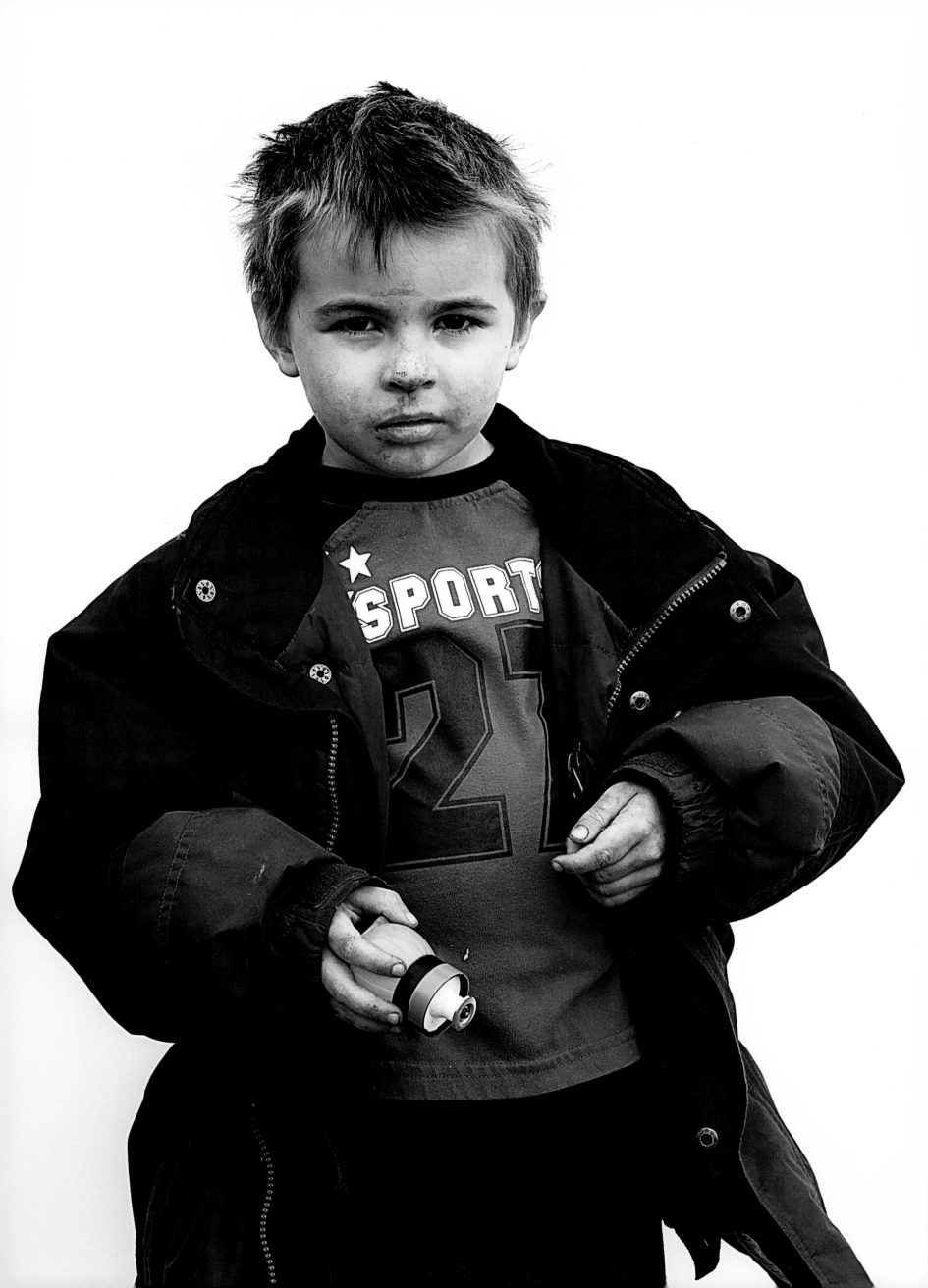

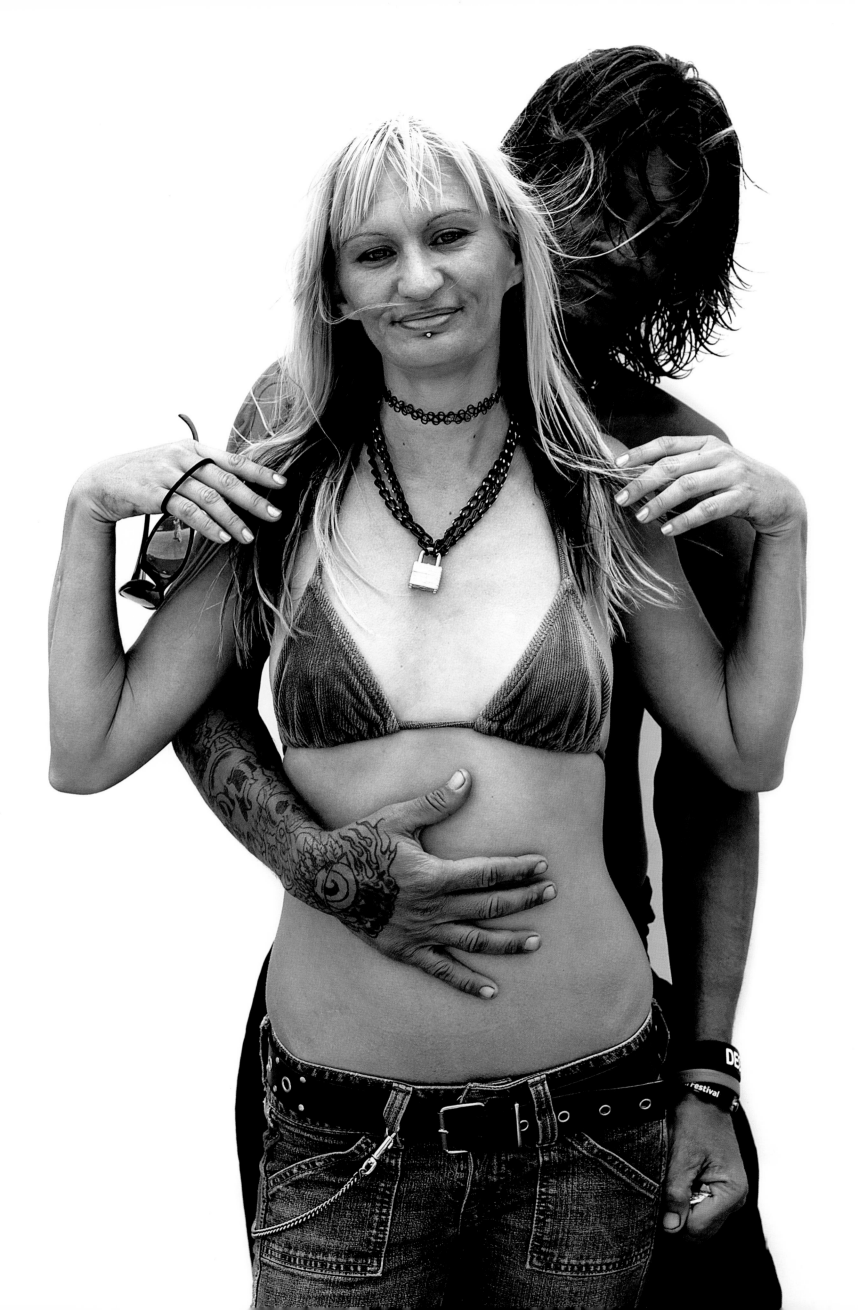

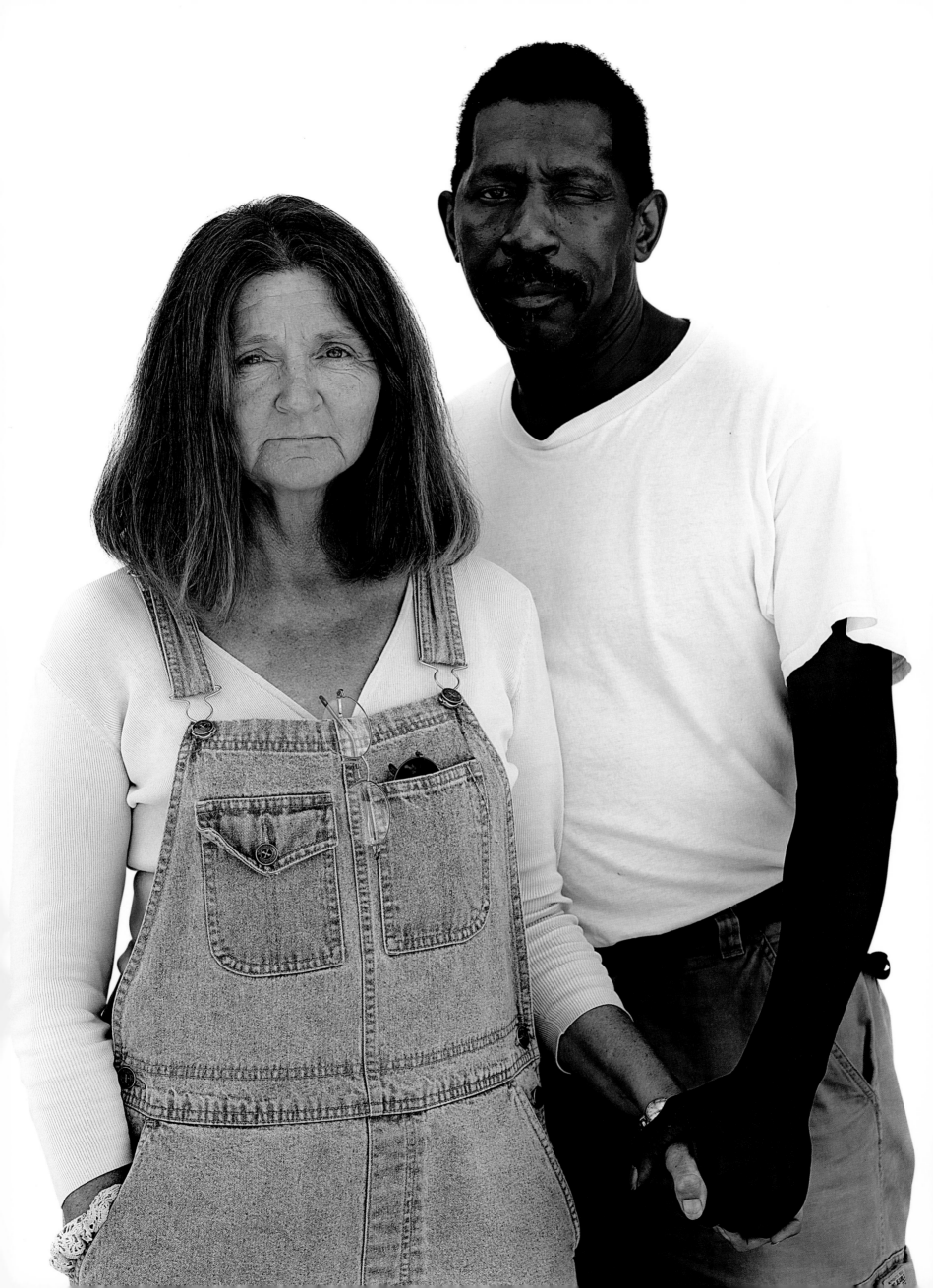

Brittany & Deborah

Salt Lake City, UT

As they embraced for this photo, sisters Brittany and Deborah began to cry. They said they felt emotional with love for one another and with sadness. Deborah, on the right, explained that this moment brought back memories of being photographed with her daughter – a daughter who was now "gone."

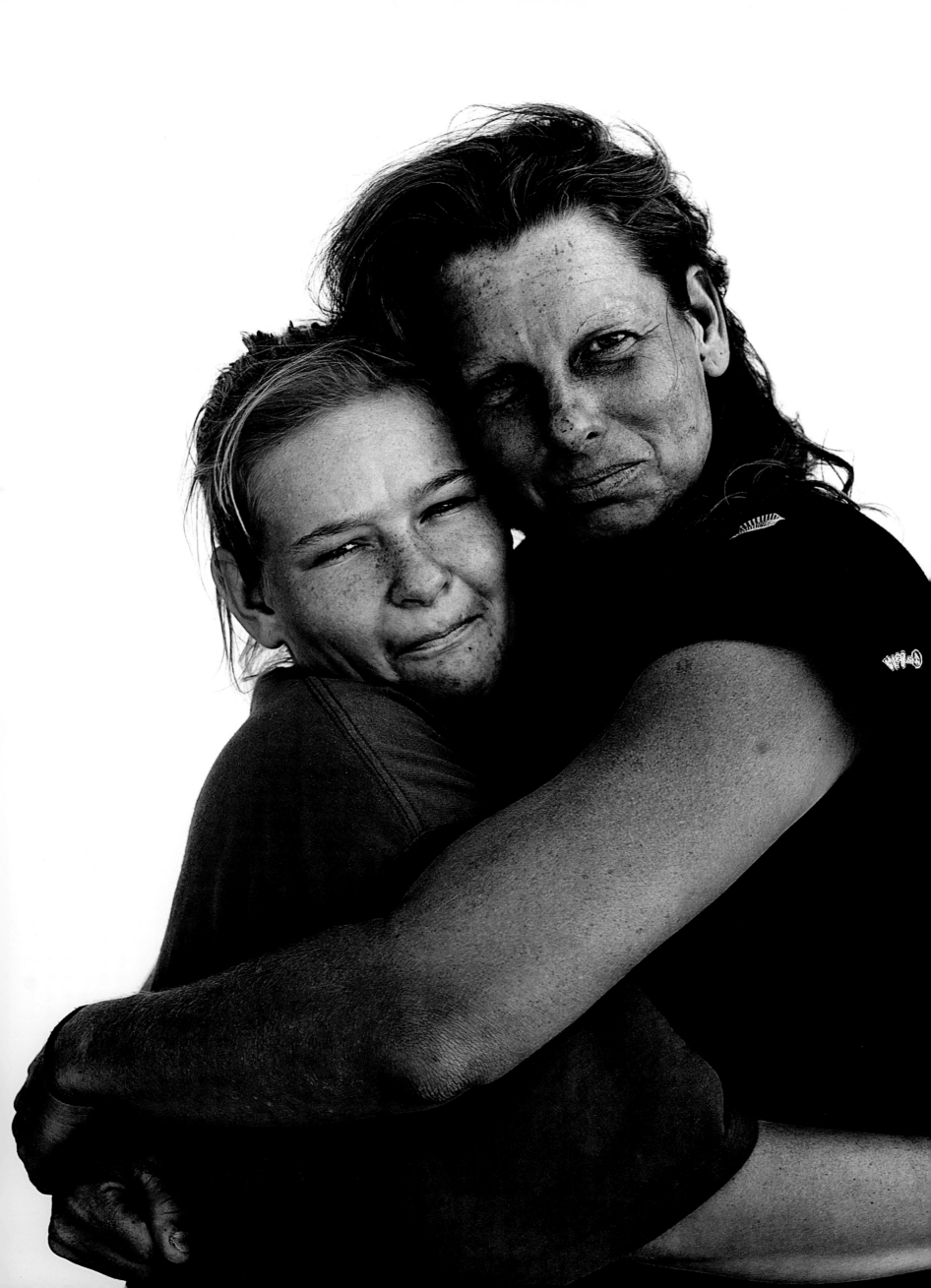

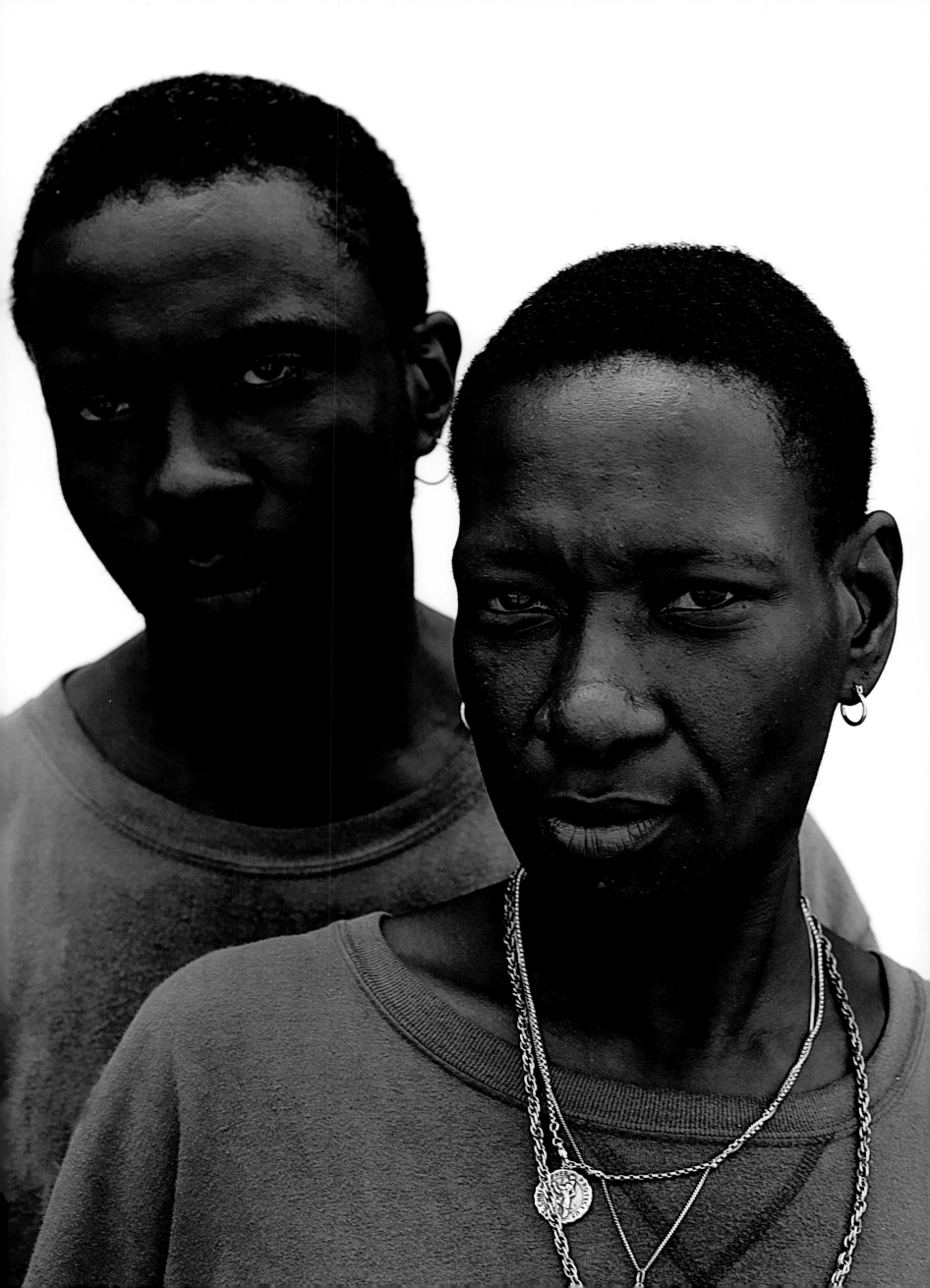

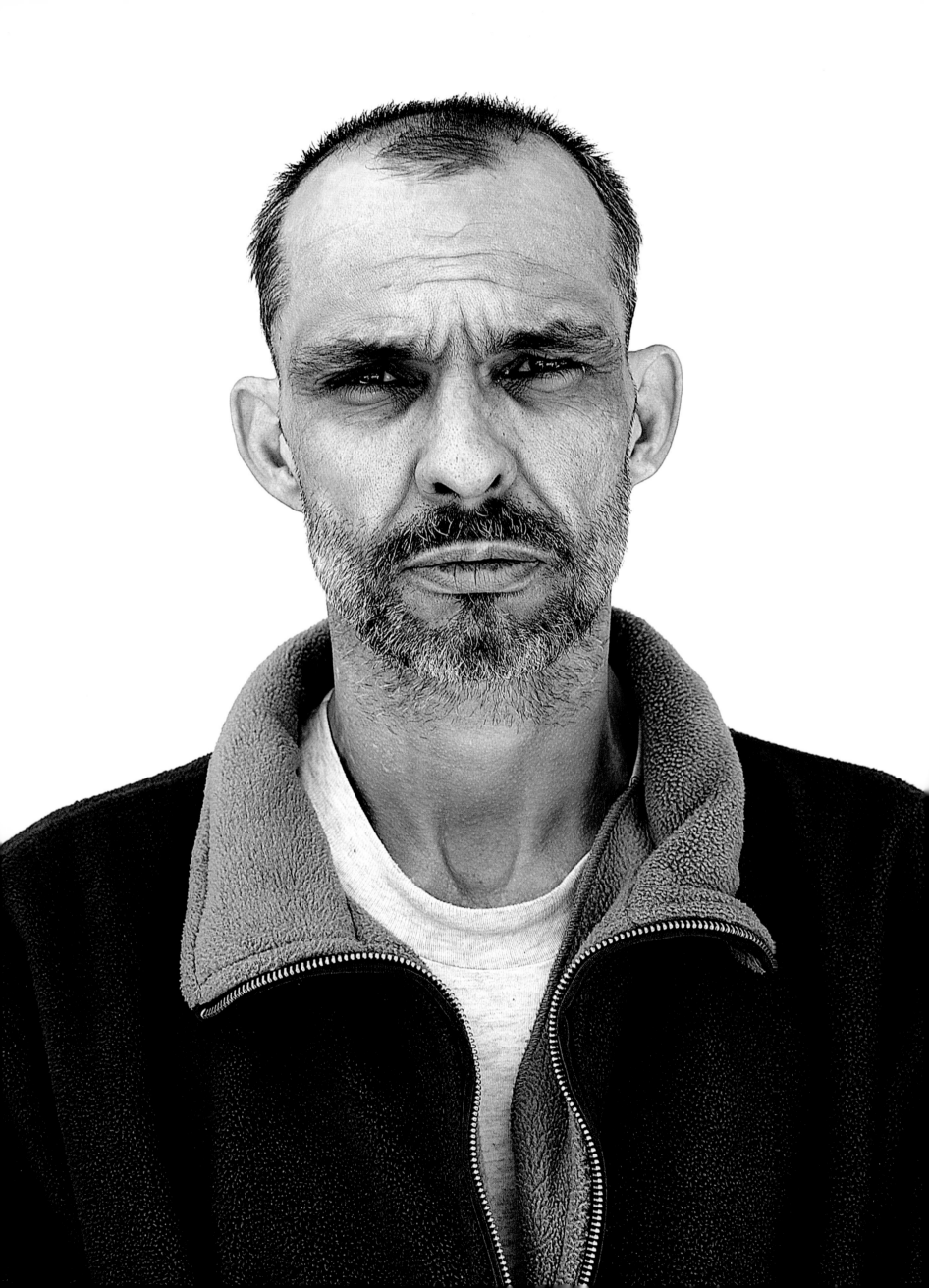

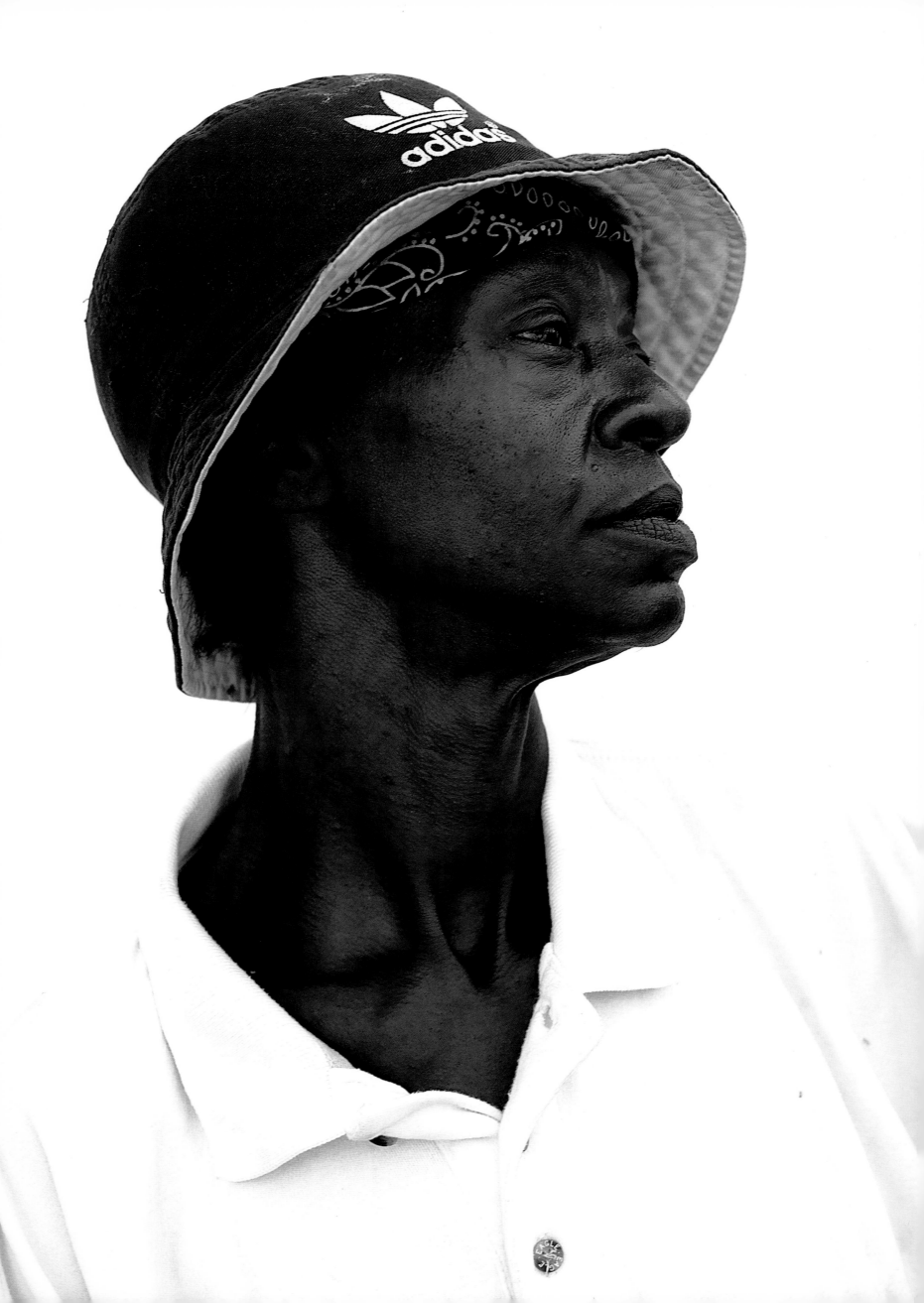

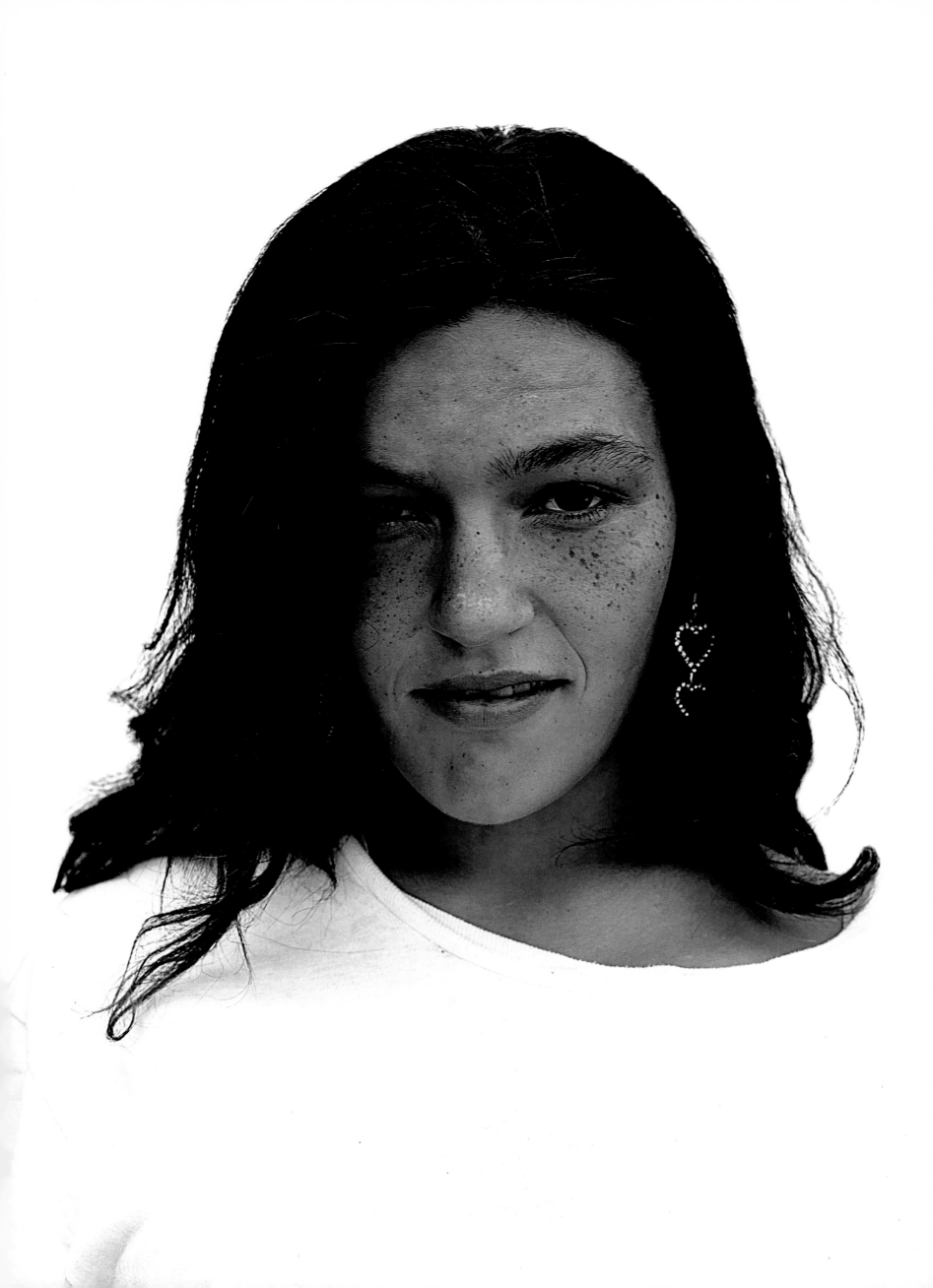

Melanie, Sabrina & Daniel

Salt Lake City, UT

It was cold in December when I saw this mother and her two children on the street outside a shelter. She was trying to get her son to look at the camera. When I saw the image I felt she was indicting me, asking, "What will you do to help with this American tragedy?"

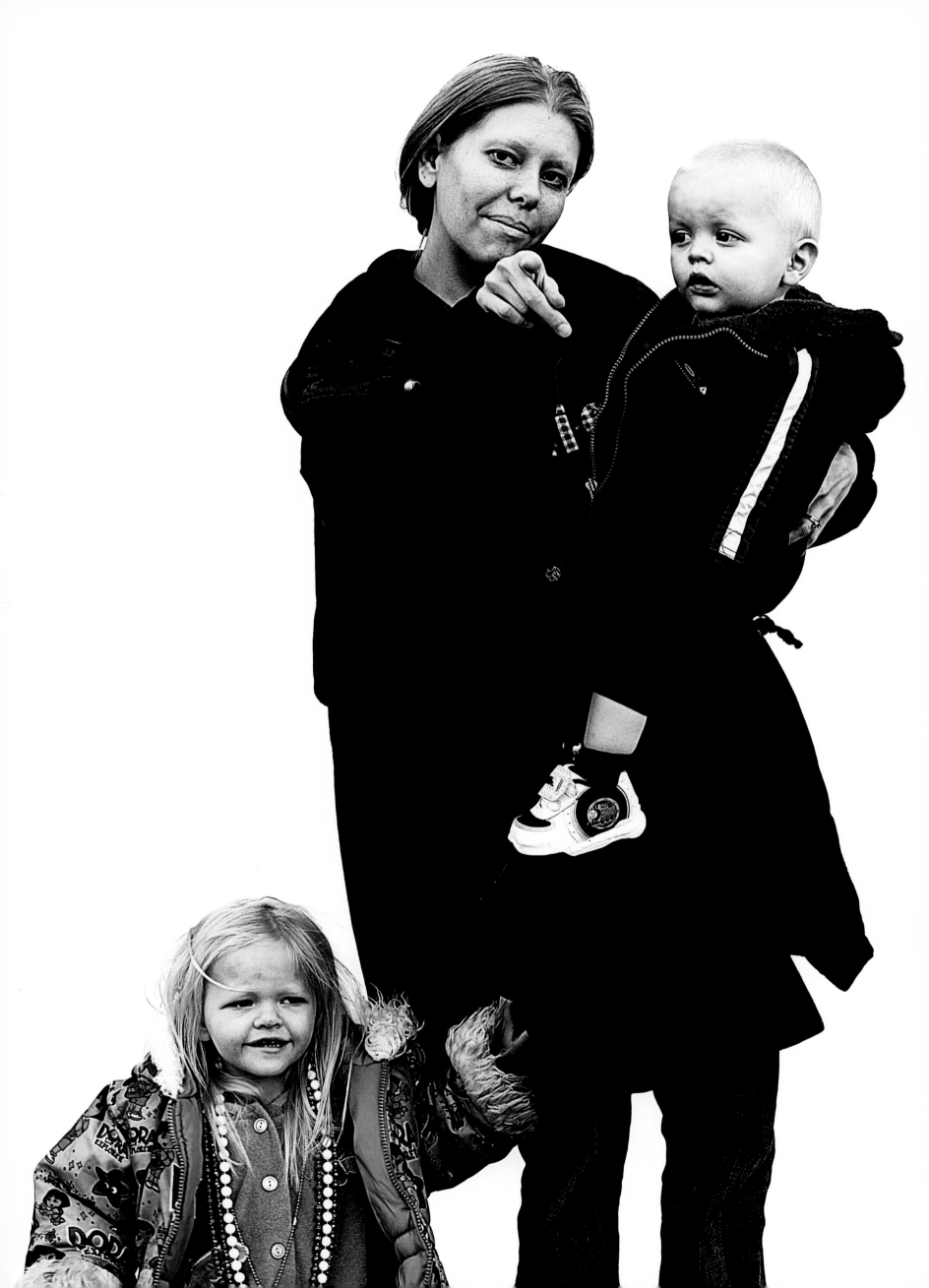

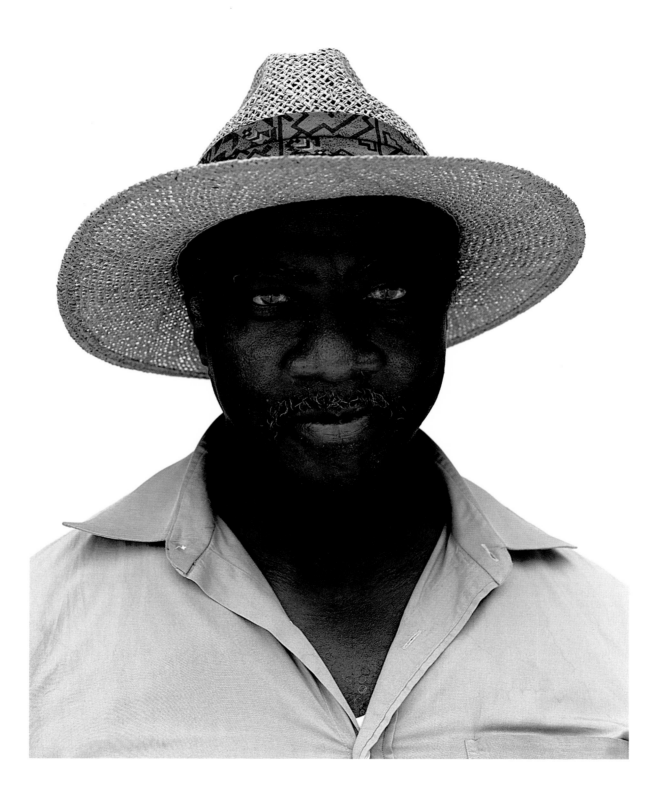

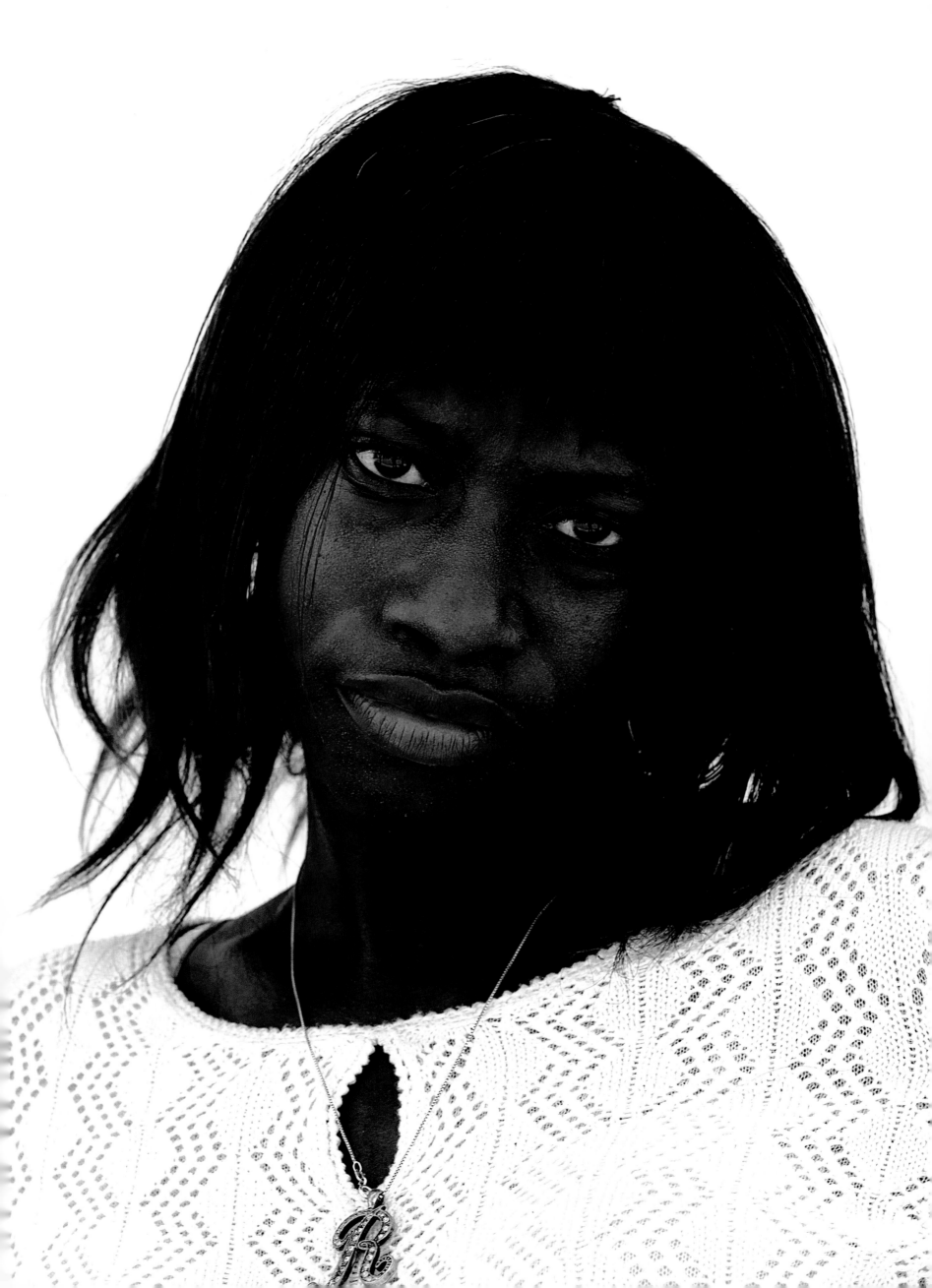

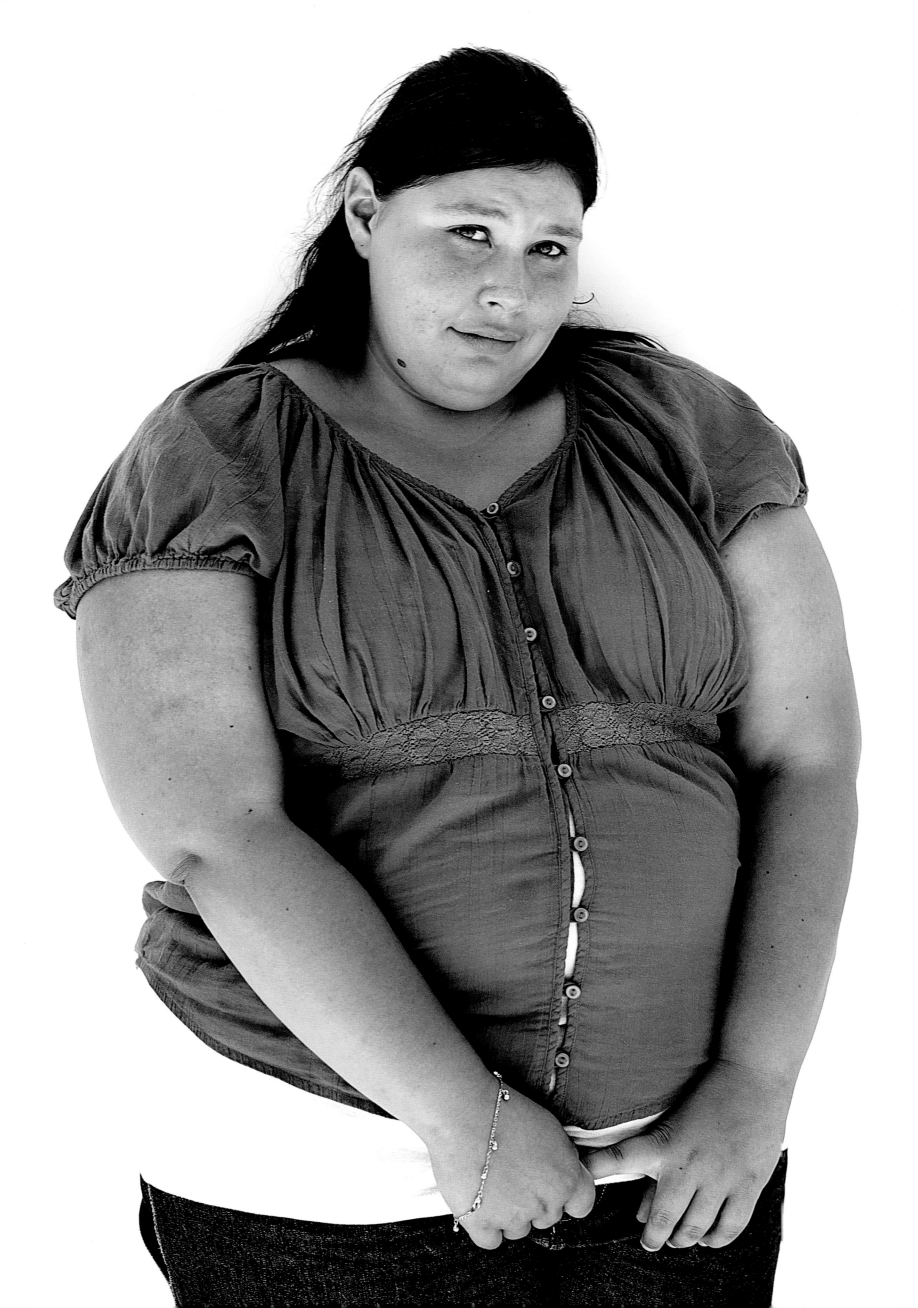

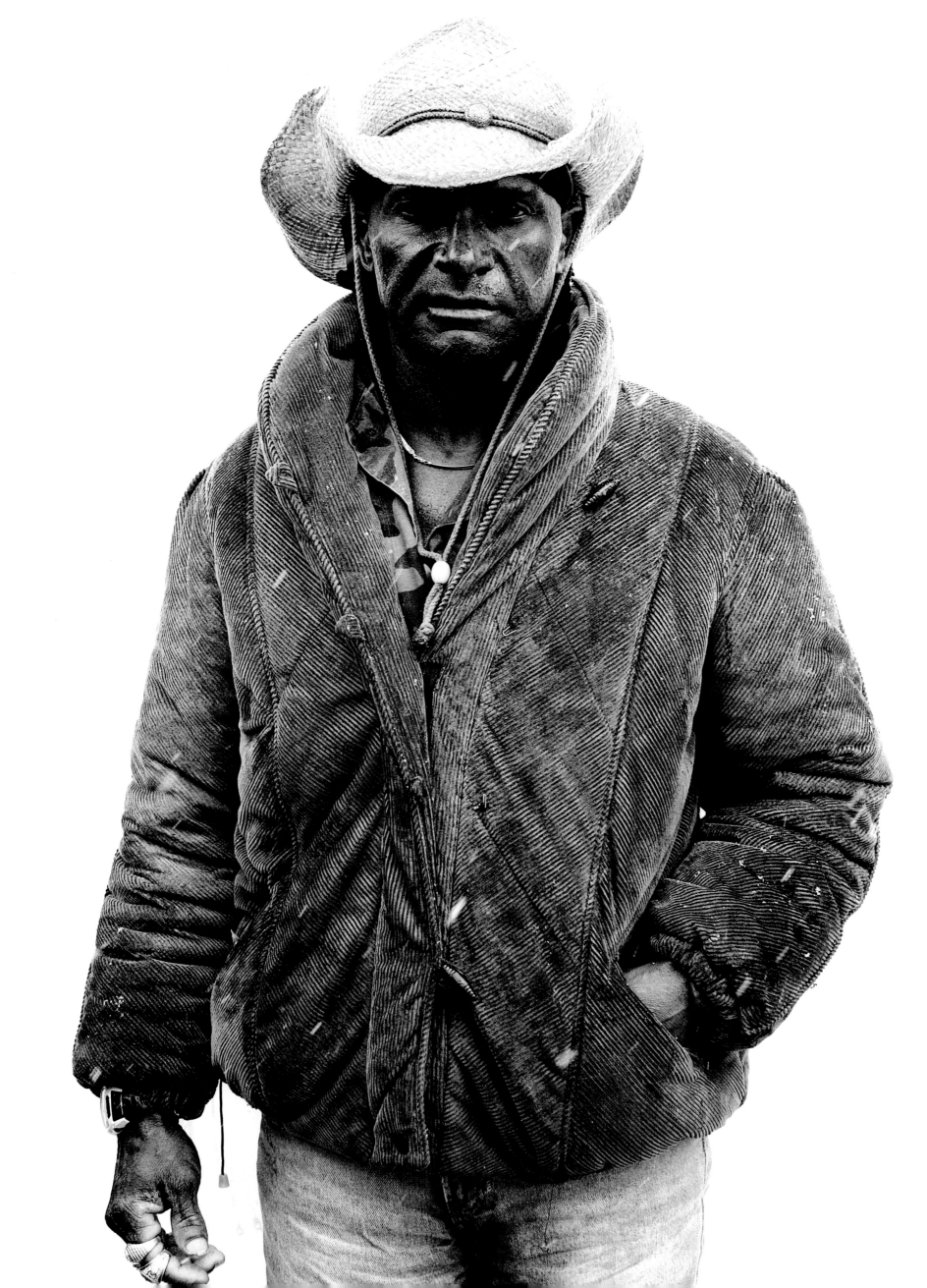

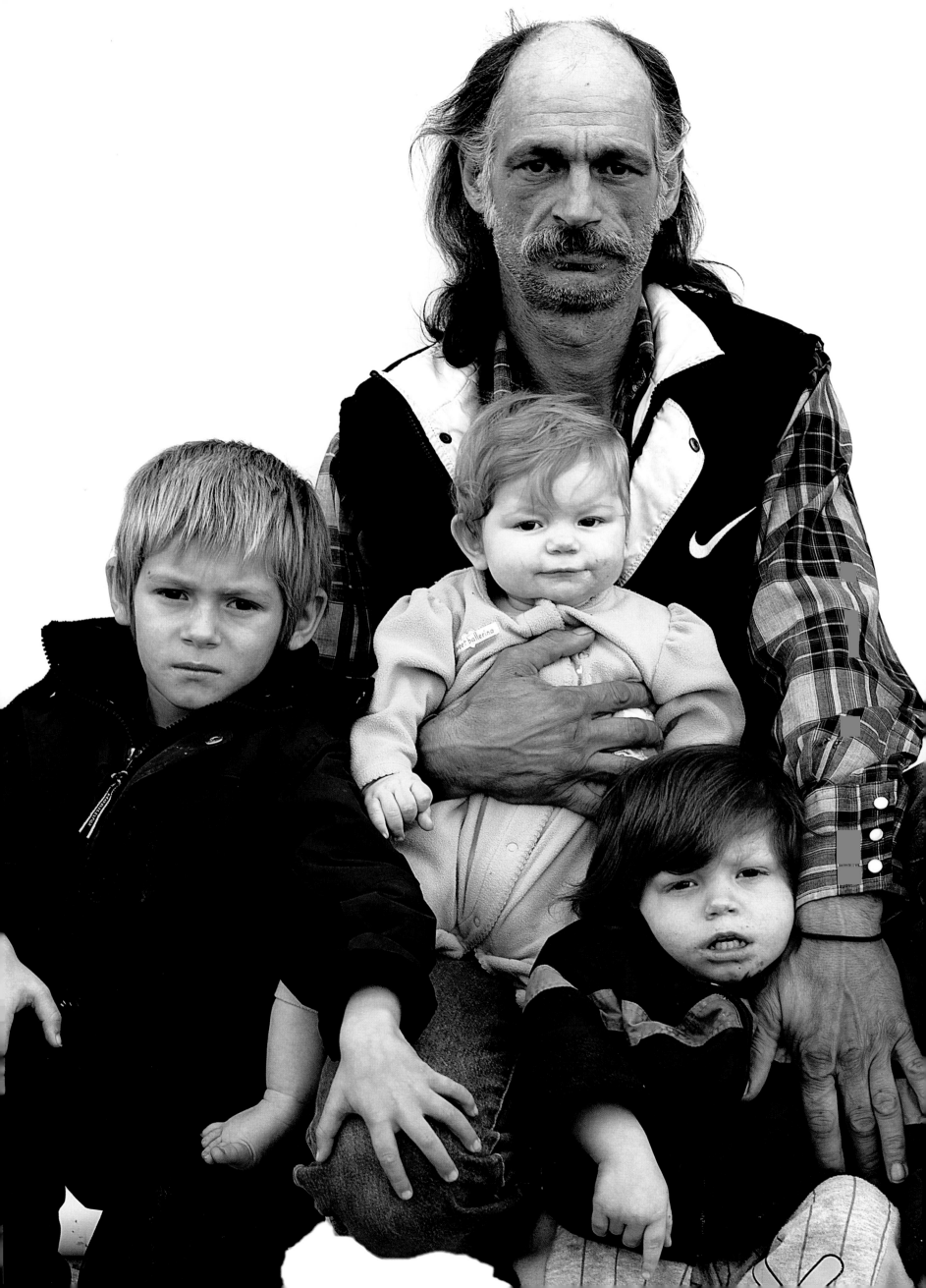

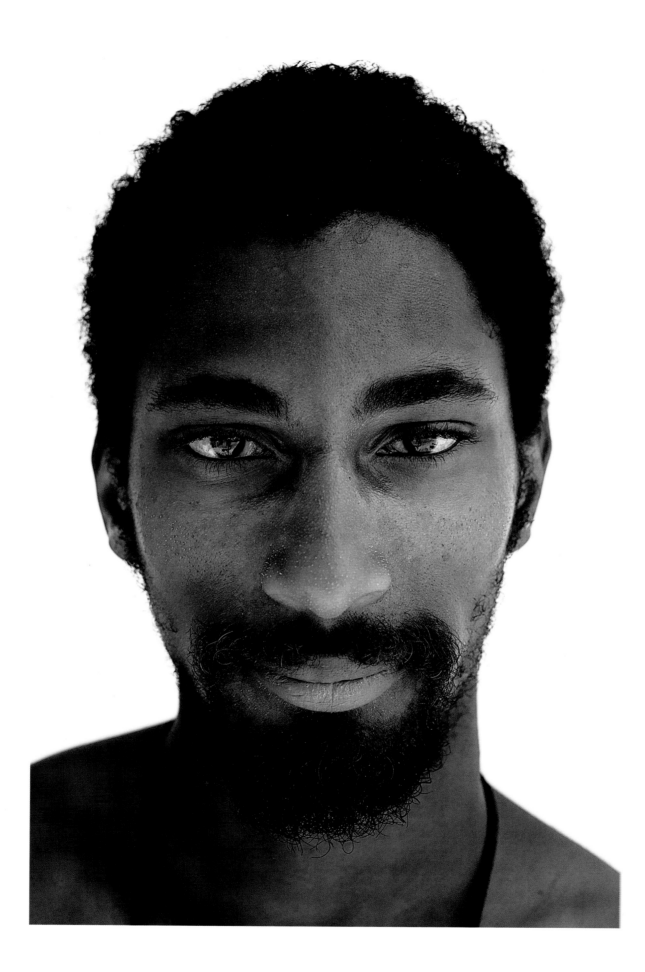

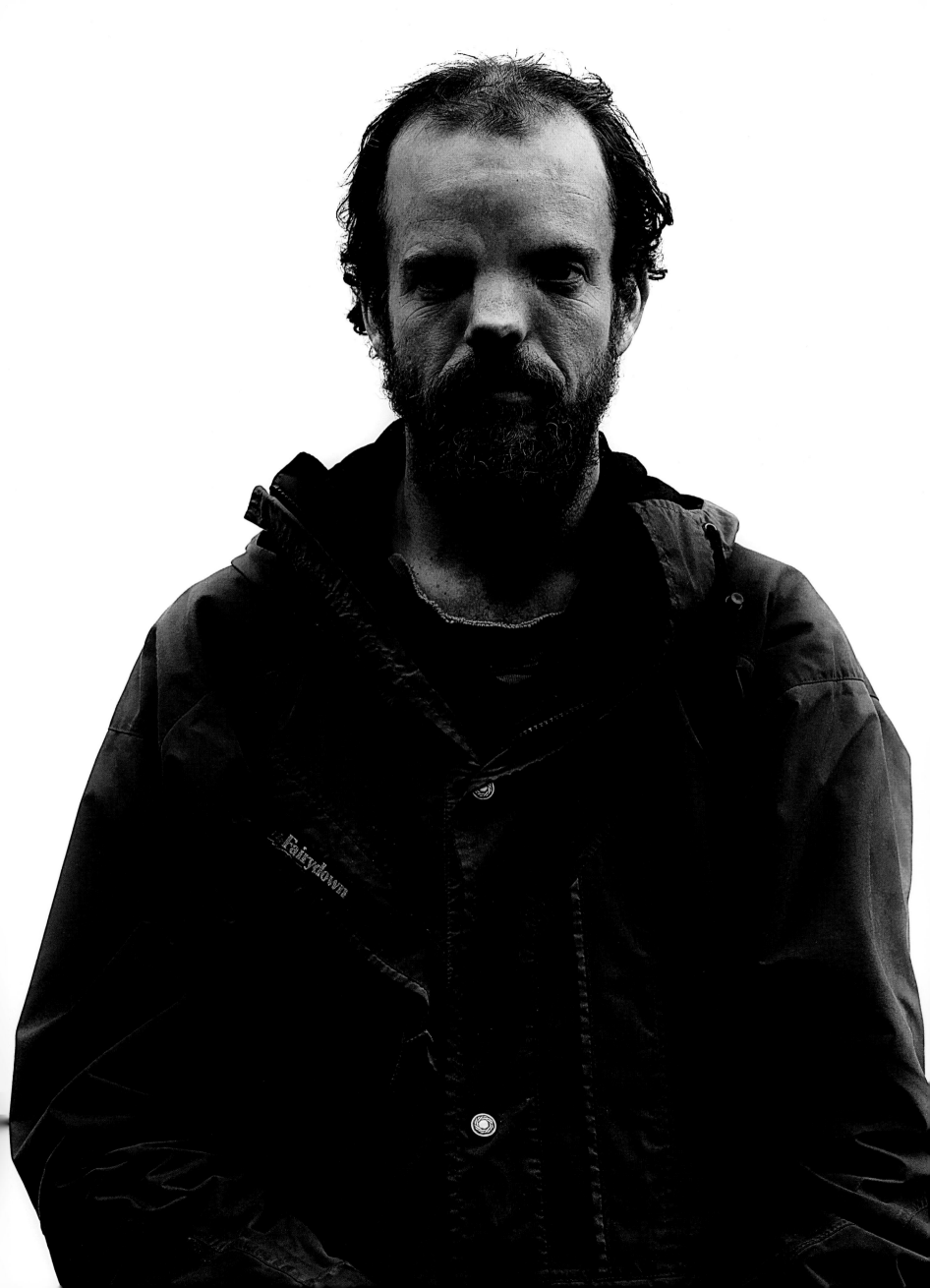

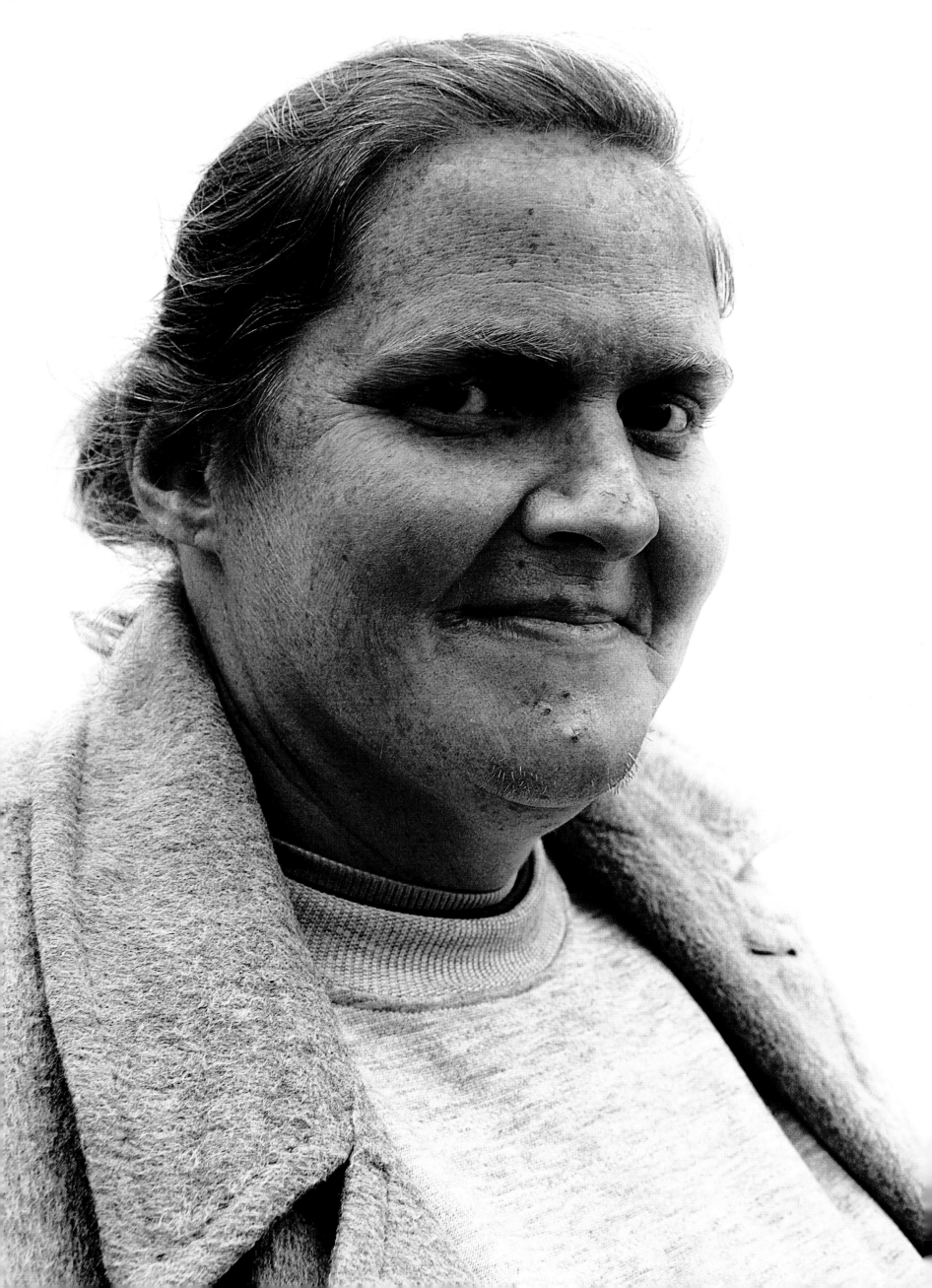

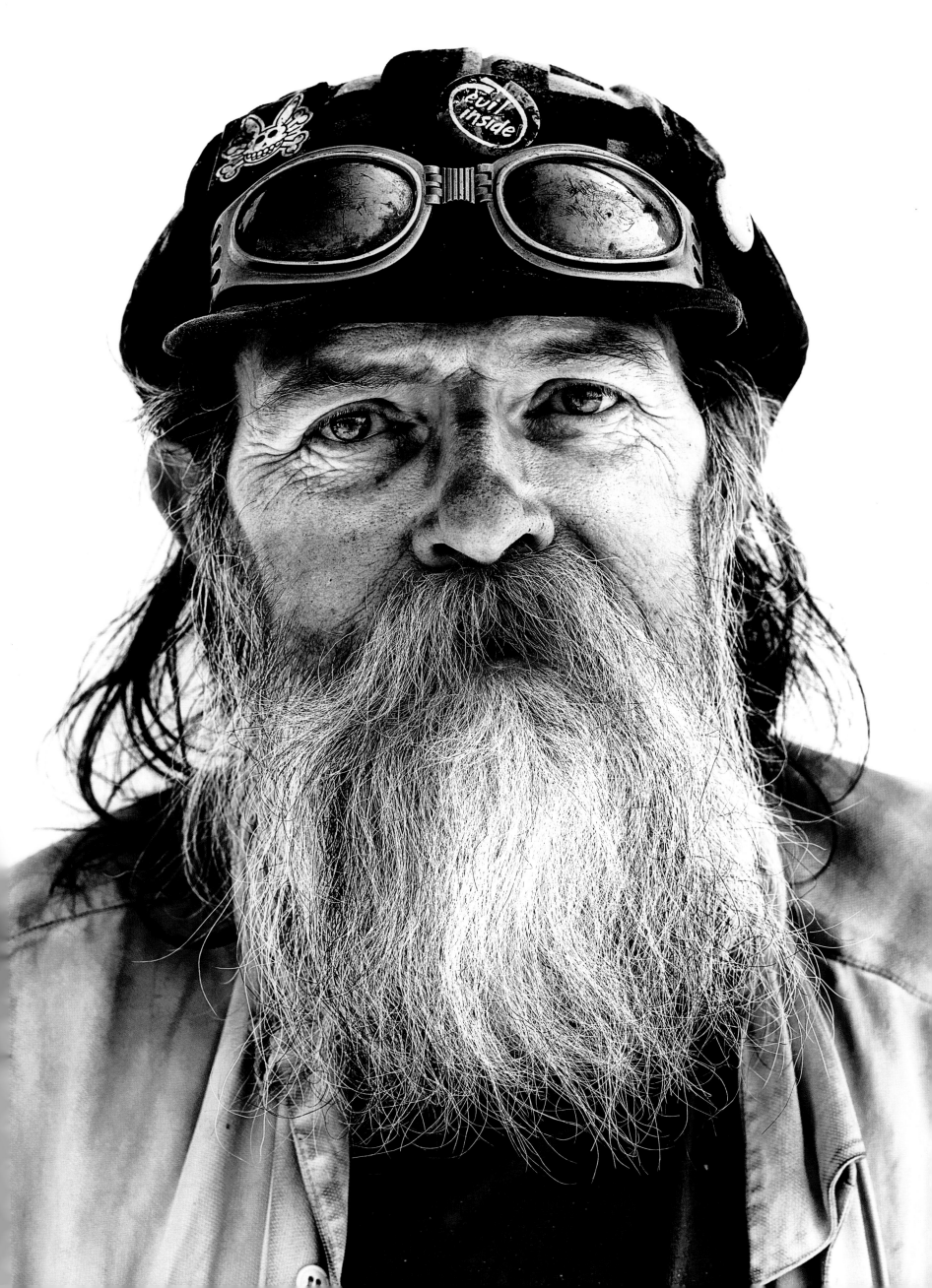

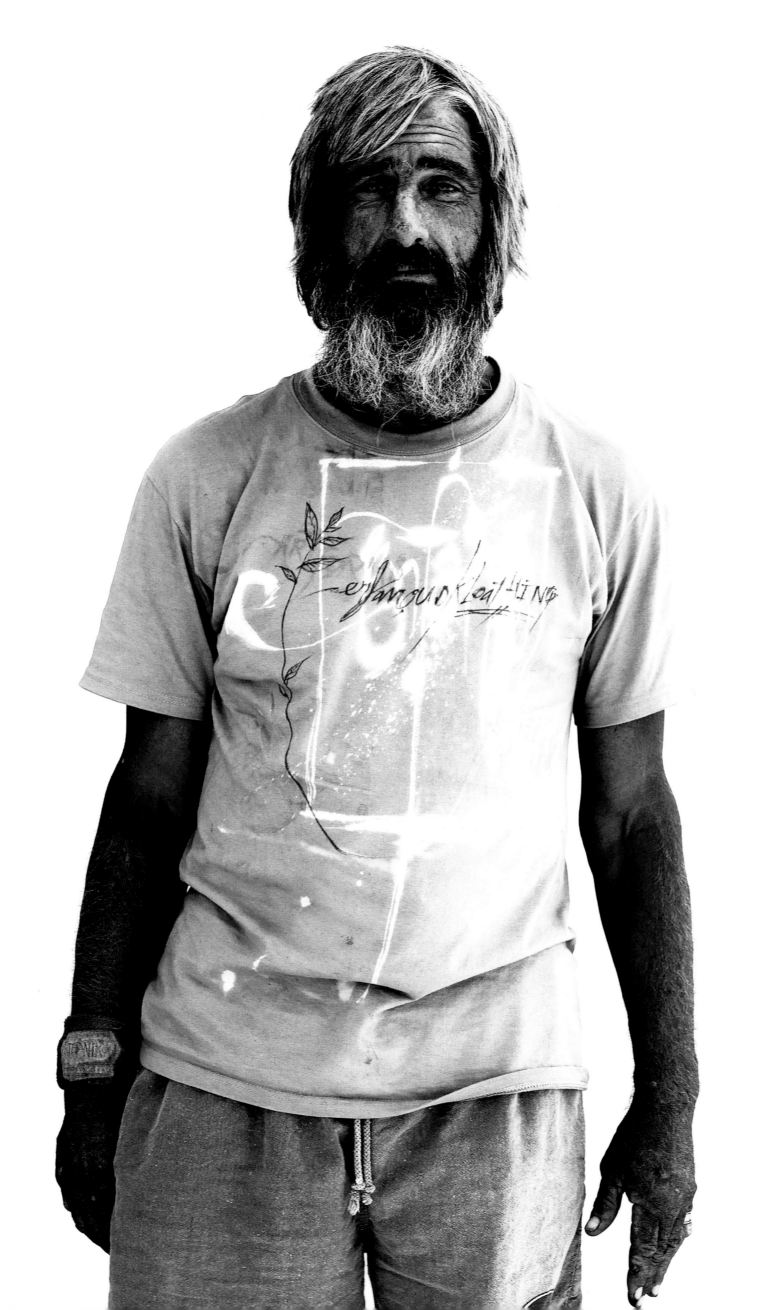

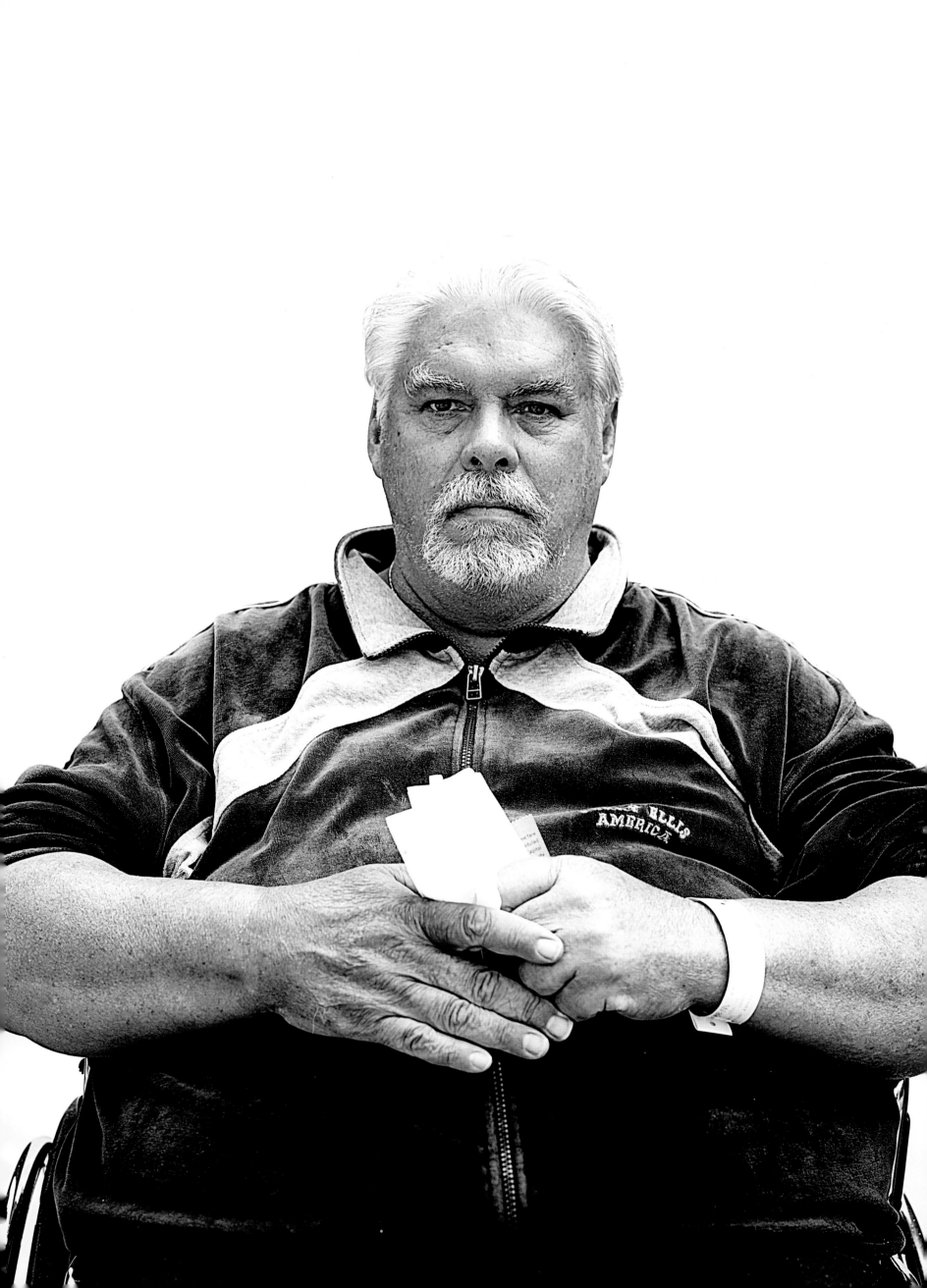

Rodney

Dallas, TX

The temperature was a hundred-plus and smoldering the day I approached Rodney. He was sitting on the sidewalk outside a locked homeless shelter, nodding in and out of sleep. Despite the oppressive humidity, he leapt to his feet, eager to help me. As Rodney set to work gathering people, I went in search of a place to hang a backdrop. The shelter turned me down. So did the business next door. Thankfully, across the street, I found a business owner willing to let us use his wall. He told me the shelter was locked during the day, no matter the weather. He'd spoken to the shelter operator about installing a garden hose to provide people with drinking water. When the shelter refused, the man installed a faucet for them on his own premises.

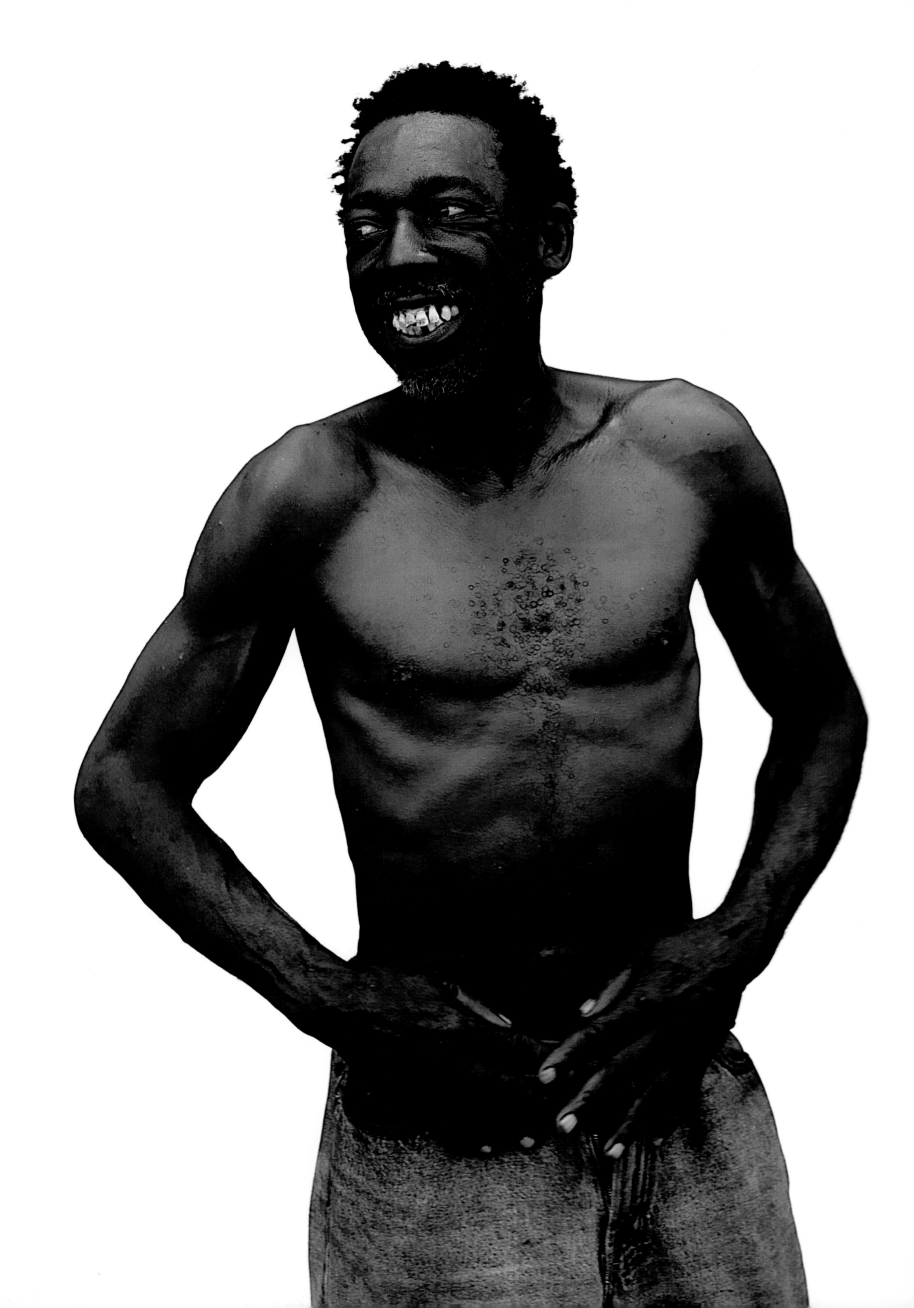

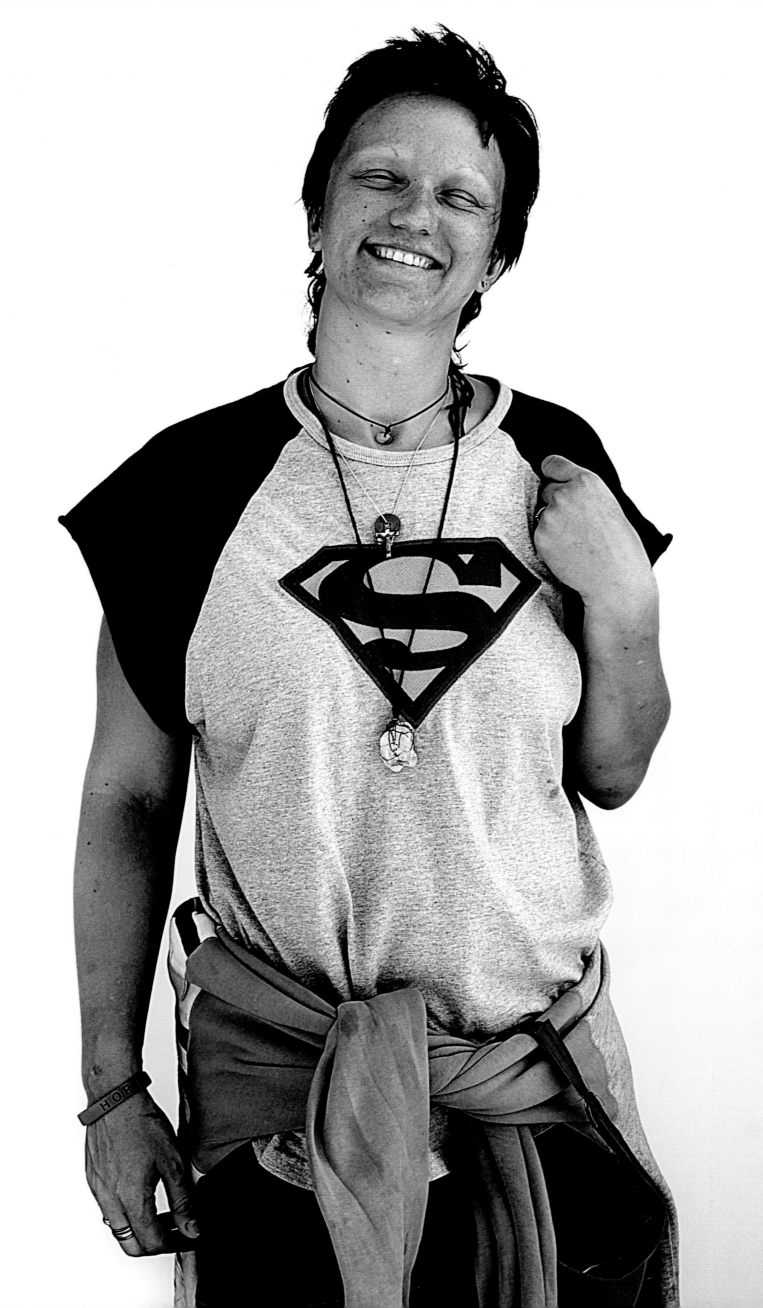

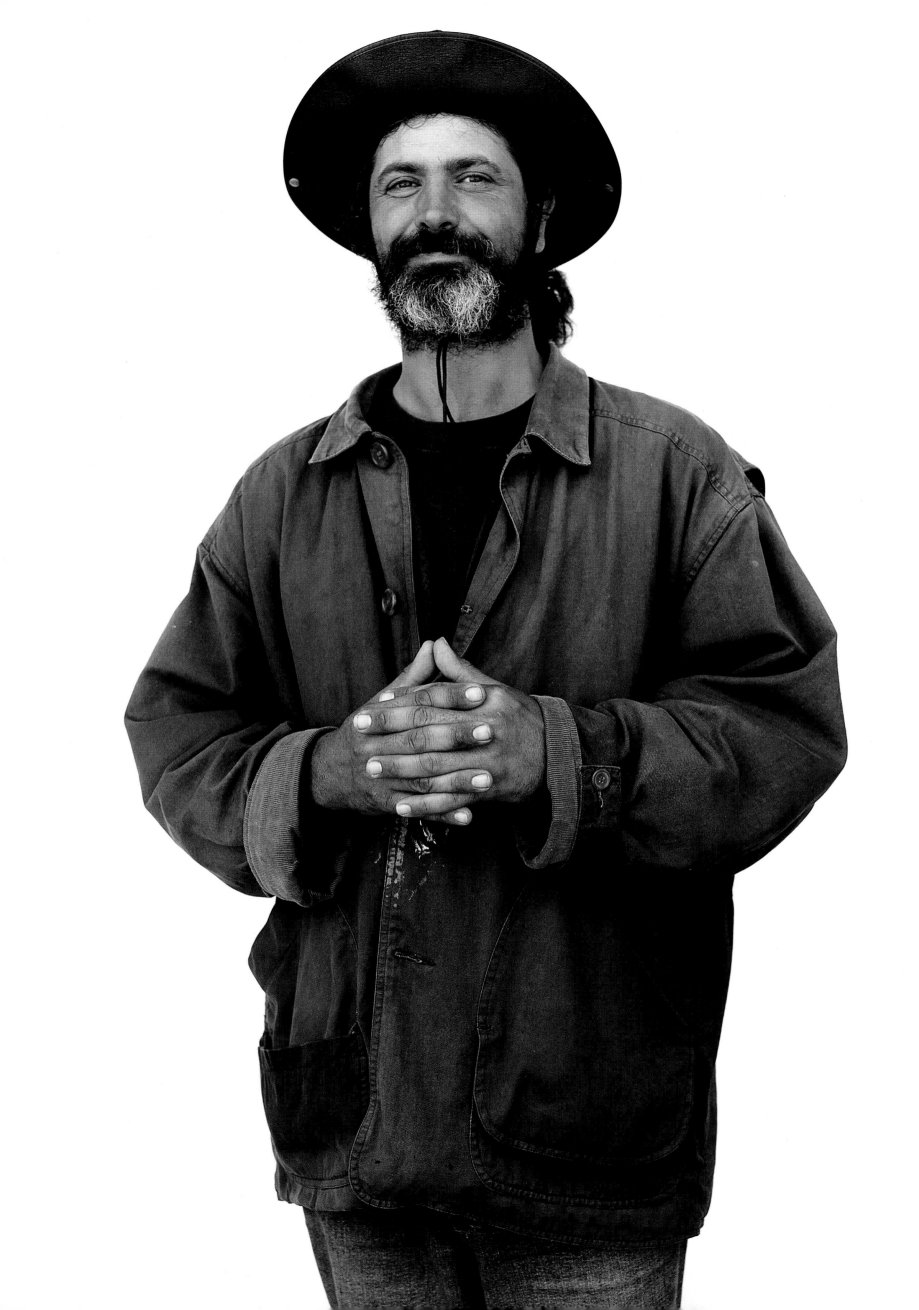

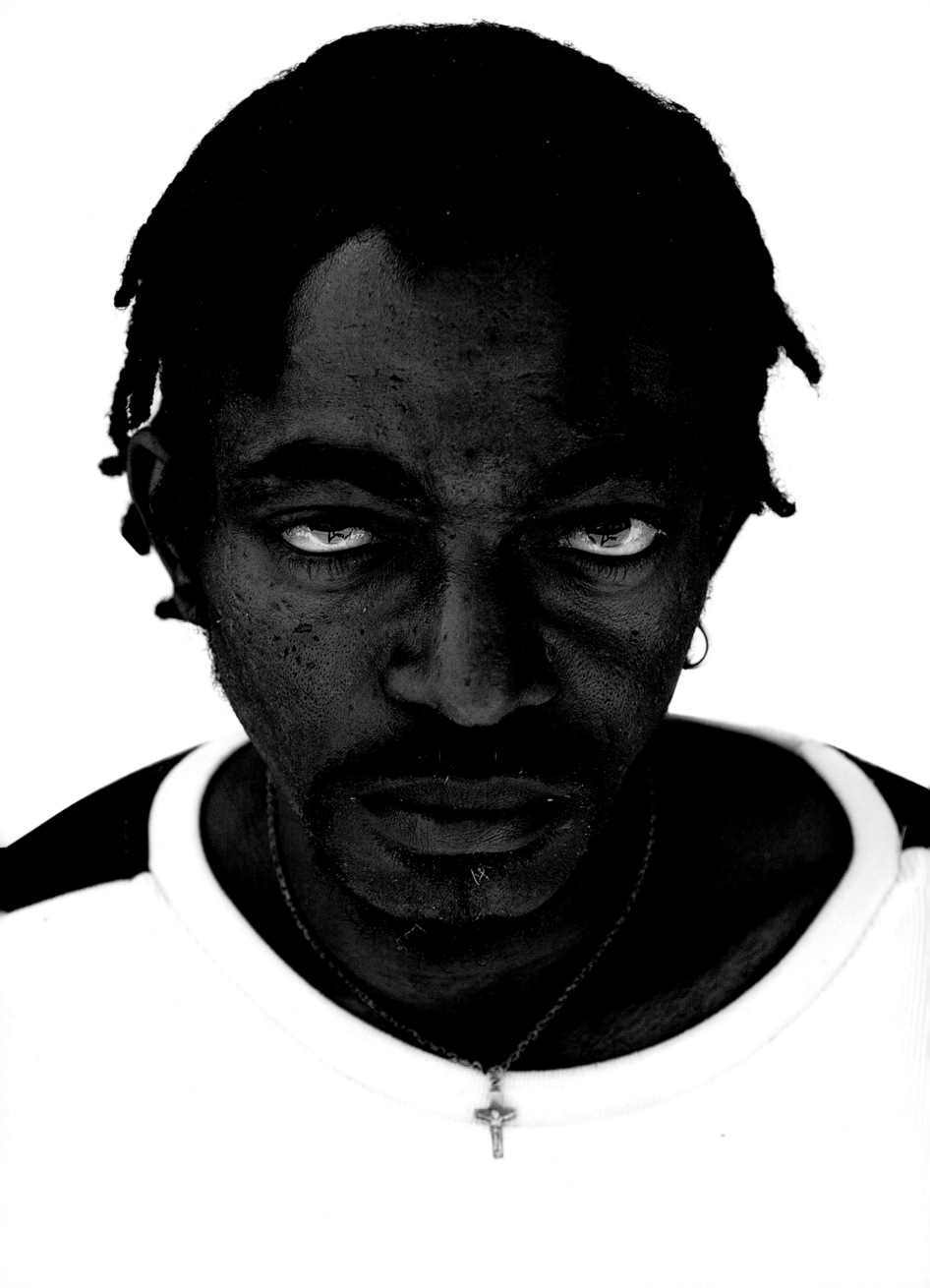

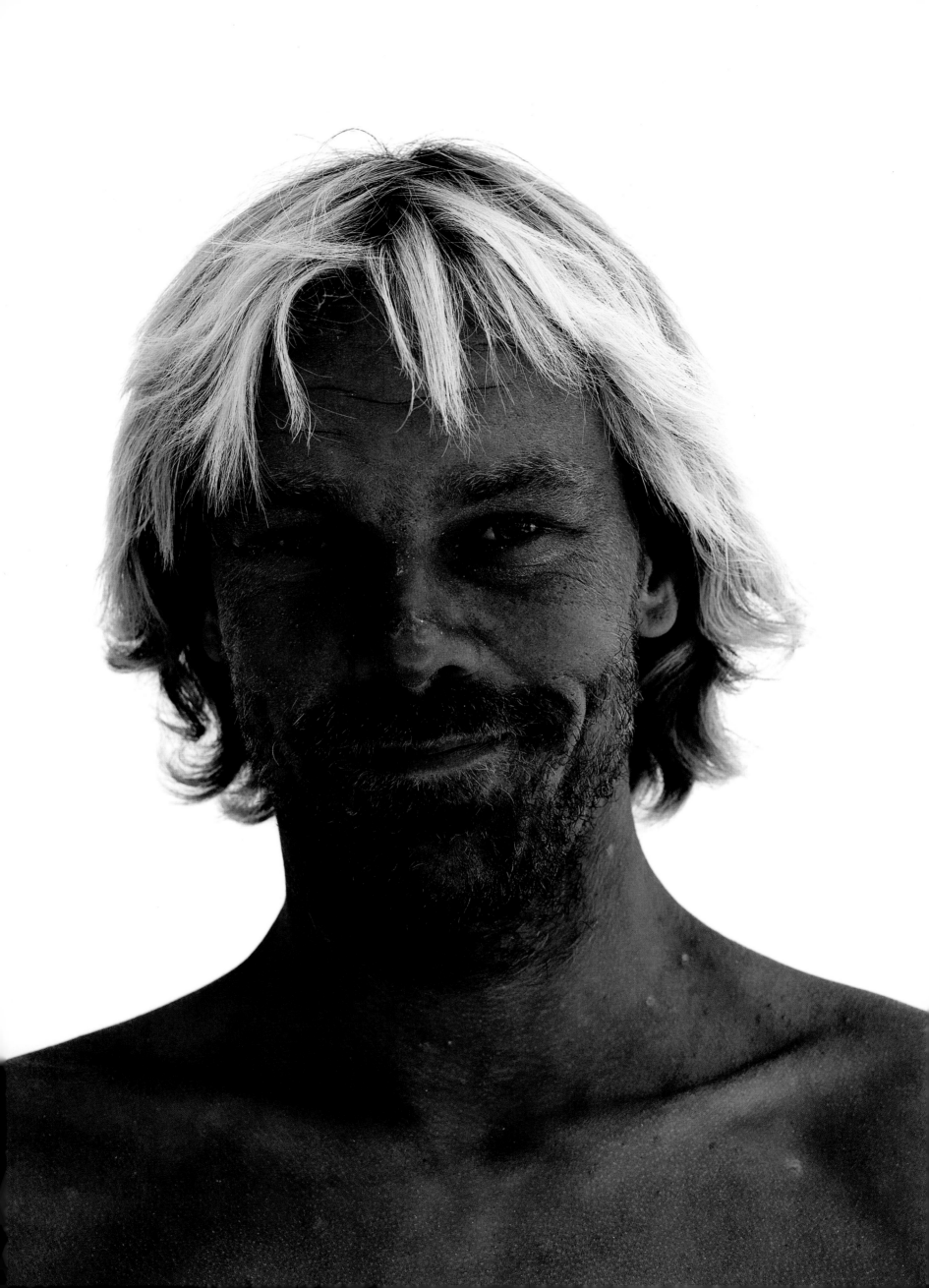

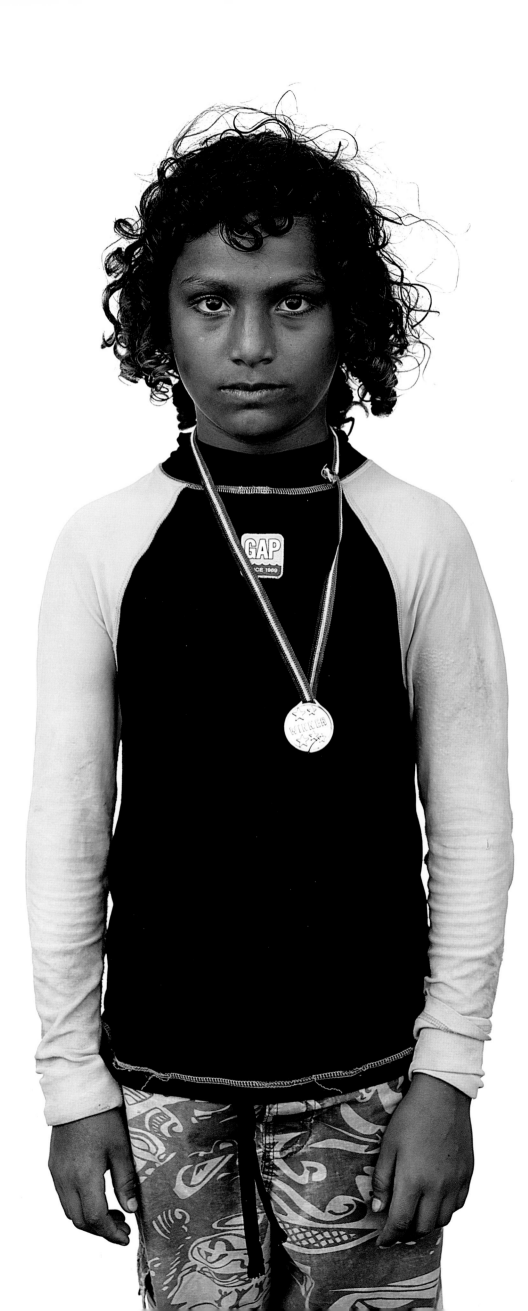

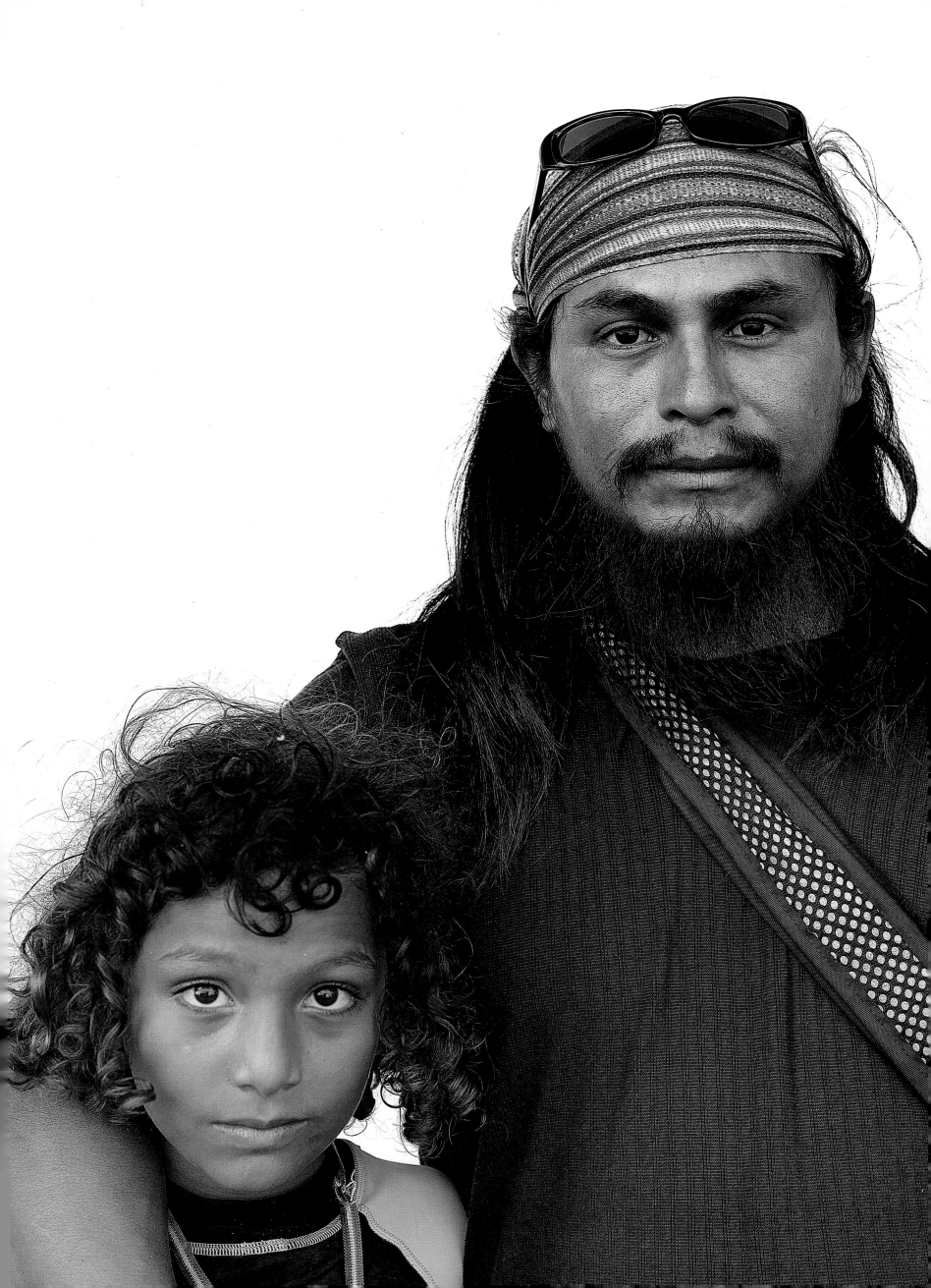

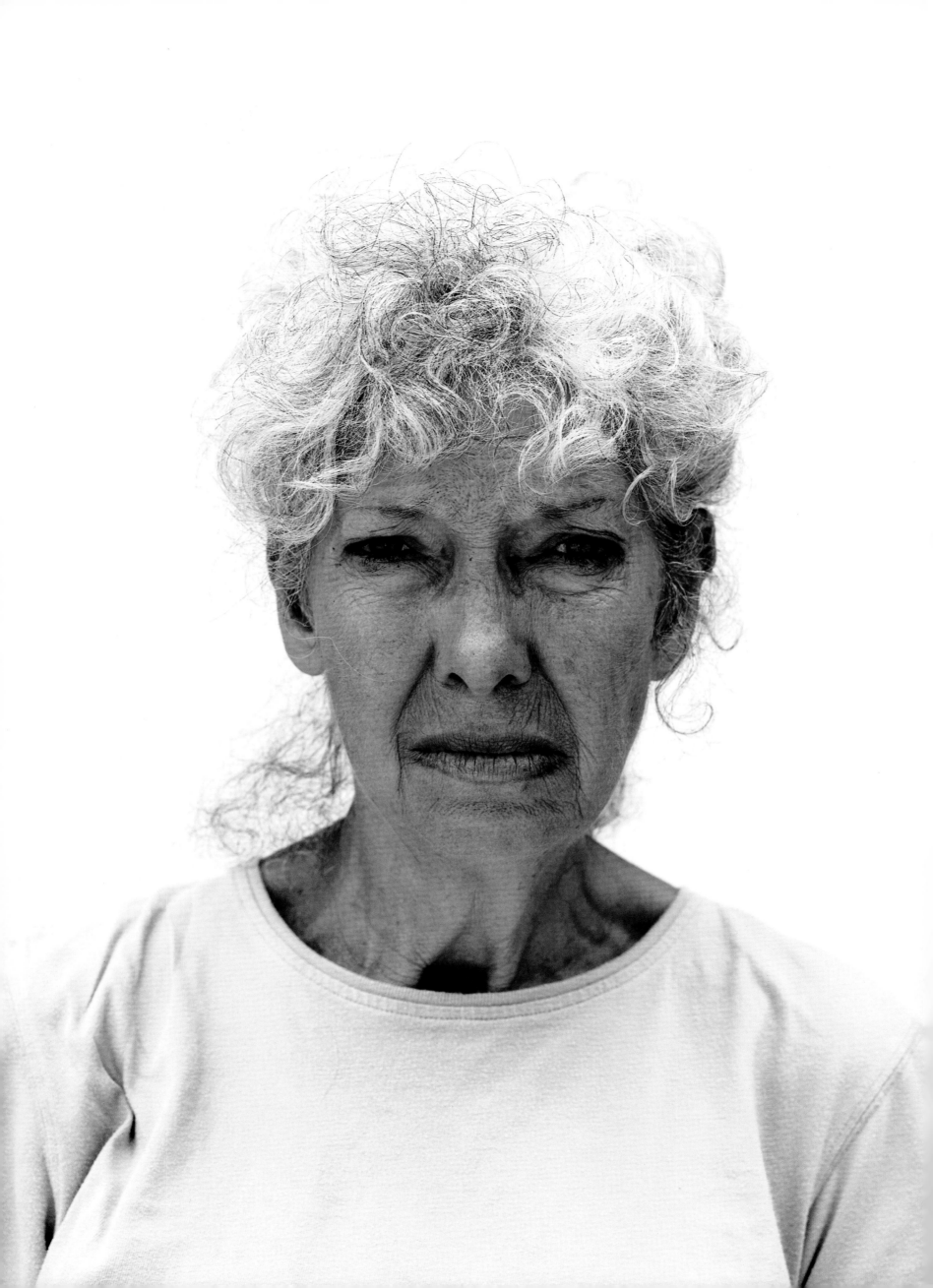

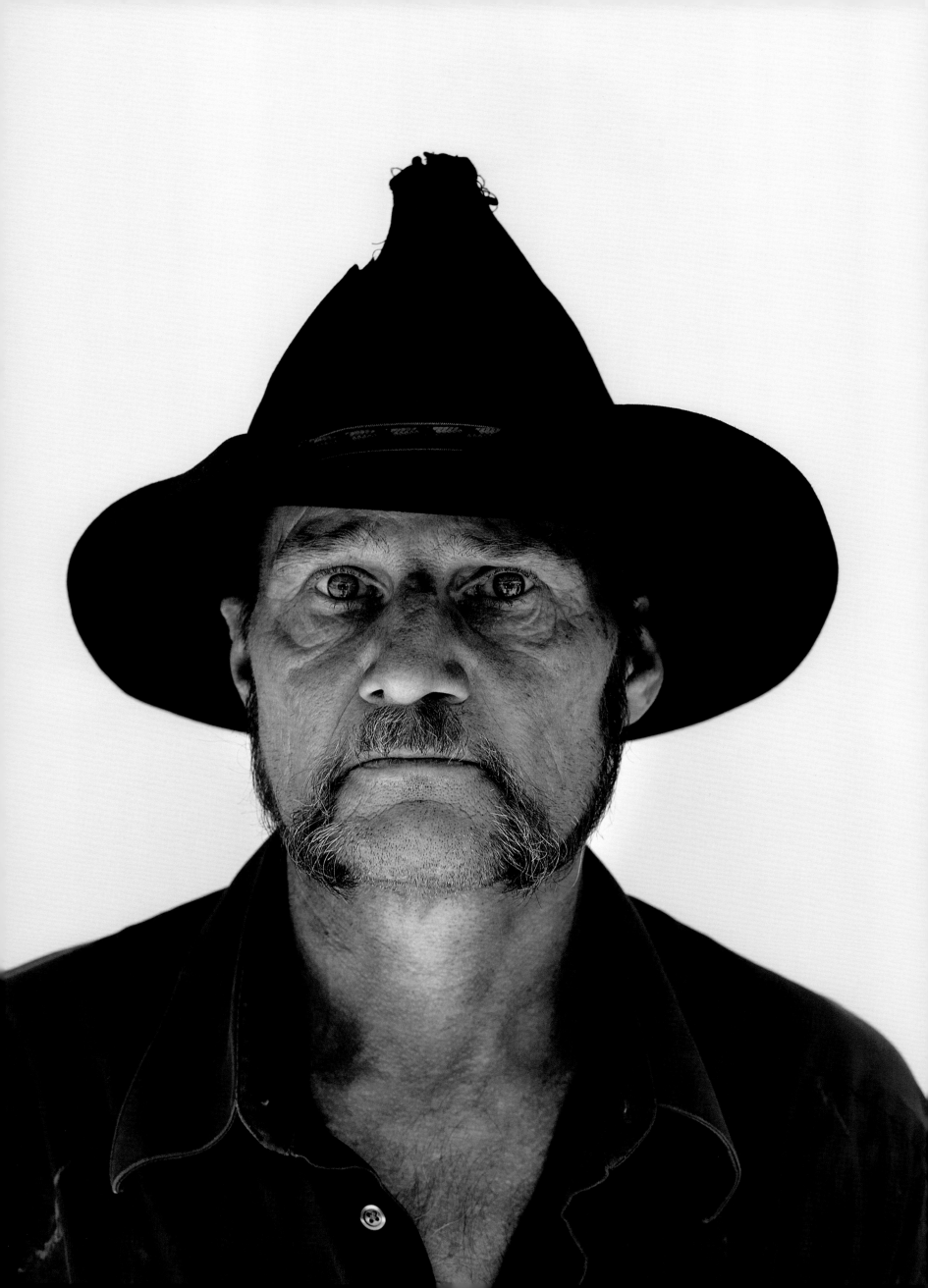

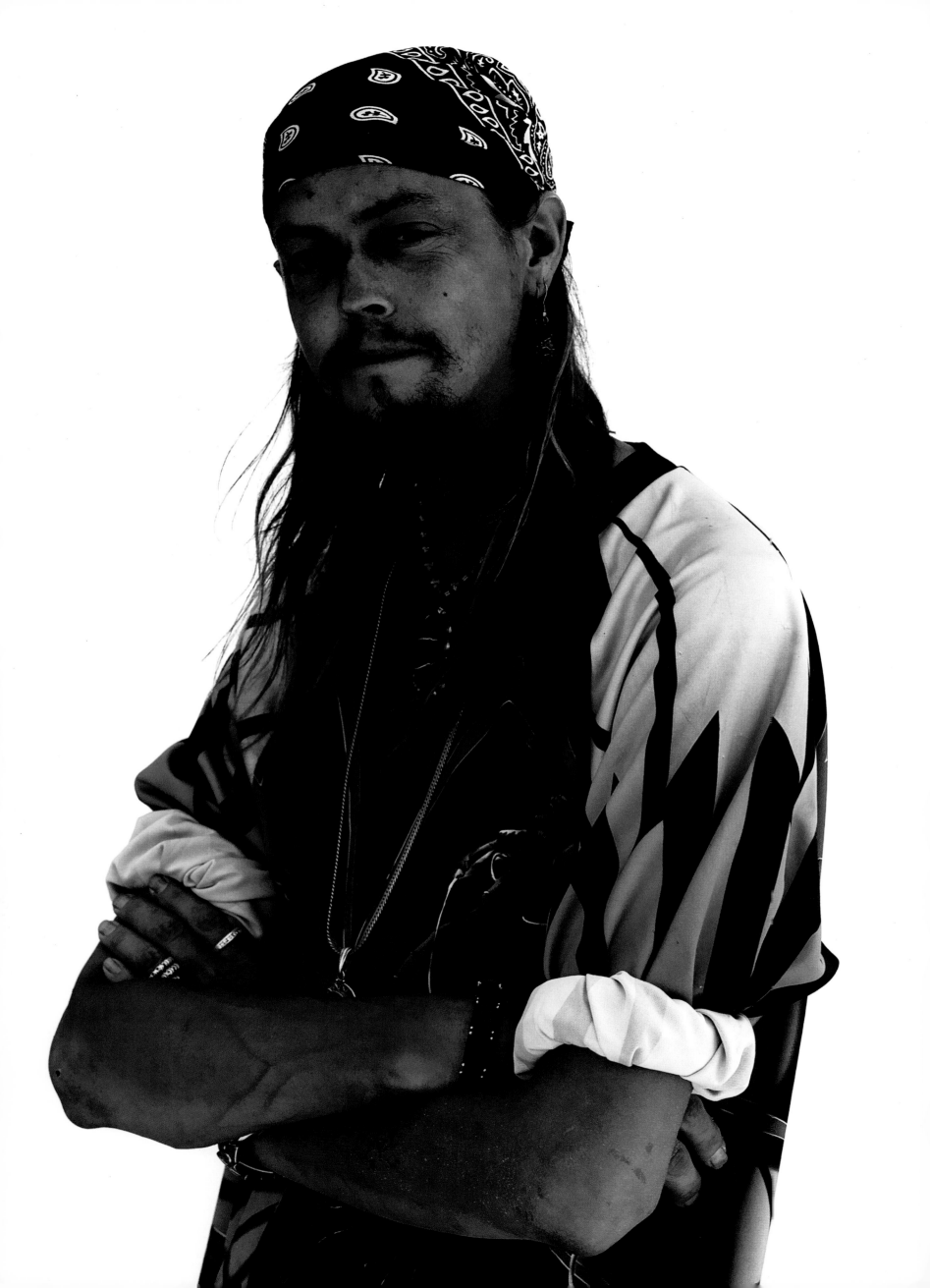

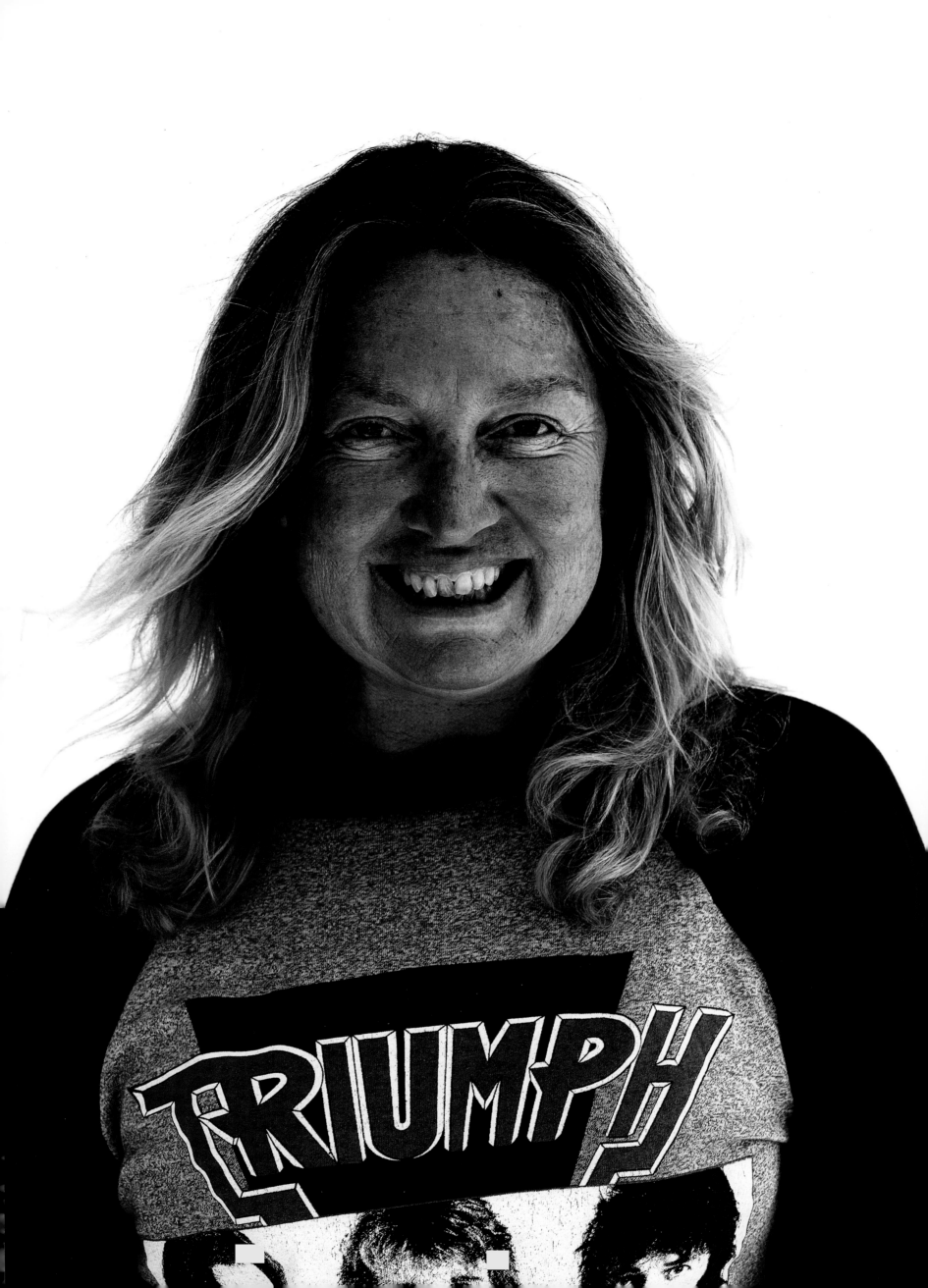

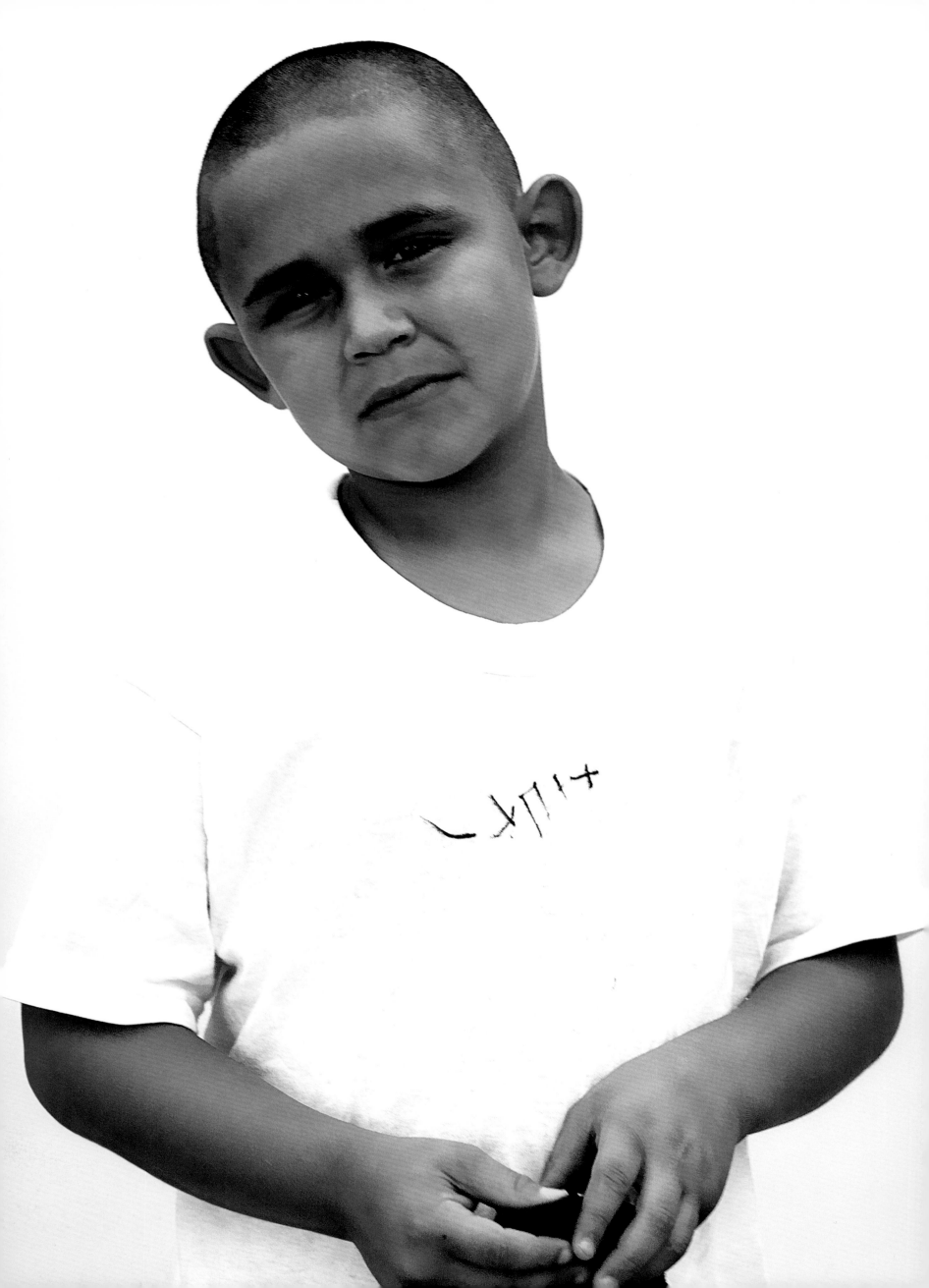

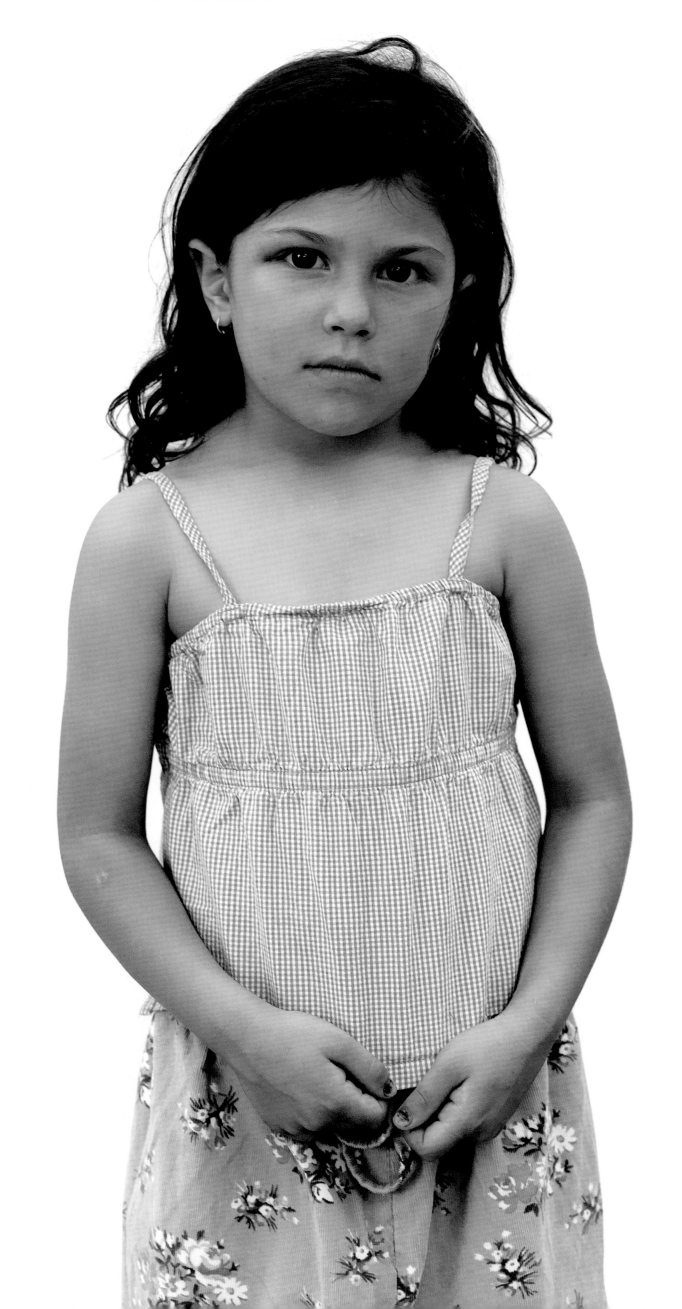

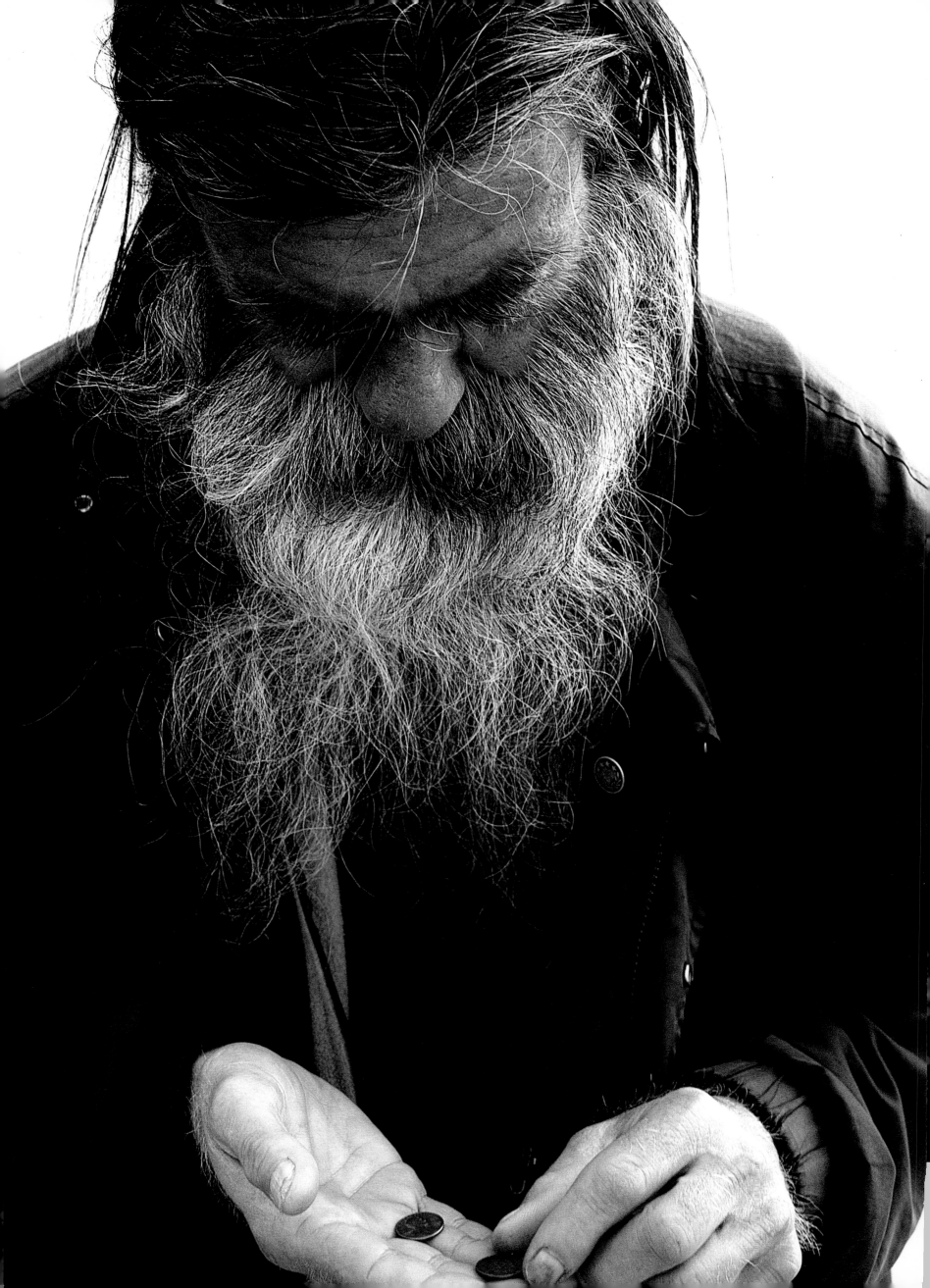

Ingo

Santa Monica, CA

I was drawn to Ingo. He had an honest presence, and his gentle eyes and gray beard gave him the look of a prophet. We talked quietly for a little while, and then he offered to show me his coin collection. He spread a half dozen pennies before me – each one old, lovingly shined and highly cherished.

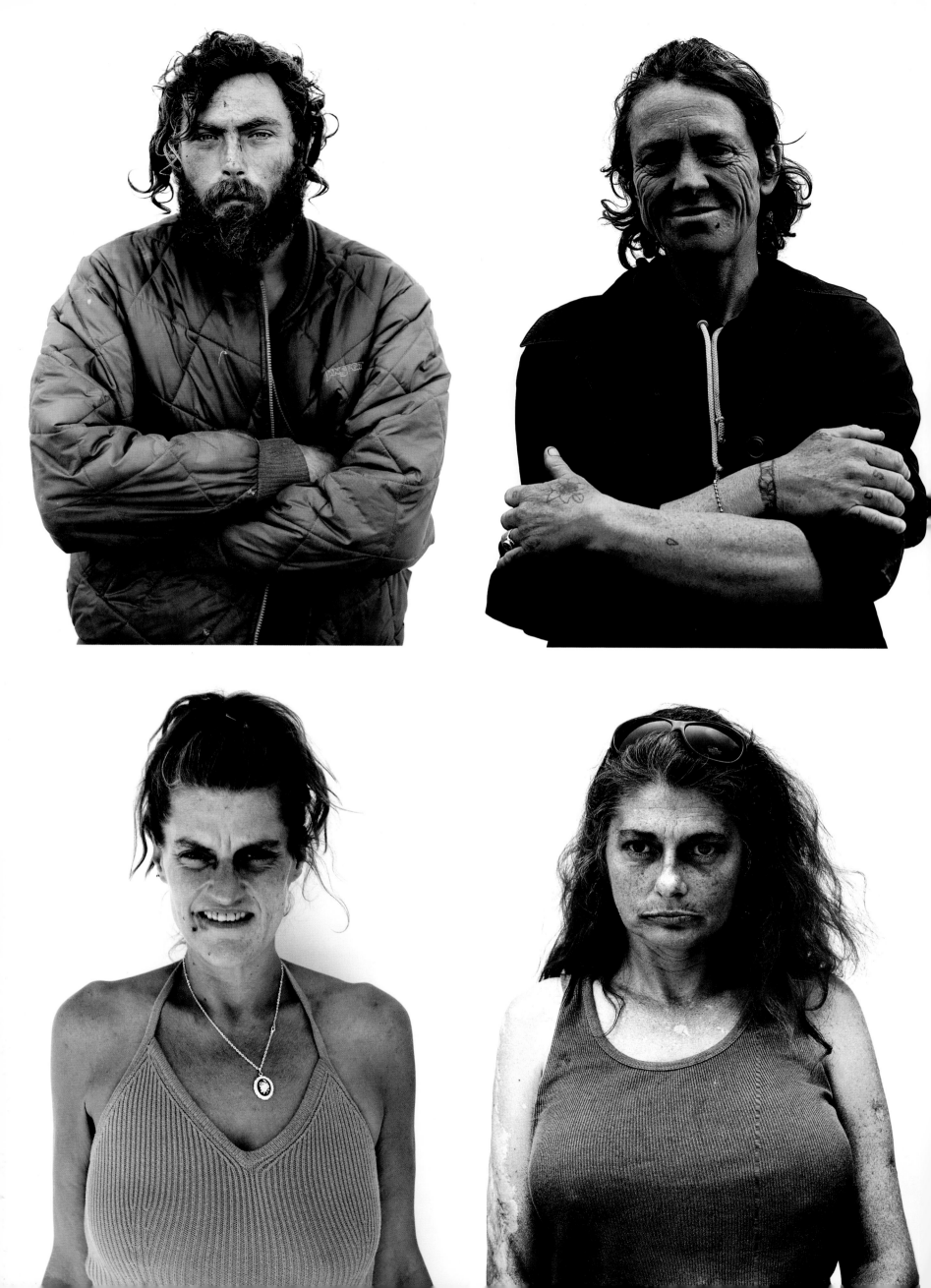

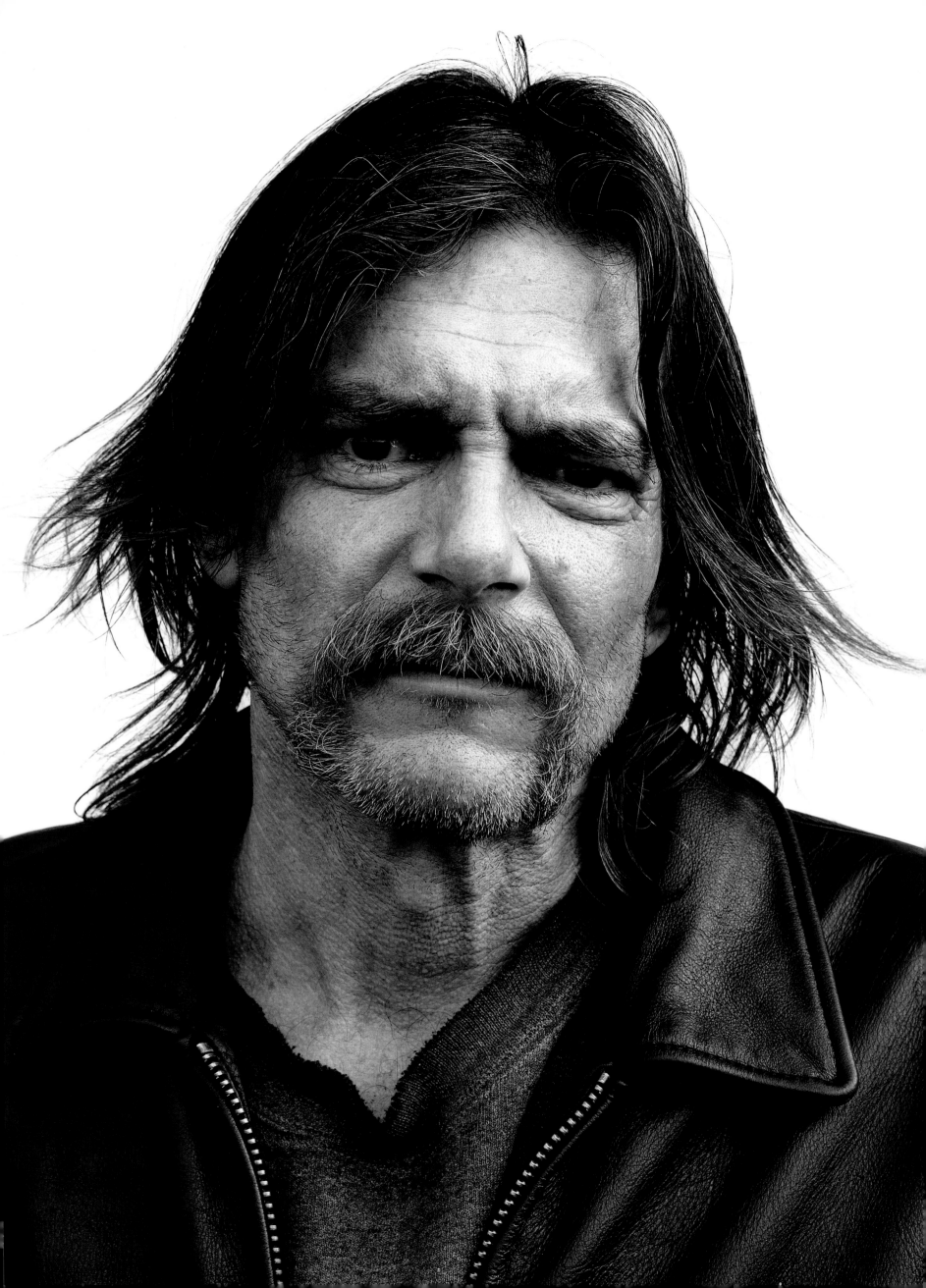

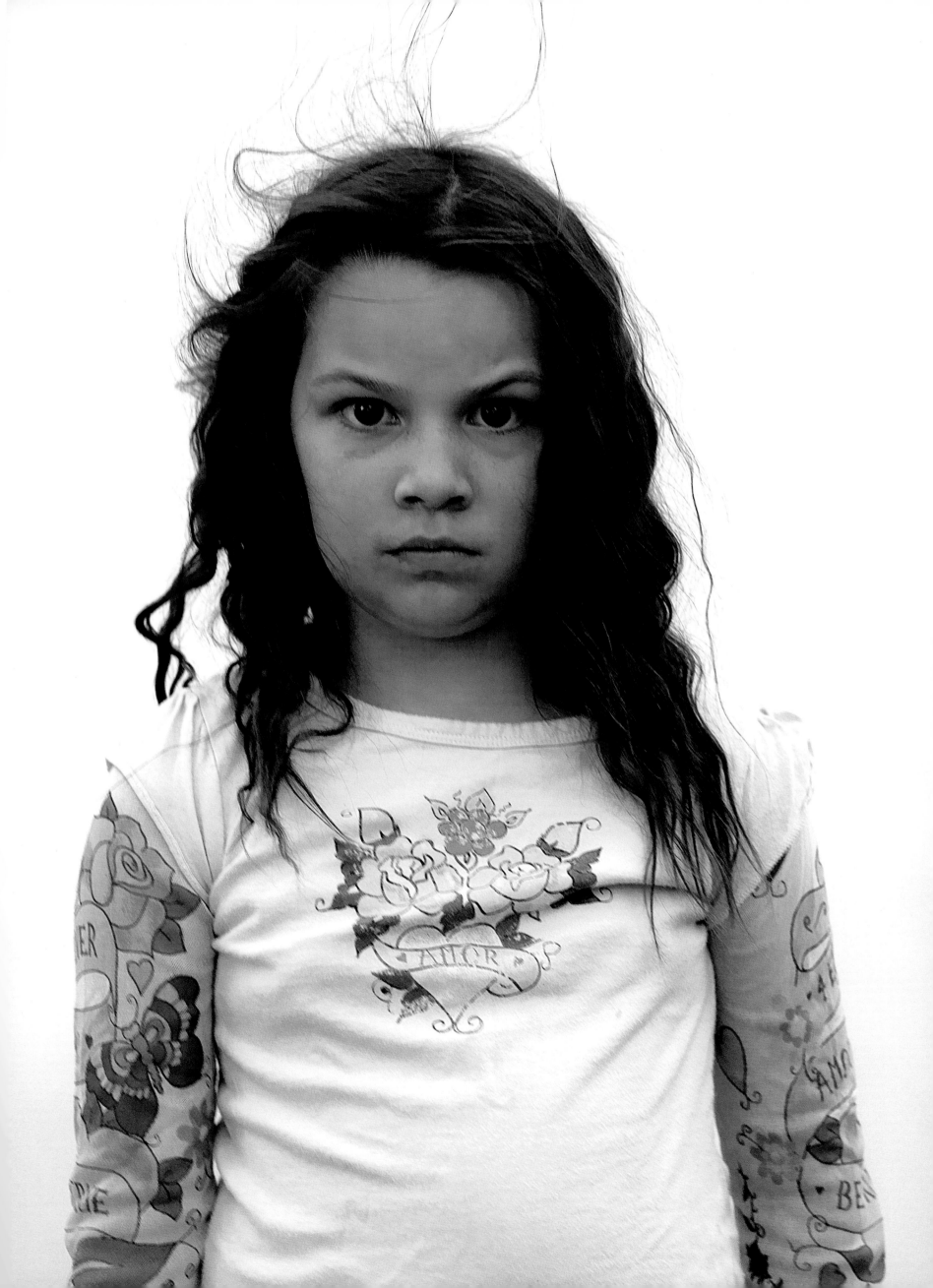

Jamie

Santa Monica, CA

Jamie looks like a typical teenager in this picture. But at 14, she'd already been homeless for over three years. Although she hadn't seen her mother at all in that time, today she was waiting for her mom to pick her up so they could have lunch together.

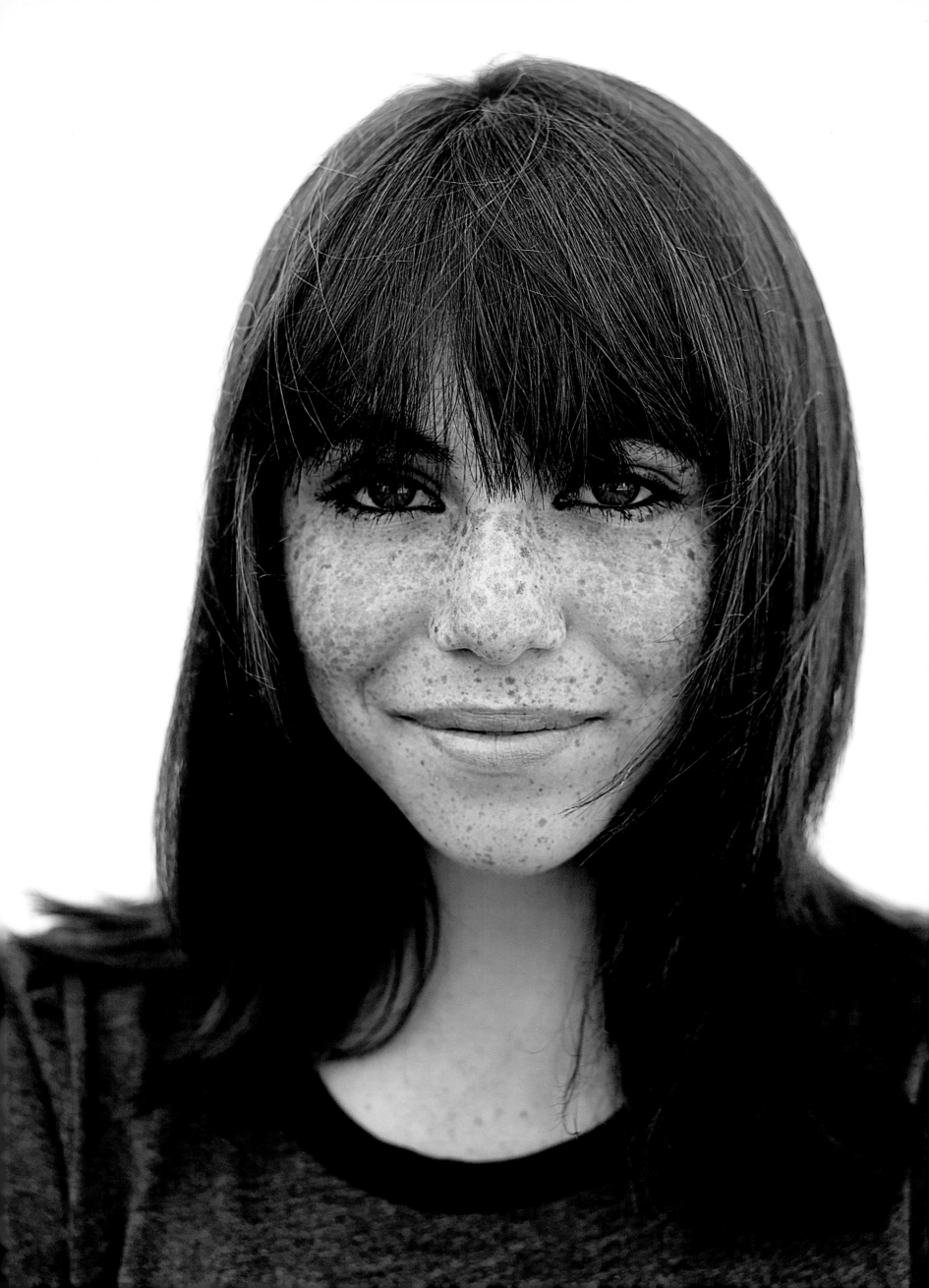

Barbara

Santa Monica, CA

Barbara's beautiful face, hair and countless bracelets were striking. Her long hair was pulled into a ponytail, red roses adorning the point where all the hair was gathered. As I photographed her, I moved back to try to capture her full presence. I worked quickly, five exposures, six, checking them in my camera's digital display. They were beautiful but not exactly "her." How could I convey Barbara's character? I suggested that she hold her hands up before her throat and knew instantly that I had an unforgettable photograph. Months later when I encountered Barbara again, the roses and all but a few of the bracelets were gone. She remembered me, but when I offered to show her a print of her photograph she refused, explaining that she was a little superstitious and would rather not see her picture.

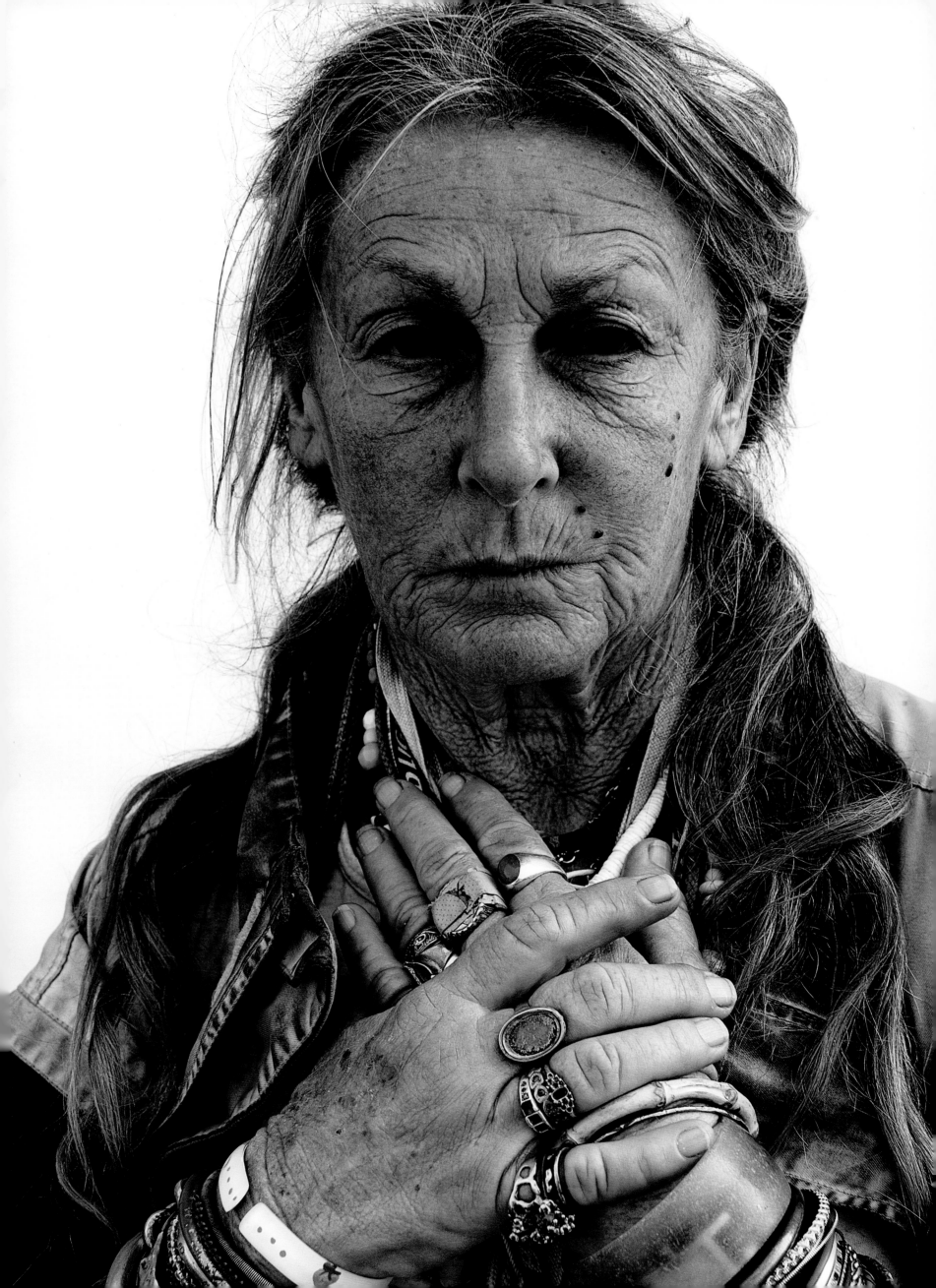

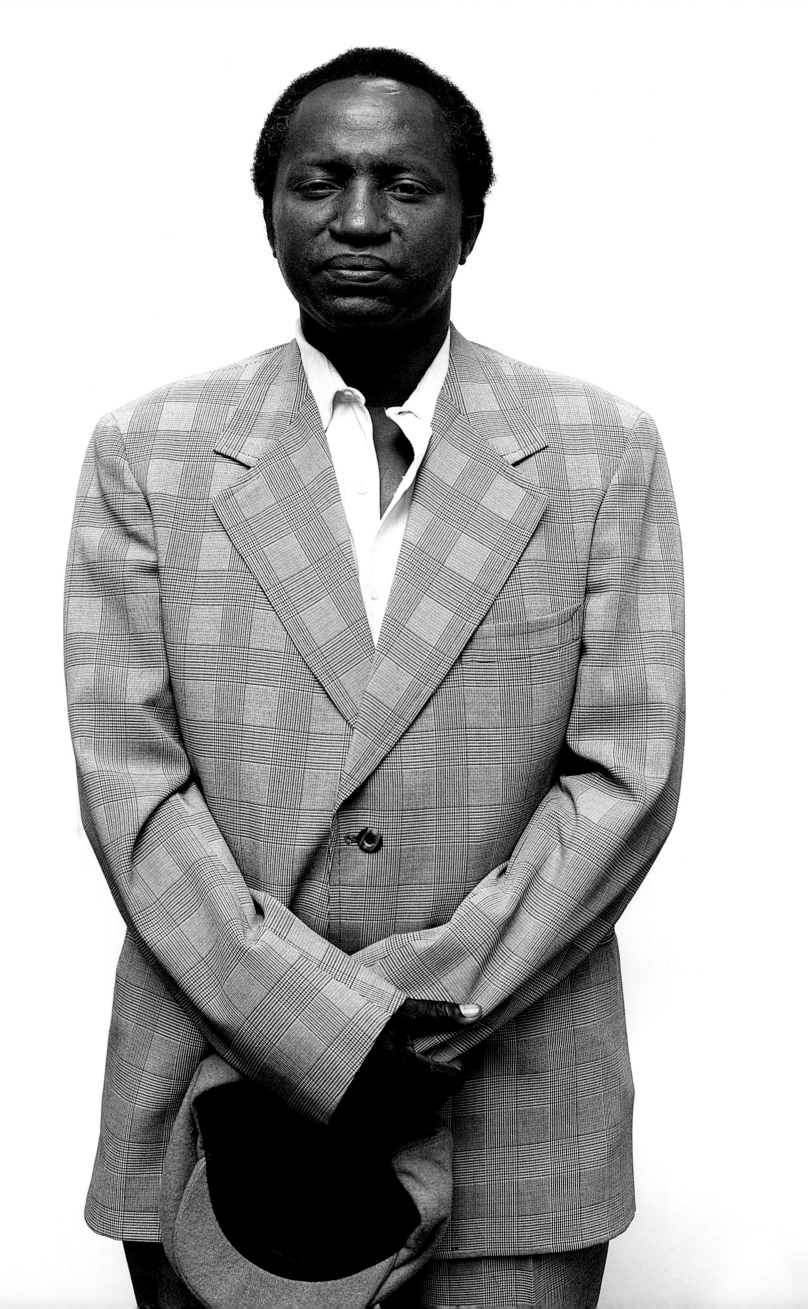

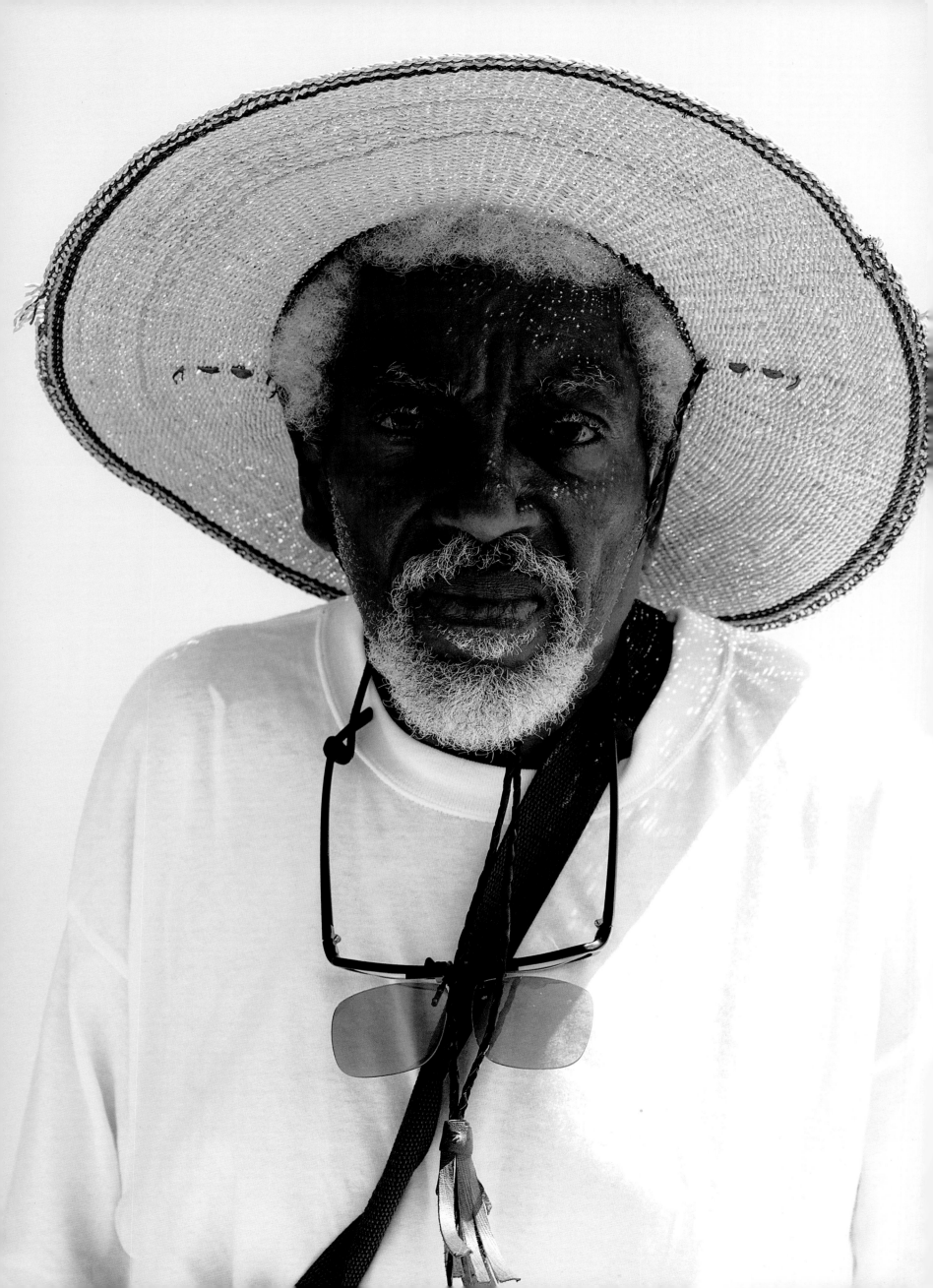

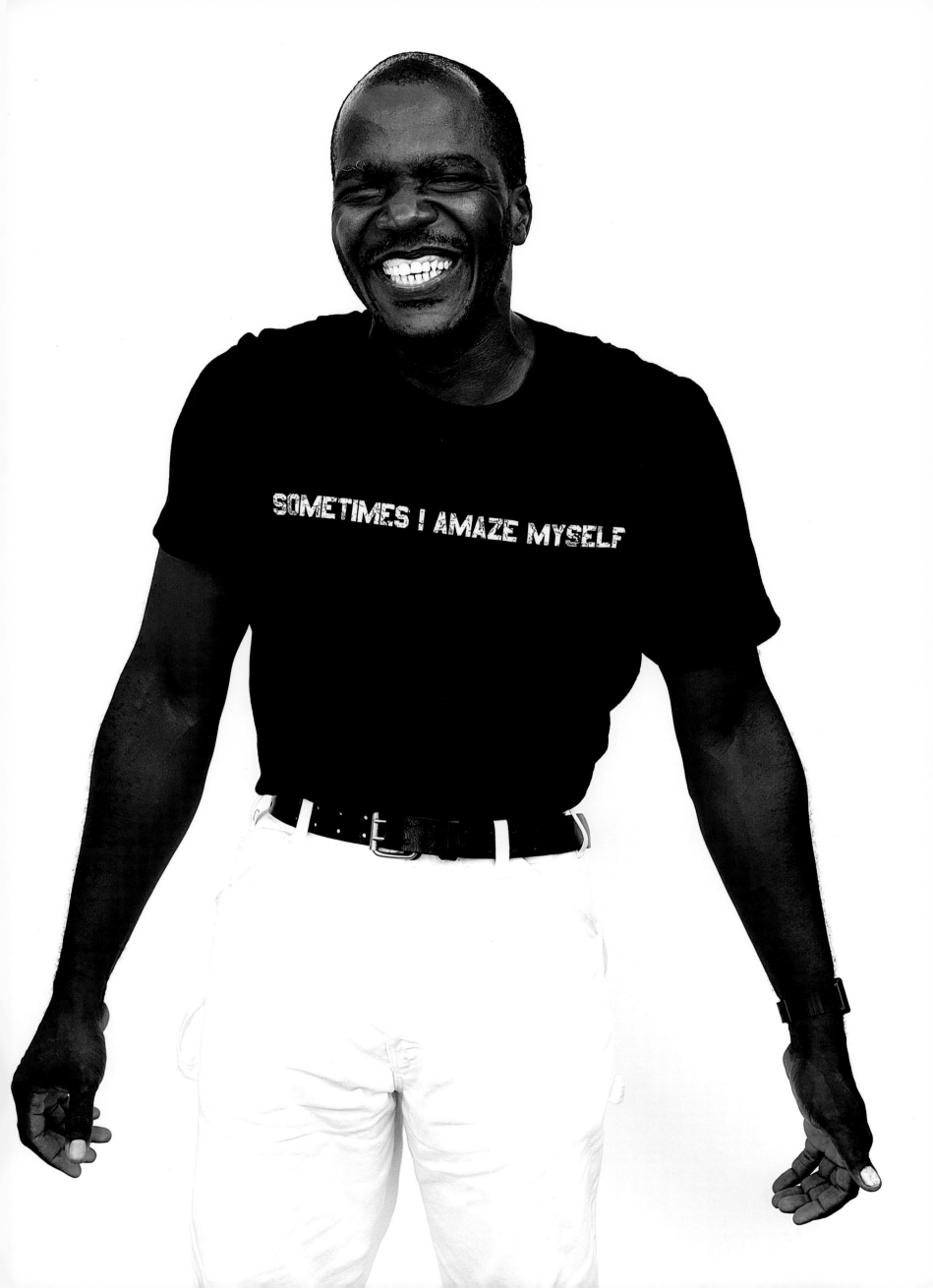

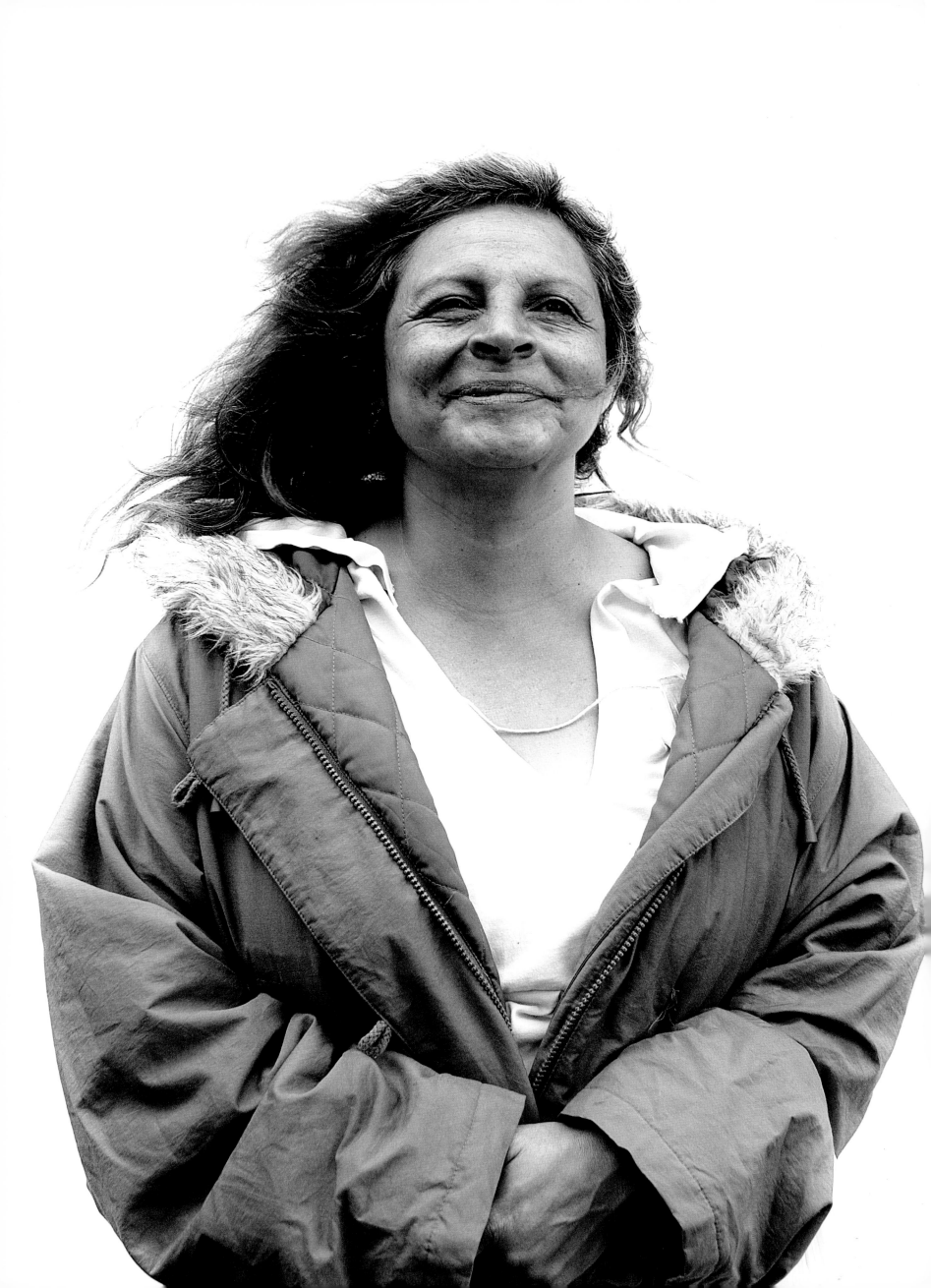

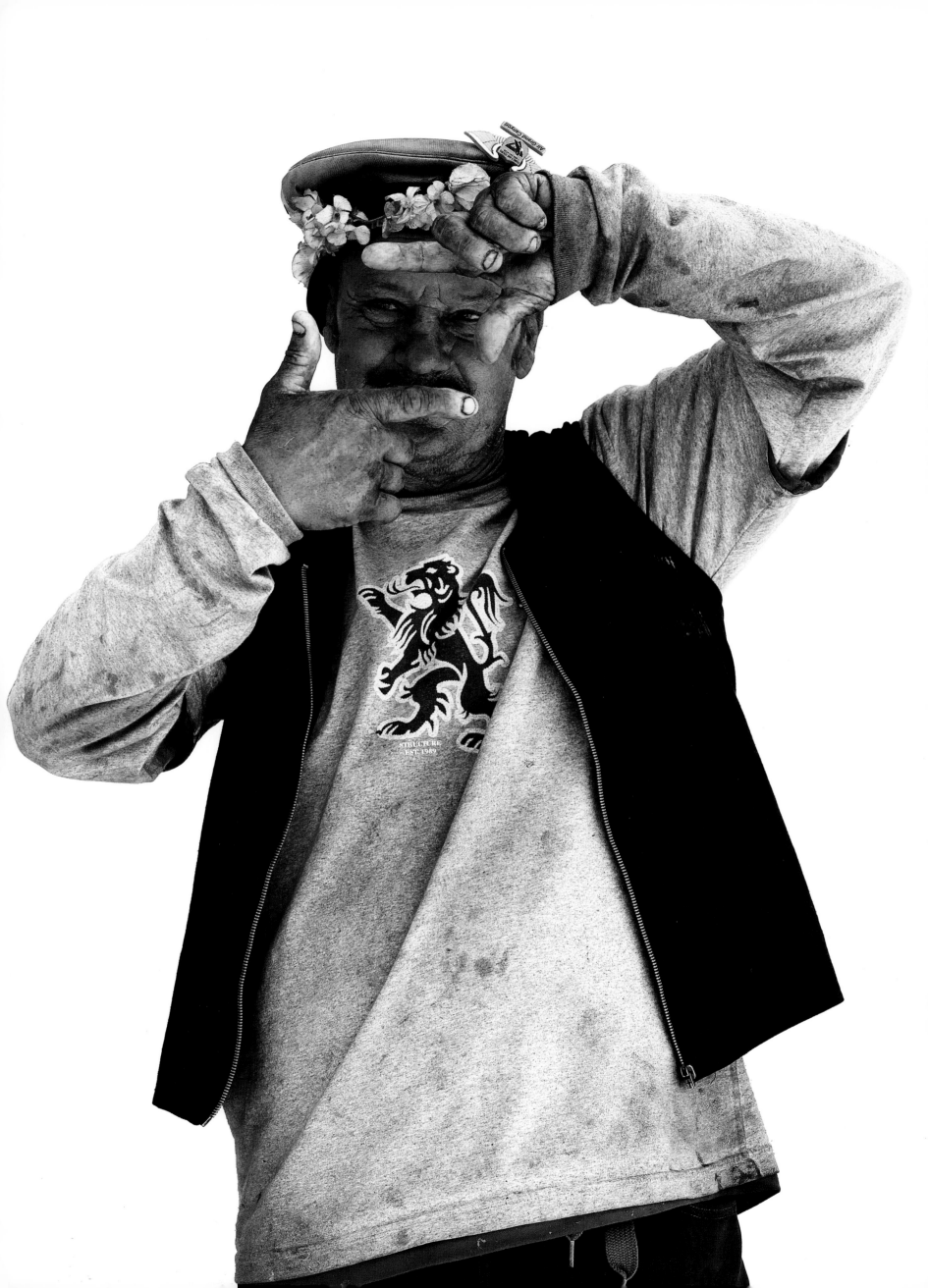

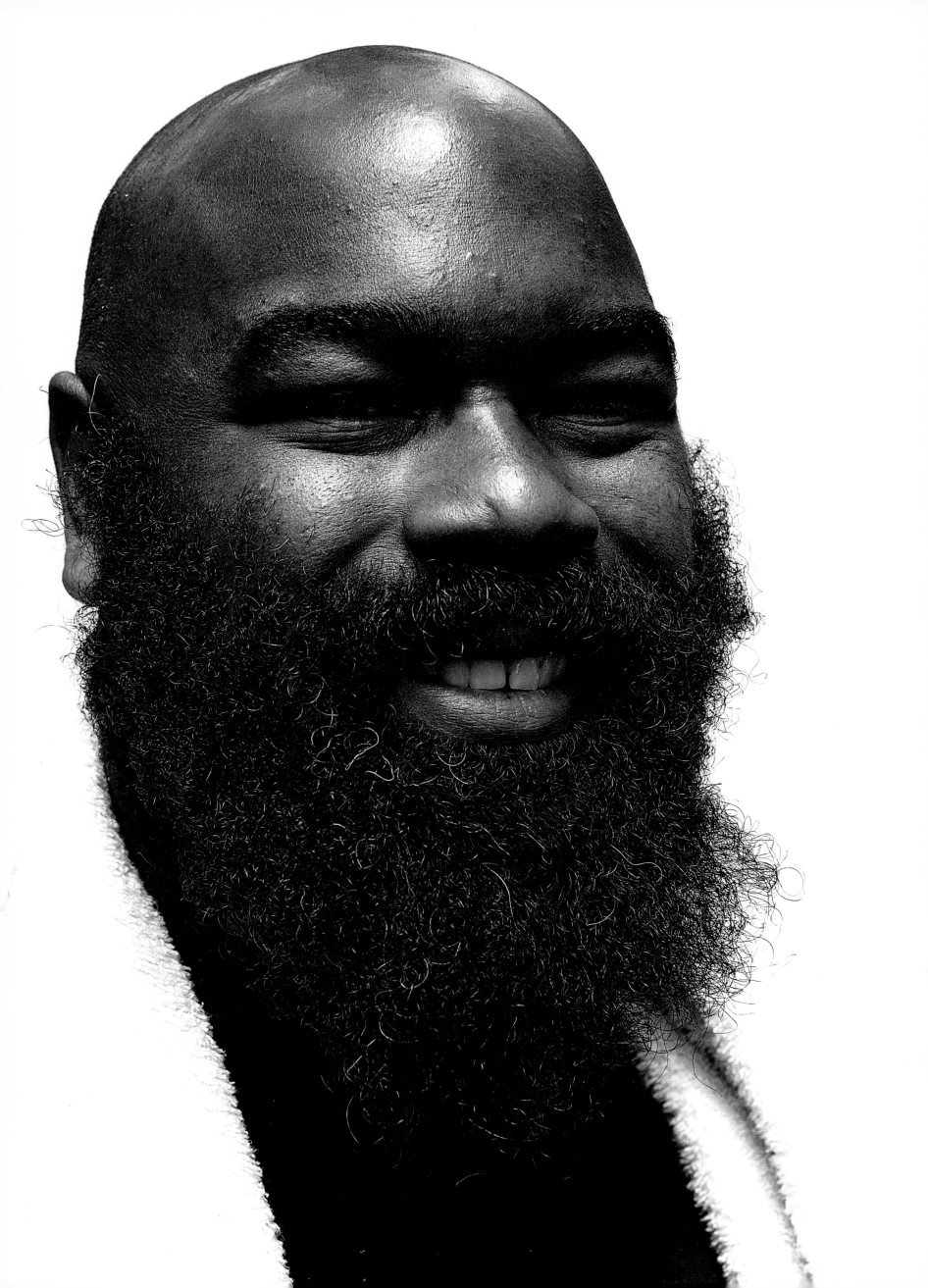

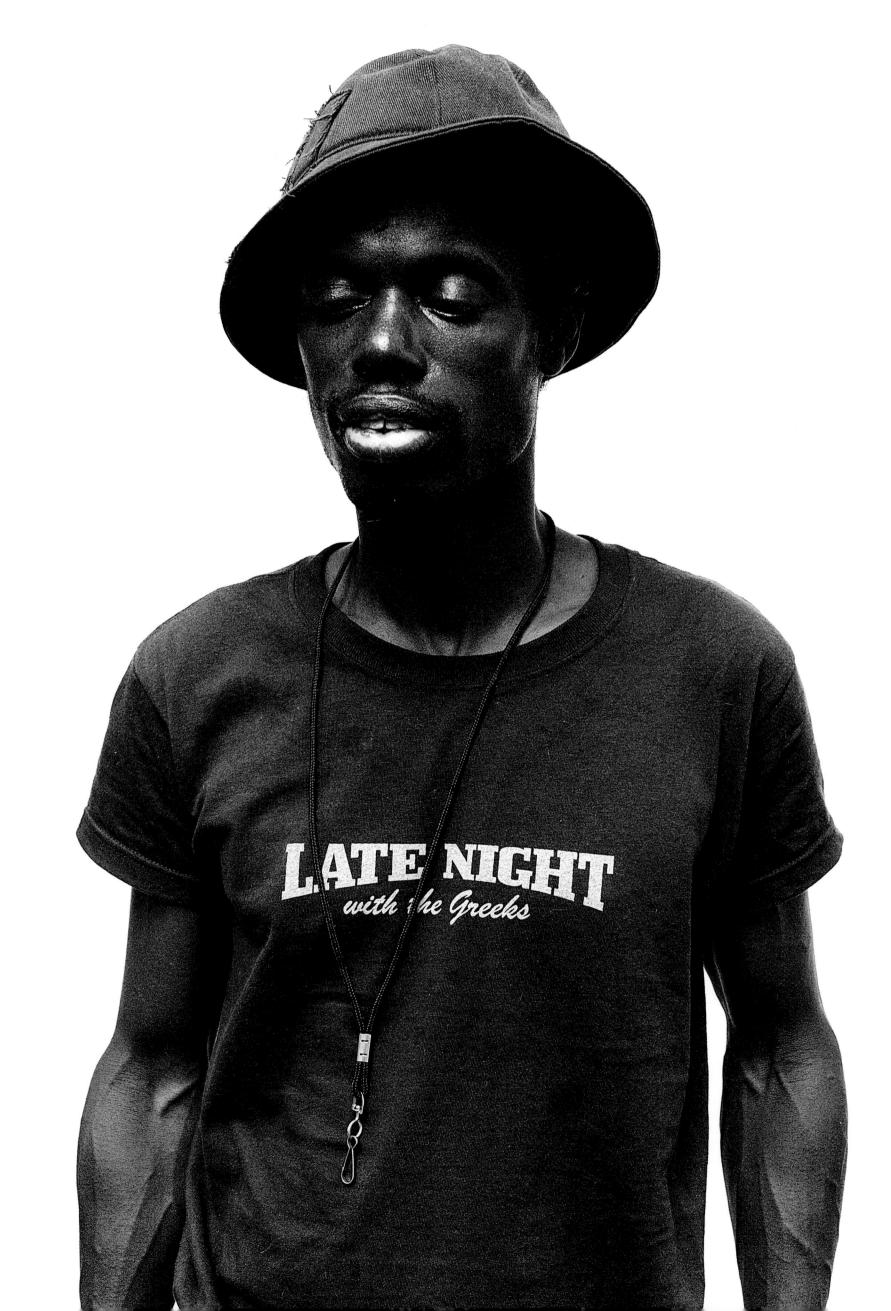

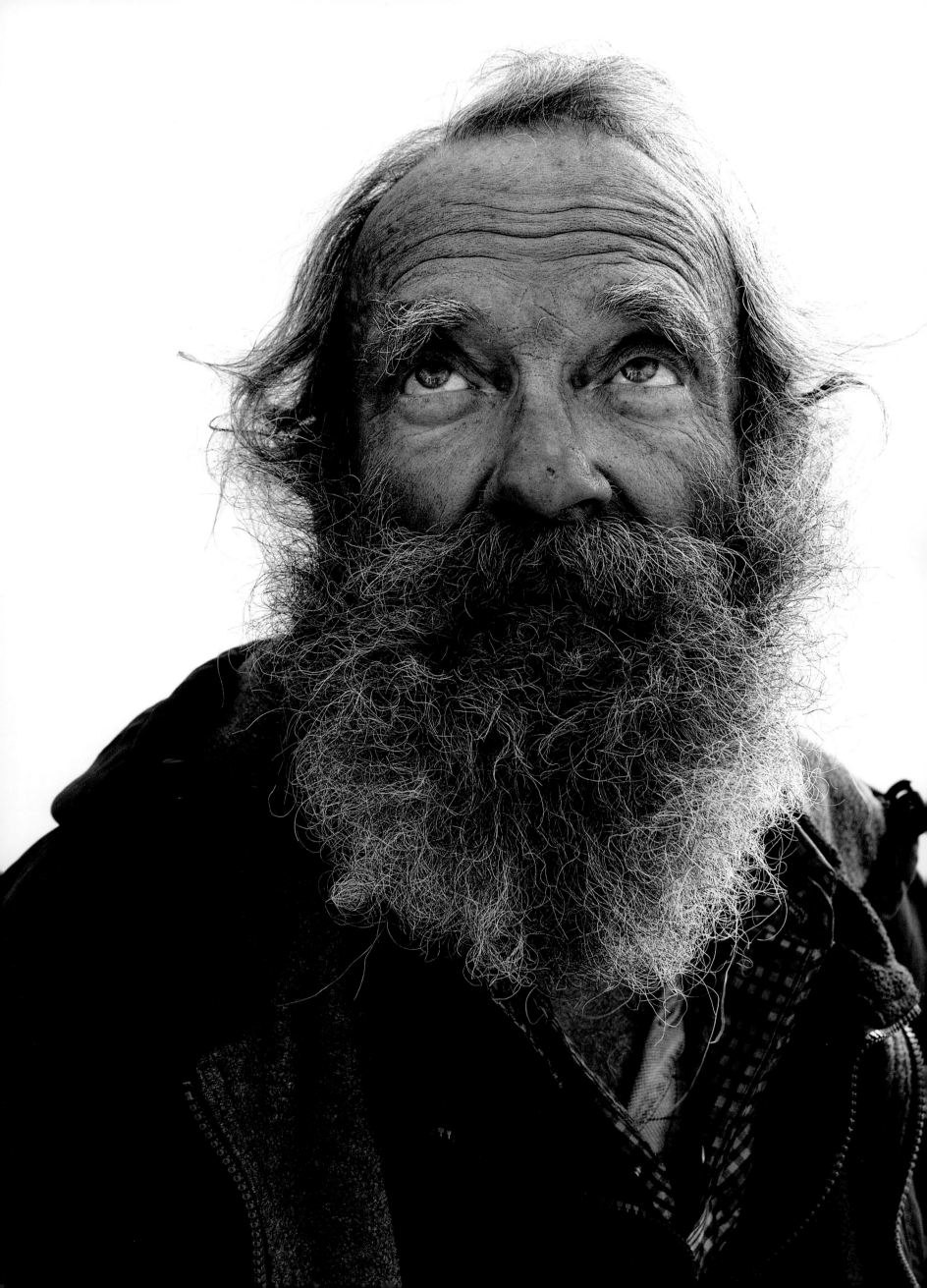

AFTERWORD

Robert Gonzalez had good reason to ignore my knock on his door. Instead, he answered. Confronted with his toothless mouth and the jagged black stitches patchworking his face, I faltered as I asked permission to photograph the boy beside him. Though I didn't recognize it at the time, that moment in 2002 was the beginning of the book you now hold in your hands.

I began taking photos in my teens. With eight siblings, there was always someone willing to strike a pose. I came from a large family of modest means, and our home was small. Fortunately, I was able to set up and fund a darkroom in the basement, where I developed my fledgling black-and-white images. By 2002, I was shooting at every opportunity, but now the lenses were the best available and the output digital. I made a good living in an entirely different field, and I had never pursued a career as a professional photographer. That didn't stop me, though, from signing up for one of the world-class Santa Fe Workshops.

In Las Vegas, Andrew Eccles gave us our first assignment. Two photos. I had to discover and make contact with subjects in the streets then tell a good story in two photos. I began to walk. One thing was obvious – many townspeople were struggling financially. And on that cold February day, it looked like they were losing the battle. A sad woman stood in the street, her purse open and barren. I felt that the theme for my photo assignment had chosen me and was unfolding before my eyes.

I kept walking until I stood in front of a mini trailer park. Four rundown homes that would never again be "mobile" sat midstream in the familiar jetsam of poverty: junked cars, discarded batteries and accumulated trash. It was the child's bicycle lying on the ground that caught my eye. Faded and rusting, it was still in use. The sagging door opened to my knock. Robert Gonzalez and Robert Jr. stood gazing back at me through the screen. The nine-year-old posed shyly, but his words for his disfigured dad were filled with pride and love. He described the horrendous auto accident two years earlier and the surgeries that followed. Hoping that my photos would convey some sense of their situation, I asked Robert Sr. if I could also photograph him. He immediately turned and walked away.

I watched his retreating back, horrified at having offended the man and uncertain how to repair the damage. I turned to leave. Just as I reached the sidewalk, I felt a tap on my shoulder. Robert Sr. was still too damaged to speak, but his message was clear. He had placed a small, gold cross around his neck. He held a ceramic statue of Jesus Christ level with his heart. In that moment, Robert Gonzalez forced me to really look at him – to see his faith and beauty. Unknowingly, he dared me to become a photographer worthy of him. Silently, I accepted the challenge.

Following my experience in New Mexico, I began taking cameras on my business trips. I travel constantly for my job, and when my meetings in Los Angeles, Dallas, Salt Lake City or Washington D.C. ended for the day, I would find and visit a local homeless shelter. I quickly learned that there are wonderful and successful shelters providing warmth, safety and a respite from the street. There are also "shelters" plagued by predators who range from bureaucratic to violent. I realized that if I wanted to take meaningful photographs, I would need a different venue. Over time, a process for taking these portraits evolved that I still use today.

My first step is to locate a shelter, but I do not set foot inside. Since nightly entry is on a first come/first served basis, there are usually homeless people gathered outside. These are the people I want to meet. I drive by, looking for a wall or fence large enough for an eight-foot tall sheet of seamless paper. I return on foot to the vicinity of the shelter – cameras, backdrop and cash in hand. I've become very adept at singling out the person who will act as my assistant for the hour-long shoot. I hire him or her and hand over a stack of release forms. I ask my assistant to find, line up and get signed releases from thirty people. Each will be paid $10 to pose for a portrait. While my assistant tackles that assignment, I begin to set up my backdrop. Someone is usually eager to help me, and I often hire one or two additional people from the crowd. My "aides" earn a little money, and from our conversations, it's clear they also enjoy the opportunity to participate and be useful.

I have discovered that there are additional,

essential prerequisites in this setting: I must allow my subjects to stand free of history or future, free of my suppositions, free from any inclination on my part to condone or condemn. In some cases, I am certain that I photographed people who would soon find a way off the street. In others, I'm sure I captured the face of a violent criminal. And it is likely that in some instances the person in the photo is now deceased. But my purpose is to see and capture one moment in the life of the person before me.

Once the white backdrop is in place, I begin to take photographs. I have people pose individually; if appropriate, as a couple; perhaps as a family. Oversized clothing is the mandatory camouflage of the street, so I may have to ask if they are willing to remove a layer – or two. We face each other in the open street, a line forming behind me, and the natural light fading. I have between two and five minutes with each person.

"I bet you could rip my head off right now," I say to the glowering, 6-foot-7 black man. He breaks into a wide grin. "That's not exactly the image I'm trying to cultivate," he replies. "Do you have any kids?" I ask the vamping woman in Dallas. She nods, dropping her act for an instant. These are the moments I hope for – the ones I work to capture on film.

Between 2004 and 2007, I shot photos in the streets of a dozen American cities. In fifty shoots, I photographed more than 1,500 homeless men, women and children. Like Robert Gonzalez, many possess fierce grace – despite pain of every kind and ever-increasing reasons for despair. By its very nature, homelessness is difficult to document. A 2004 study estimates that 3.5 million Americans will experience homelessness in a given year. Some are veterans. A number are elderly. And too many – about 1.35 million – are children.[1] Foodbank reports are consistent nationwide: each month, a growing number of the elderly and working poor fail to close the gap between low income and basic expenses. Heat, shelter and the bus fare to work cannot wait. Too often, by the end of the month, there is nothing left for food.

Yet my street-based photo sessions gave me reason to hope by introducing me to individuals and organizations working to combat homelessness. San Francisco Mayor Gavin Newsom has literally taken to the streets of his city to look homelessness in the face. He continues to implement programs that include housing and ongoing medical care. In Dallas, Mayor Laura Miller has championed an innovative $25,000,000 homeless project. This campus-like complex is geared to housing not only people, but also the service and support organizations that can make a difference through assistance with finding homes, work and treatment.

John McGah is the founder and director of Give US Your Poor Project in Boston. He is also the soul behind the unique CD recording he initiated to raise both awareness and funds. Bruce Springsteen, Natalie Merchant and Bon Jovi are among the recognized artists who donated their time to record face-to-face and ear-to-ear with homeless musicians. The Give US Your Poor Project CD overflows with vibrant music.

David Langness was homeless at fourteen. Today, David is a corporate communications director. He is also the co-founder of Homeless Healthcare Los Angeles – the largest service agency on L.A.'s skid row. Since 1985, HHLA has provided housing, a clinic, drug treatment, AIDS treatment and needle exchange programs. David told me: "Most homeless people say it's being invisible that's the most painful part; no glance, no acknowledgment. It makes them feel useless and nonexistent."

I offer *Finding Grace* in the hope that we can develop the desire and courage to see beyond the myths that all homeless people are lazy, addicted or crazy. Perhaps we can begin to see people in need, and to acknowledge our own fears – of illness, economic downturn and becoming a "bag lady." I believe that if we look into these eyes, we will recognize our mothers, brothers and daughters, and we will discover talented musicians, bricklayers and stockbrokers, businesswomen and poets.

–Lynn Blodgett

[1] "Homelessness in the United States and the Human Right to Housing," January, 2004, The National Law Center on Homelessness and Poverty.

WHAT YOU CAN DO

1 First, talk about homelessness. Most of us are one disaster or a few paychecks away from homelessness ourselves, so it can be a difficult or even frightening topic of conversation. But talking about it with friends, family, neighbors and colleagues will encourage others to think about the homeless, raise their level of awareness and make the issue more visible among a wider audience.

2 Find a good, reputable homelessness service agency in your area and ask them how you can help – serving as a volunteer, personally contributing and/or fund-raising, working with their board of directors, etc. This avenue of service to homeless people is the most effective long-term way of addressing the problem and not just the symptoms.

3 Identify an elected or appointed official in your area that has a progressive position on poverty and homelessness issues and get involved with that person's office. Vote for that person, call the official's staff, find out if there is anything you can do to help and urge others to support their public policies.

4 Get to know a homeless person or family. Find a service agency, a shelter, a feeding program or a church that provides services to the homeless, spend some time there and get to know someone who is homeless. Homelessness is more than just the fact of not having a place to live – it's a socially isolating condition of not having a network of supportive family and friends, too.

5 When you see a homeless person, especially one who is asking you for money, make eye contact and say hello. Please don't look away or ignore the humanity of that person. Whether you give money or not (I recommend giving money to homelessness service agencies, but you should do what your heart dictates when you are asked for money by a poor person), remember that inside every homeless person is a noble human being.

—David Langness

David Langness is a writer, journalist and public relations executive and one of the founding board members of Homeless Healthcare Los Angeles since its inception in 1985.

• In 2003, more than one third (39%) of the homeless population were children younger than eighteen, and 42% of those children were younger than five.[1]

• A 2005 survey of 24 U.S. cities found that 15% of homeless persons are employed.[2]

• 6% of homeless people are between fifty-five and sixty-four years of age.[3]

• More than one third (37%) of homeless women are fleeing domestic violence.[4]

• In 1998, a family's average time on a public housing waiting list was thirty-three months.[5]

• In 1970, there was no gap between low-income renters and the number of affordable housing units available. In 1995, the gap was 4.4 million – the largest shortfall on record.[6]

• Federal support for low-income housing fell 49% between 1980 and 2003.[7]

• In all fifty states, more than the minimum wage is required to afford a one-or two-bedroom apartment defined as affordable.[8]

• In 2004, approximately 45.8 million Americans (15.7% of the population) had no health care insurance.[9]

• 169 homeless people were murdered between 1999 and 2006, and 303 acts of harassment, kicking, setting on fire and beatings were also reported.

The victims were four months to seventy-four years of age. The accused/convicted were 11 to 75 years of age. [10]

[1] National Law Center on Homelessness and Poverty, 2004

[2] U.S. Conference of Mayors, 2005

[3] National Law Center on Homelessness and Poverty, 2004

[4] American Civil Liberties Union, 2004

[5] U.S. Department of Housing and Urban Development, 1999

[6] Institute for Children and Poverty, 2001

[7] National Low Income Housing Coalition, 2005

[8] National Low Income Housing Coalition, 2005

[9] U.S. Bureau of the Census, 2005

[10] National Coalition for the Homeless, 2007

NAMES

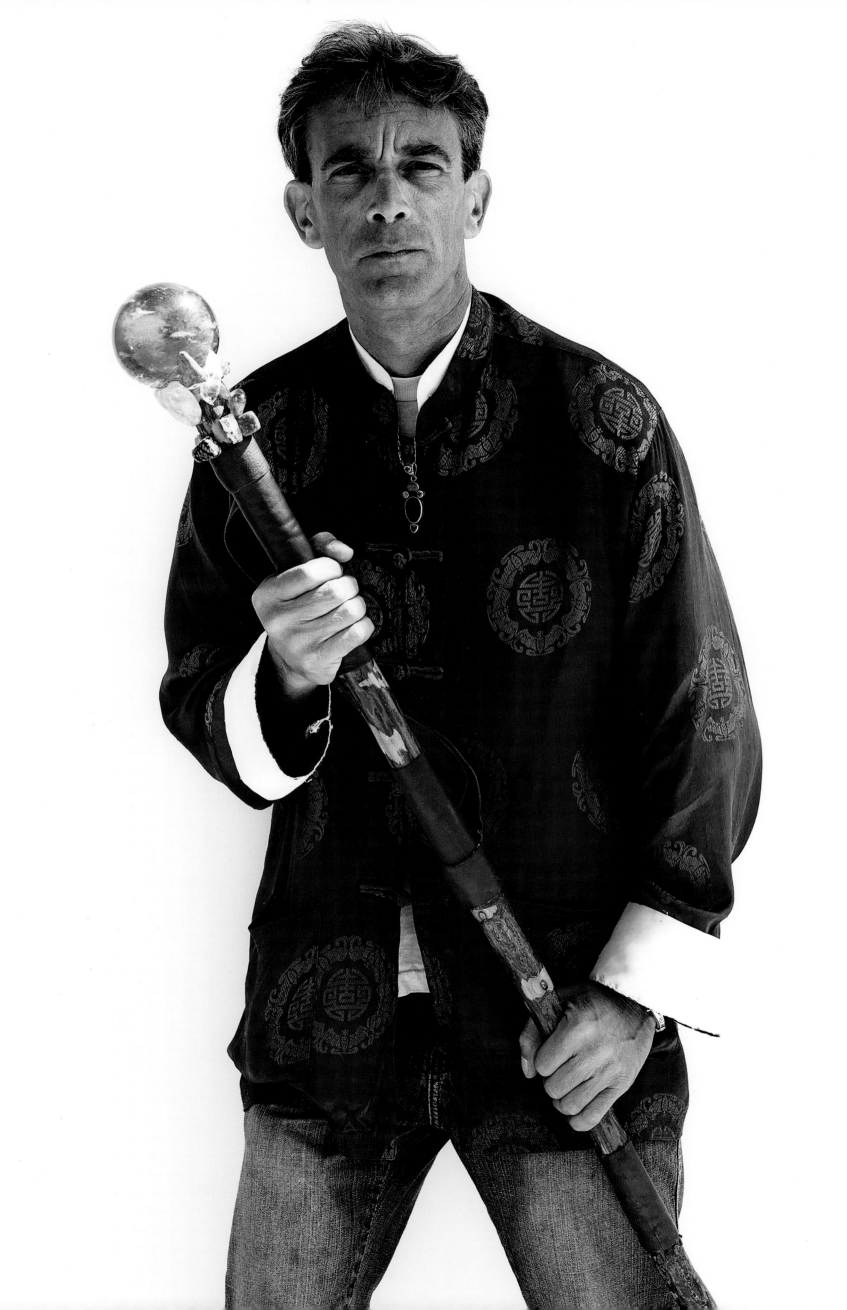

Amazing grace, how sweet the sound

That sav'd a wretch like me!

I once was lost, but now am found,

Was blind, but now I see.

Thro' many dangers, toils and snares,

I have already come;

'Tis grace has brought me safe thus far,

And grace will lead me home.

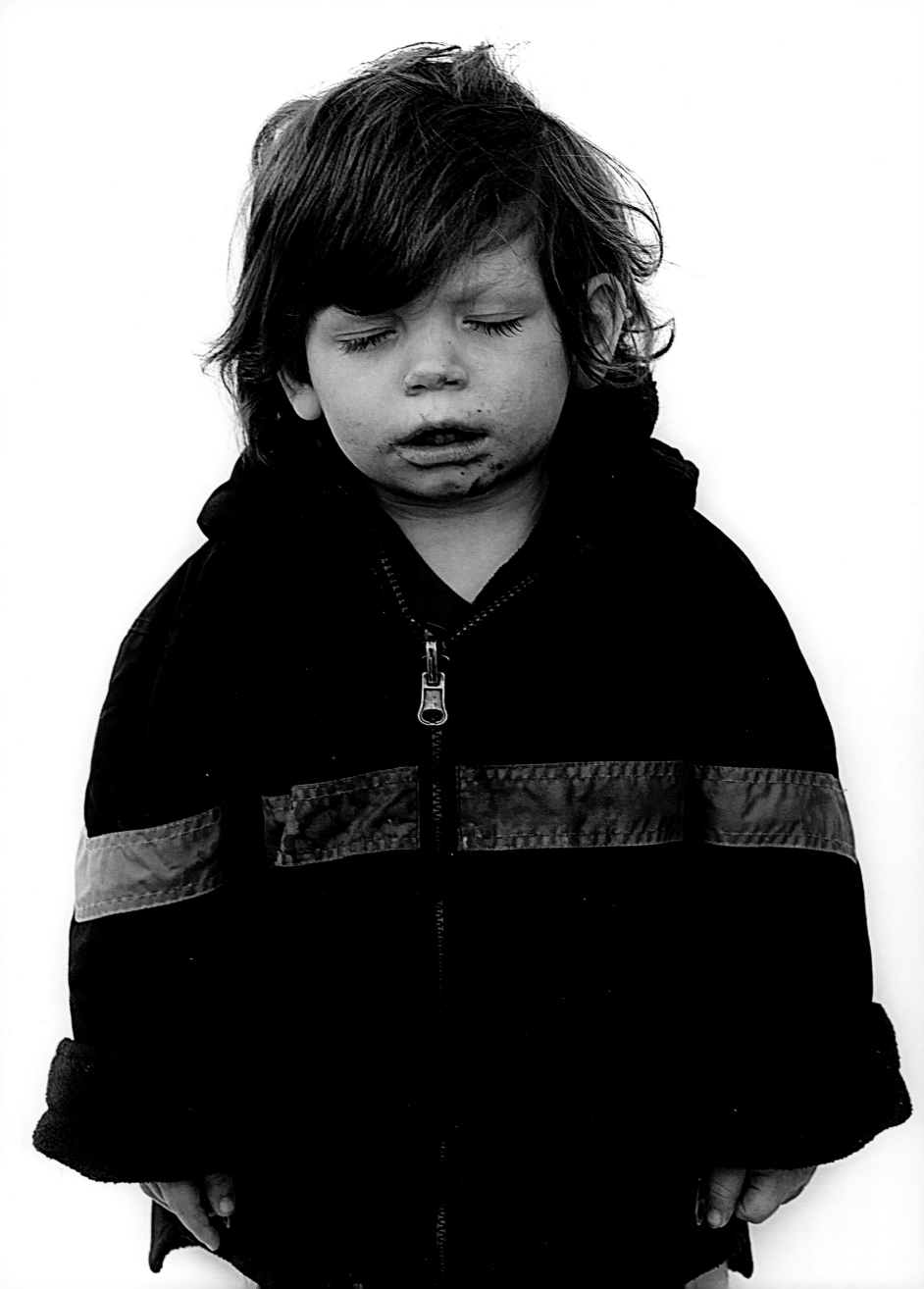

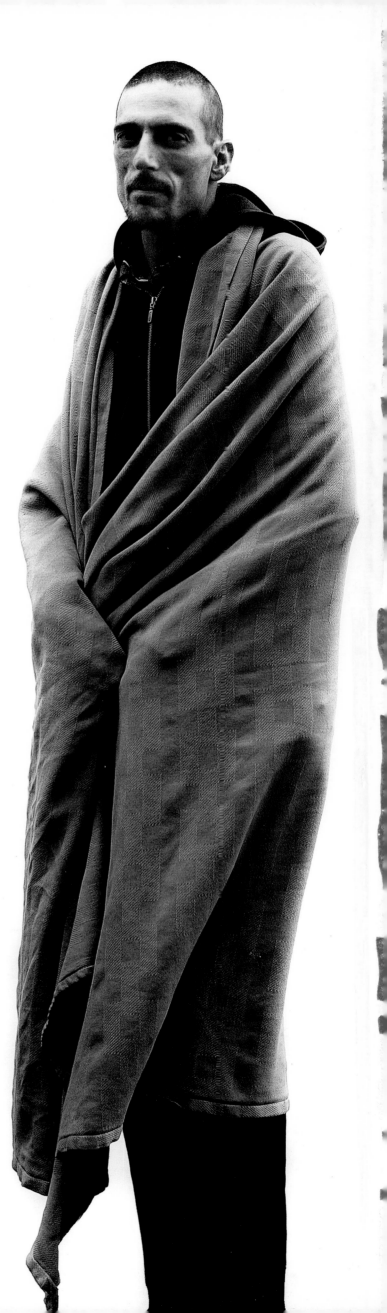

COLOPHON

Publisher & Creative Director: *Raoul Goff*

Executive Director: *Peter Beren*

Acquiring Editor: *Lisa Fitzpatrick*

Art Director & Designer: *Iain R. Morris*

Managing Editor: *Jennifer Gennari*

Press Supervisor: *Noah Potkin*

Editorial Assistants: *Sonia Vallabh & Amy McElroy*

Many people have supported me in the creation of this book. My thanks to each of you, and to all who agreed to step before my lens. I extend special thanks to my agent Jan Miller Rich, Corinne Dunow, Andrew Eccles, Laurie Kratochvil, Gordon Bowen, Michael Rawlings, Tracy Tandy, Raoul Goff and the people of Palace Press, Earth Aware Editions and Pictureline.

—Lynn Blodgett